P A B L O

PICASSO

T E X T B Y

HANS L.C. JAFFÉ

Professor of Modern Art, University of Amsterdam

DOUBLEDAY & COMPANY, INC., Garden City, New York

1980

Translated by NORBERT GUTERMAN

ISBN 0-385-17013-0

Library of Congress Catalog Card Number: 79-3827 All rights reserved. No part of the contents of this book may be reproduced without the written permission of the publishers Printed and bound in Japan Reproduction rights reserved by S.P.A.D.E.M., Paris

PUBLISHED IN COOPERATION WITH HARRY N. ABRAMS, INC., NEW YORK

CONTENTS

PABLO PICASSO by Hans L. C. Jaffé	9
DRAWINGS AND PRINTS	45
BIOGRAPHICAL OUTLINE	61
Selected Bibliography	160

COLORPLATES

SELF-PORTRAIT Philadelphia Museum of Art	65
CHILD WITH A DOVE Collection Lady Aberconway, London	67
LA VIE The Cleveland Museum of Art	69
LA REPASSEUSE (WOMAN IRONING) Collection J. K. Thannhauser, New York	71
ARLEQUIN AU VERRE (AT THE LAPIN AGILE)	
Collection Mr. and Mrs. Charles S. Payson, New York	73
FAMILY OF SALTIMBANQUES National Gallery of Art, Washington, D. C.	75
LA COIFFURE The Metropolitan Museum of Art, New York	77
GERTRUDE STEIN The Metropolitan Museum of Art, New York	7 9
LES DEMOISELLES D'AVIGNON The Museum of Modern Art, New York	81
WOMAN WITH A FAN The Hermitage, Leningrad	83
DRYAD The Hermitage, Leningrad	85
THE RESERVOIR AT HORTA DE EBRO Private collection, Paris	87

PORTRAIT OF DANIEL-HENRY KAHNWEILER The Art Institute of Chicago	89
MAN WITH A PIPE Private collection, Paris	91
THE AFICIONADO Kunstmuseum, Basel	<i>93</i>
BOTTLE, GLASS, AND VIOLIN Collection Tristan Tzara, Paris	9 5
WOMAN IN AN ARMCHAIR Kunsthaus, Zurich (Mme. I. Pudelko Collection)	97
VIVE LA FRANCE Collection Georges Salles, Paris	99
PIERROT The Museum of Modern Art, New York	101
THREE MUSICIANS The Museum of Modern Art, New York	103
THREE WOMEN AT THE SPRING The Museum of Modern Art, New York	105
MOTHER AND CHILD Collection the Alex Hillman Corporation, New York	107
PAUL IN A CLOWN SUIT Collection the Artist	109
MANDOLIN AND GUITAR The Solomon R. Guggenheim Museum, New York	111
WOMAN WITH MANDOLIN Private collection, New York	113
THREE DANCERS Collection the Artist	115
THE STUDIO Collection Sean Sweeney, New York	117
SEATED WOMAN Collection James Thrall Soby, New Canaan	119
THE STUDIO The Museum of Modern Art, New York	121
SEATED BATHER The Museum of Modern Art, New York	123
PITCHER AND BOWL OF FRUIT Private collection, New York	125
THE DREAM Collection Mr. and Mrs. Victor W. Ganz, New York	127
BULLFIGHT Collection Mr. and Mrs. Victor W. Ganz, New York	129
YOUNG WOMAN DRAWING Musée National d'Art Moderne, Paris	131
WEEPING WOMAN Collection Roland Penrose, London	133
GIRL WITH COCK The Baltimore Museum of Art	1,35
NIGHT FISHING AT ANTIBES The Museum of Modern Art, New York	137
WOMAN WITH FISH HAT Stedelijk Museum, Amsterdam	139
STILL LIFE WITH PITCHER, CANDLE, AND ENAMEL POT	
Musée National d'Art Moderne, Paris	141
LA JOIE DE VIVRE Musée Grimaldi, Antibes	143
PORTRAIT OF A PAINTER (AFTER EL GRECO) Collection Rosengart, Lucerne	145
PORTRAIT OF J. R. WITH ROSES Collection the Artist	147
THE WOMEN OF ALGIERS XIV (AFTER DELACROIX) Collection the Artist	149
THE STUDIO Collection Mr. and Mrs. Victor W. Ganz, New York	151
LAS MENINAS (THE MAIDS OF HONOR) OCTOBER 2, 1957 Collection the Artist	153
STILL LIFE Galerie Louise Leiris, Paris	155
LE DÉJEUNER SUR L'HERBE (LUNCHEON ON THE GRASS) JULY 10, 1961 Collection the Artis	st 157
WOMAN WITH DOG Formerly Galerie Louise Leiris, Paris	159
-	

PICASSO

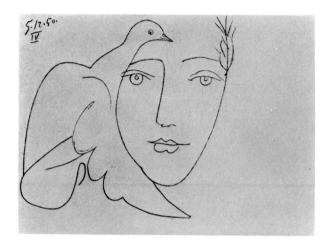

I. FACE OF PEACE. 1950. Drawing, pencil on paper. Photo courtesy Cercle d'Art, Paris

re

1. cesso

For MANY YEARS the art and person of Picasso have been an essential aspect of our twentieth-century world. Though his work has been steadily transforming itself since the beginning of this century, it has become a fixed point against which we measure other art. And Picasso himself has become one of the dominant figures of our age. How has the multiform, varied work of this capricious and stubborn man come to be taken as so reliable, so lucid a criterion ?

That is the fascinating and disturbing question raised by this great man and his work. Throughout the more than seventy years of his creative activity—that is, throughout the period of the rise of modern art— Picasso has been at the center of the artistic and spiritual life of our time. He has become the prism, the lens of this life, capturing and focusing all its light, and reflecting it, transformed, into the darkest corners of our world.

And yet this universal and central figure has always kept for himself a great solitude, the solitude of his native Spain: "Nothing can be accomplished without solitude; I have made a kind of solitude for myself." He guards this solitude even in relation to his own works, for once he has created them, he dissociates himself from them; and they lead a life independent of their creator. In the art of Picasso, the personal becomes impersonal, his own experience becomes the experience of his age, of mankind.

This solitude is at the root of Picasso's independence;

it also accounts for the fact that in his painting, sculpture, print-making, and ceramic work he follows no rules, is bound by no routine. For him art has always been an adventure: "To find is the thing."

The man who says: "I do not see why so much importance should be attached to the idea of 'research' in painting" must be sure of his own ability to find and to make use of what he has found. It is only thus that Picasso has achieved absolute freedom in relation to the objects around him, as well as in relation to his own painting: "I treat paintings as I treat objects. If a mindom in a picture looks wrong I close it and draw the curtains, just as I would do in my own room."

As a result of this freedom, this independence, Picasso has remained completely flexible. That is why there is no "evolution" in his painting, no historically determined sequence, only continual and spontaneous transformation, a perpetual renewal: "For me, art has neither past nor future. All I have ever made was made for the present." And this present, this throbbing life surrounding the artist's solitude, is incarnated in his work, thanks to the curiosity, the avidity with which he pursues it, devours it. Not only the life of art, but life itself is captured by this lens, this prism which seems to draw light to it.

The man who has become his epoch's guide recognizes no preconceived paths: "A painting is not the result of working toward a goal, it is a stroke of luck, an experience." His works are not like milestones

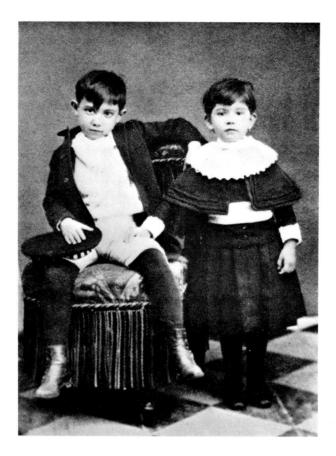

2. Picasso and his sister, 1888

placed at regular intervals along a road; rather, they are like the pebbles tossed out at random by a grownup Tom Thumb to make it possible for his friends to trace his steps, to follow him through the trackless wast. The path that Picasso has traced since 1900 cuts across our entire epoch: "I have never painted anything but my time."

It is perhaps this fact that best defines Picasso's creative genius: not only has he observed his own time, borne witness to it; he has lived it, and lived it most intensely, with all its vicissitudes, its hopes and disappointments. And he has always grasped its truth, its authenticity: "Art is a lie that makes us realize truth." These words bring to mind the lines that Vincent van Gogh wrote to his brother: "All right, call them lies if you will, but they are more exact than literal truth." Picasso, who explicitly rejects the idea of groping for a visual truth, is nonetheless seeking the essential truth of our conception of the world and of our life; like Vincent, he seeks it passionately. And this is why he finds

He finds in the manner of a genius—that is, unexpectedly. Concerning a find of an entirely different kind, Goethe wrote these lines, which Picasso could make his own:

Ich ging im Walde so für mich hin, und nichts zu suchen, das war mein Sinn . . . (I went to the woods just to walk, nor was my purpose to find a treasure . . .)

Picasso himself says: "The work one does is another way of keeping a diary." Facts and events, even those encountered at random, are thus incorporated in the work, and constitute finds which lead to the discovery of the truth.

For truth is the goal—and the source—of this art; and thus Picasso takes his place in that succession of great artists who give truth precedence over pictorial beauty. Of the latter, he takes a rather disparaging view: "The academic gospel of beauty is a fraud." Our notion of beauty changes, he realizes, being

3. Picasso, 1904

merely an instrument, one aspect of a given conception of the world. What we call beauty is always threatening to turn into conformity—and Picasso, as a Spaniard with a solid anarchist upbringing, abhors all conformity. Truth is revealed only through disconcerting discoveries.

Authentic truth is Picasso's domain, and this domain is limitless. When he says, speaking of painting in general but actually referring to his own painting, "A painter paints to rid himself of his sensations and his visions," he stresses the visionary, prophetic aspect of his discoveries. In his art he is always fully committed: like Jacob wrestling with the angel, he does not let go of what he has in his grasp until he has conquered it. The intense and diverse life that has characterized his works over more than a half-century stems from this commitment: "I want the work to reflect only feeling." These words locate the source of his authenticity and at the same time explain why Picasso has not devoted himself to any one genre. His curiosity, his sensibility are so universal that they cannot be confined to a single area of painting, nor even to painting alone. Picasso is one of the few universal artists of our timeand it is his authenticity that makes him universal.

This is also why Picasso has never been a partisan of so-called abstract art: "From the point of view of art, forms are neither abstract nor concrete; they are simply forms—lies—some of which are more convincing than others." And elsewhere he writes: "There is no abstract art. One must always begin with something. Then all traces of reality can be removed. There isn't any danger then, because the idea of the object has left an indelible mark. It is what moved the artist originally, inspired his ideas, set his emotions to vibrating. In the end his ideas and emotions become imprisoned in his painting. No matter what happens, they can no longer escape from the picture."

These lines are proof of Picasso's commitment, his attachment to the objects of his paintings—the objects of life. This great art is fully rooted in man's life, in our time. It is also an eloquent refutation of the romantic myth that sees artists of genius as ahead of, outside of, their time: in actual fact, they are the first to see that time clearly, they are among the few who do not lag behind Picasso illustrates this truth not only in *Guernica*, which is its sublime proof, but in his work as a whole.

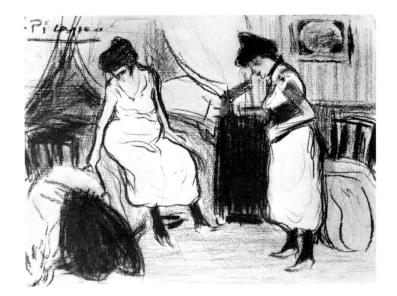

4. TWO WOMEN. 1900. Colored crayon on white paper, $10^5/_8 \times 8^1/_8$ ". The Abrams Family Collection, New York

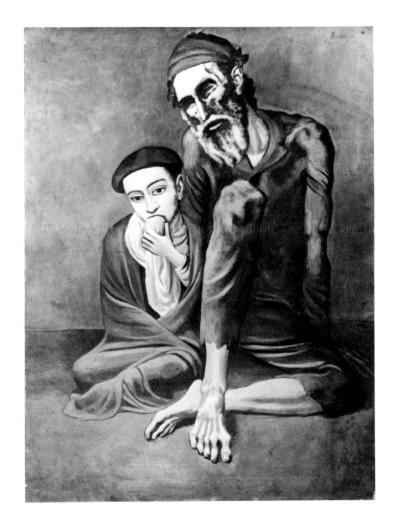

5. OLD JEW. 1903. Oil on canvas, $49^{1/4} \times 36^{1/4}$ ". The Hermitage, Leningrad

Guernica (figure 34) is a striking and deeply moving testimony to Picasso's involvement in the fate of our epoch; at the same time it shows how deep are his roots in Spain, his native land. To anyone who traces the path Picasso has followed since the beginning of this century-as the reader will do in examining the reproductions in this book—it will be clear that nearly every new phase in the master's art seems to have been nourished by a visit to Spain, a return to his source. This continual renewal, these fresh starts, suggest the ancient myth of Antaeus whose strength is restored when he comes into contact with the earth, his mother: Picasso's gigantic work is re-created each time he reestablishes contact with Spain. And the monumental Guernica, which may be regarded as the high point of his art, came into being at a moment when his native land was in mortal danger

But the bombing of Guernica—the actual event which occurred on April 28, 1937—was more than a threat to Spain. The raid by Nazi planes in the service of Franco on the open and defenseless Basque city was

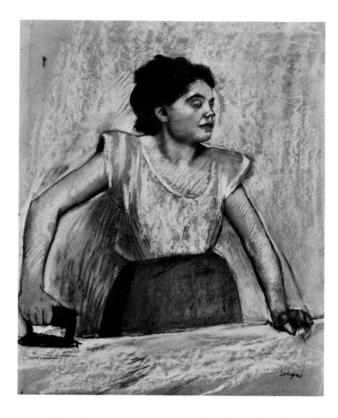

7. Edgar Degas: the laundress. 1869. Charcoal and pastel on paper, $29^1/_8\times24''.$ The Louvre, Paris

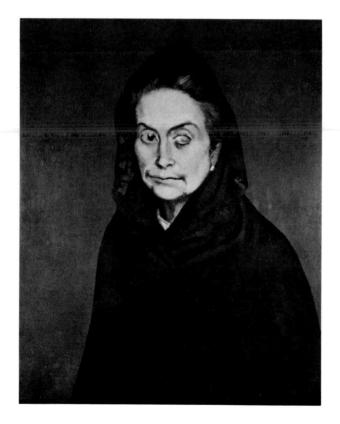

6. CELESTINE. 1903. Oil on canvas, $37^7/_8 \times 23^5/_8''$. Collection the Artist

the initial act of aggression committed against humanity by barbarians. Picasso has never trusted abstractions: for him human beings are the essential reality. That is why he painted *Guernica*, and that too is why he declared after the end of the Second World War. "No, painting is not interior decoration. It is an instrument of war, for attack and for defense against the enemy."

Picasso's art, his work as a whole, is not easily accessible to his contemporaries—and this is true of any authentic and original work. Nonetheless it deals with reality, with the life of men, and it is always relevant to it. Among the great creators of modern art, Picasso is not only the most universal, but also the most ardently human. It is because he has lived our epoch intensely, that he has become its light, its beacon. This light, which he has gathered with such fervor from every contemporary source, is radiated, transformed by his enthusiasm, by his freedom, by his untiring creative genius: "In our mutilated epoch, nothing is more important than to create enthusiasm." This is what Picasso has been doing for more than sixty years. * * *

Pablo Ruiz Picasso was born at Malaga in southern Spain on October 25, 1881. His father, José Ruiz Blasco, taught drawing and painting at the provincial school of arts and crafts, which was the center of art education in that part of Andalusia. His mother, Maria Picasso Lopez, whose name he later chose to bear, kept the house, situated at No. 36 (now No. 15), Plaza de la Merced. There the young Pablo grew up in the early part of his youth—in that very southern city, with a climate like Africa's, and an eventful history going back to Mediterranean antiquity (figure 2).

In 1891—Pablo was a little less than ten—the family left Malaga and southern Spain: his father became an instructor at the Da Garda school of arts and crafts at La Coruña, in Galicia. Pablo lived in this Atlantic port, which to a native of southern Spain must have seemed typically northern, until he was fifteen. What a change in his surroundings-for a boy with wide-open eyesfrom the Mediterranean Andalusia to the rough, rocky coast of the Iberian Atlantic! And we have proof that the young Pablo did use his eyes in his drawings of that time, some of which have survived. The story is that José Ruiz, struck by his son's extraordinary gifts, gave him his own paints and brushes, thus conferring on him the vocation of painter. Don José Ruiz, though a talented painter, was provincial in his outlook : he specialized in pictures of pigeons and still lifes with flowers. After his son's "initiation," Don Ruiz appears to have given up painting devoting himself exclusively to teaching.

In 1895 Don José Ruiz was made instructor of drawing and painting at the La Lonja art school in Barcelona. After spending the summer in Malaga, Pablo's birthplace, the family moved to Barcelona, the financial and intellectual capital of Catalonia. Thus the young Pablo left the confined atmosphere of provincial Spain for a metropolis artistically and intellectually linked with Europe's cultural centers, not only because of its bustling port, but because the independent Catalans had always regarded themselves as a people more international in spirit than the Spanish, a people whose traditional ambitions were not bounded by the Pyrences.

In 1896 the fifteen-year-old Pablo was admitted to the art school where his father taught. He demonstrated his exceptional gifts as a painter by his brilliant performance in the entrance examinations. As elsewhere in Europe, these required of the candidate meticulous observation of the subject in all its detail, and a naturalistic technique which not many boys of that age possessed.

In 1897 he went even further: with the backing of his family, who were full of admiration for his gifts and thought him deserving of the best teachers in

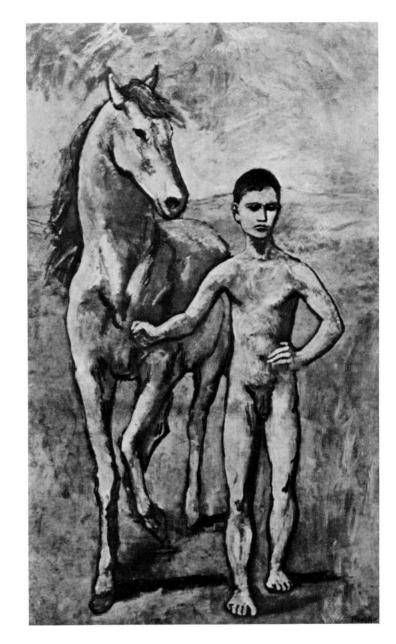

8. BOY LEADING A HORSE. 1905. Oil on canvas, $76^3/_4 \times 38^1/_4''$. The Museum of Modern Art, New York (on loan from the William S. Paley Collection)

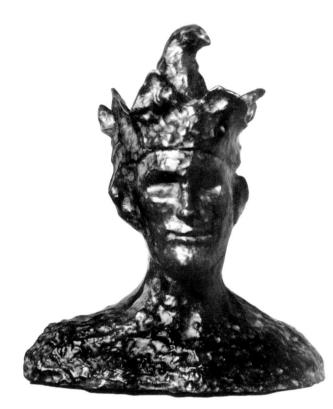

9. HARLEQUIN. 1905. Bronze, height 16¹/₈". The Phillips Collection, Washington, D. C.

Spain, the young artist applied for admission to the Royal Academy of San Fernando in Madrid, the most important art school in Spain at the end of the nineteenth century. The teaching there was academic and traditionalist. Picasso passed the admissions requirements of this academy with as much ease and brilliance as he had those of the Barcelona school; the entrance examination so dreaded by his fellow candidates posed no difficulties for him. Moreover, he had already shown a painting, Science and Charity-a work treating a symbolic subject-at an exhibition in Madrid in the spring of 1897, that is, prior to his admission to the Academy in October, and had been awarded Honorable Mention. The next year a painting of his won medals at exhibitions in Madrid and in Malaga. Thus the young painter had every chance of professional success in Madrid. But he took an intense dislike to the city, and having been ill with scarlet fever, went back to Barcelona. Early in 1898 he went to Horta de Ebro (also called Horta de San Juan) in the foothills of the Pyrenees, to convalesce.

When he returned from the country to Barcelona he joined a circle of young artists and intellectuals whose meeting place was the café Els Quatre Gats. At this establishment frequented by the Catalan bohemians he had his first one-man show in 1897—a series of portraits of friends and acquaintances belonging to this noisy and active circle. This exhibition brought him his first notice, in the magazine *La Vanguardia*. It was at Els Quatre Gats that the young Picasso met the Catalan painters and writers who influenced him at the outset of his career: Eugenio d'Ors, a critic and essayist; Miguel Utrillo, an art historian; Jaime Sabartés, a young poet who remained his faithful friend through the years; Carlos Casagemas, and the brothers Gonzalez, painters who introduced him to the young Catalan school, and others.

The artists of the Catalan school, in contrast with the traditional artists of Madrid, found their inspiration in the North, in the English "decadent" style. They

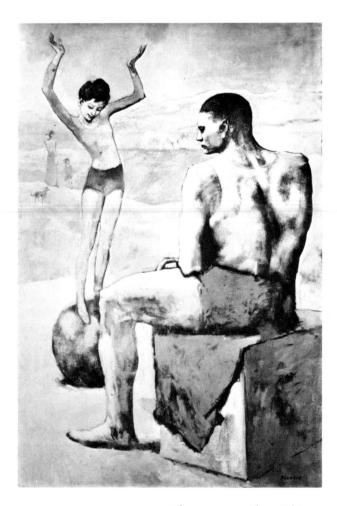

IO. GIRL ON A BALL. 1905. Oil on canvas, $57^{1/2} \times 38^{1/8''}$. Pushkin Museum, Moscow

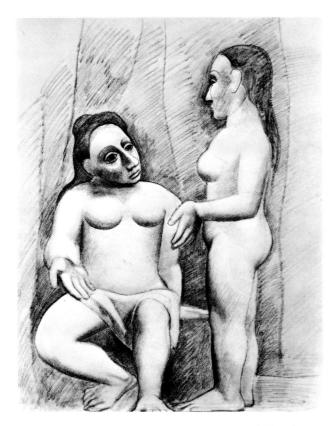

11. WOMAN SEATED AND WOMAN STANDING. 1906. Drawing, charcoal on paper, $23^{3/4} \times 18^{1/8''}$. Philadelphia Museum of Art (Louise and Walter Arensberg Collection)

were influenced, too, by the art of Steinlen, and had social ideals. Their drawings and illustrations appeared frequently in newspapers and magazines. The style of these works—especially the sinuous, flexible line clearly relates them to the Symbolist school and to Art Nouveau. Toulouse-Lautrec was their model.

Picasso's first drawings published in 1900 in the Spanish magazine *Joventut* (a younger sister of the Munich *Jugend*) are also in this style, inspired by Parisian painting and lithography. They place Picasso as an illustrator among that little group of penetrating and pessimistic observers whose awakened and critical minds display, in their rapid sketches from life, an occasional flash of sardonic humor. Though Picasso and some of his friends practiced this style in Catalonia, its center was Paris.

To Paris Picasso went, with his friend Casagemas. He arrived there toward the end of October and stayed in the studio of the Spanish painter Isidre Nonnell at 49, Rue Gabrielle. His first Parisian success came when he sold three sketches to Berthe Weill, an enterprising art dealer. Pedro Mañach, a Spaniard, offered him a 150-franc "contract" in exchange for his production. Little is known about the work he did during his Paris visit; *Le Moulin de la Galette*, a painting in the manner of Lautrec, may date from this first trip.

Around Christmas Picasso went back to Barcelona. The following year he went to Malaga, and then to Madrid where he met Pío Baroja and Ruben Darío, members of the group of '98, and Francisco Soler. With Soler he founded the avant-garde magazine *Arte Joven*. The first of the two issues published, dated March 31, 1901, was illustrated by the young artist. This magazine, which did not confine itself to purely artistic questions, reveals the spirit of the youthful Picasso and his friends; it was polenical, revolutionary, anti-bourgeois, satirical, and independent; its chief ambition was to carry the modern spirit of Barcelona to the Spanish capital. The attempt was bound to fail. For one thing,

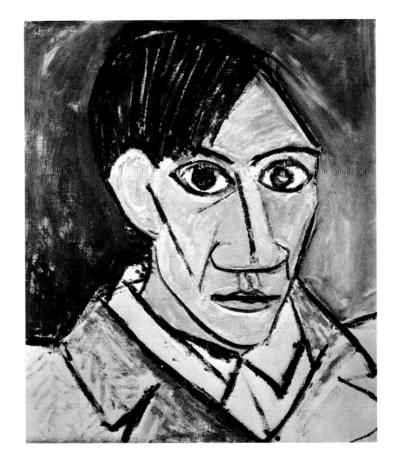

12. SELF-PORTRAIT. 1907. Oil on canvas, $22 \times 18^{1/8''}$. National Gallery, Prague

Picasso left for Paris on almost the day the first issue appeared. But the very fact that the two friends published the magazine, as well as their intention to write a book entitled *Madrid*, is eloquent proof of the young Picasso's independent attitude, his social ideals, and his revolutionary spirit tinged with Catalan anarchism.

His second trip to Paris brought him an exhibition at Ambroise Vollard's which was reviewed most favorably in *La Revue Blanche*. At about the same time an equally flattering review of his exhibition of pastels at the Salon Parés in Barcelona was published in the *Pel y Ploma*, edited by Ramón Casas. These early paintings and pastels, some of which have survived, display the young painter's talent and versatility; they do not as yet disclose his originality. The twentyyear-old artist had by then been exposed to, and assimi-

13. TWO FEMALE NUDES. 1908. Drawing, ink on paper, $18^{7}/_{8} \times 12^{1}/_{4}$ ". Pushkin Museum, Moscow

lated, several influences: that of Toulouse-Lautrec, from whom he derived chiefly the ambiance of his subject—the cafés, the Parisian cabarets; that of the Impressionists, which is manifested in his brilliant gamut of colors; that of Art Nouveau, as shown by his tendency to use a stylized line. But the spirit that dominates all these works is still that of the little group of the café Els Quatre Gats in Barcelona, inspired by the ambition to emulate the freedom and independence of the Paris school of the time. Until the end of 1901 Picasso was a disciple—talented but provincial—of this school.

However, at the end of that year, when Picasso returned to Barcelona, a deep and significant change took place in his painting. This change strikes us first of all in his choice of colors: the variable range of brilliant tones yields to a single dark and oppressive blue. But this transformation in his painting-the first in a long series-was more than a mere change in color, more than the adoption of a new tonality. It was above all the result of a new attitude toward people. Instead of observing them ruthlessly and satirically, he now treated his models with sympathy, with melancholy tenderness. His subjects changed, too. Instead of painting café scenes, Parisian interiors with women in big hats seated at tables and drinking, he began to represent, to imagine enigmatic, emaciated figures standing rigid and silent against a vague or empty background. These men and women no longer evoke contemporary life, they have nothing in common with the tense, nervous atmosphere of Paris at the beginning of this century; they are beggars, blind men, and poor streets artists, transformed by the painter's compassionate and affectionate vision into almost mythical figures that belong to no particular epoch (figure 64). The atmosphere in which Picasso places them is more or less that in which similar figures appear in Rilke's poems, written the same year, 1901an atmosphere of solitude, hunger, and everyday misery, borne with dogged courage. And this spiritual atmosphere is suggested not only by the angular lines of the emaciated bodies, but above all by the sad, distressing color, the subdued blue, which dominates the pictorial space and the figures by its remote and silent unreality.

Child with a Dove, probably painted near the end of 1901, is the first of the series of canvases that comprise

14. HEAD. 1909. Drawing, ink on paper, $25 \times 18^{1/2}$ ". Private collection. Paris

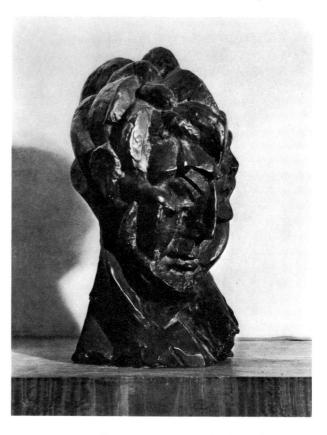

 WOMAN'S HEAD. 1909. Bronze, height 16¹/₄". The Museum of Modern Art, New York

Picasso's Blue Period (page 67). Here, the artist's tenderness manifests itself for the first time, in clear contrast with the spirit of sharp and satirical observation that characterized the street and café scenes. Was it the theme of childhood that lod Picasso to discover this poetry of tenderness? Or was it the detail of the dove that awakened memories of his childhood, when he often watched his father painting pigeons? However that may be, Picasso was conscious of his change in style: from 1901 he signed simply "Picasso," where previously he had used also his patronymic of Ruiz (or its abbreviation).

His second trip to Paris, in 1901, also brought a change in his personal landscape, as his circle of young Catalan bohemian friends was replaced with a group of Parisian poets and eccentrics, among them Max Jacob, whom he had met at Vollard's, and Gustave Coquiot, the art critic of whom he painted two portraits during this visit. The work of his Blue Period during which he produced a number of paintings showing solitary figures such as the portrait of his friend Sabartés, or the guitarist, or the old Jew (figure 5)—was done partly in Paris and partly in Barcelona. In 1902 Berthe Weill and Vollard again exhibited his paintings. He was then in Barcelona, and did not return to Paris until the end of the year. He stayed a few months; early in 1903 he was back in Barcelona, to remain until early in 1904.

The fact that most of the works of the Blue Period were painted in Barcelona accounts for the resemblance of many of his models to figures by El Greco. His affinity with this master of Spanish Mannerism is apparent in the great composition of 1901, which dates from the beginning of the Blue Period—the evocation or burial of the painter Casagemas, now in the Petit Palais in Paris. Like El Greco's *Burial of Count Orgaz*, this painting is divided into two zones, one earthly and the other transcendent; the element of pathos that appears here for the first time arises from Picasso's deeply felt attachment to his friend. In the paintings of the immediately following years this affinity with El Greco asserts itself more and more. The elongated proportions, the ecstatic and angular gestures, the relation between space and figures, all this brings to mind the great Spanish master, but the feeling in Picasso's works remains authentically his own. He makes use of El Greco's elongated forms and hallucinatory space, but he employs these elements to express a feeling peculiar to his time-solidarity with distressed, famished, oppressed humanity. Célestine (figure 6) is a superb example of this feeling and of the style in which it found its form: this portrait of an old oneeved woman, dressed in somber color, achieves, thanks to the simplicity of its color and the economy of its line, an austere nobility which relates it to El Greco's most restrained portraits. From the same year, 1903, dates the enigmatic, symbolic composition entitled La Vie (page 69) showing a nude couple and a woman

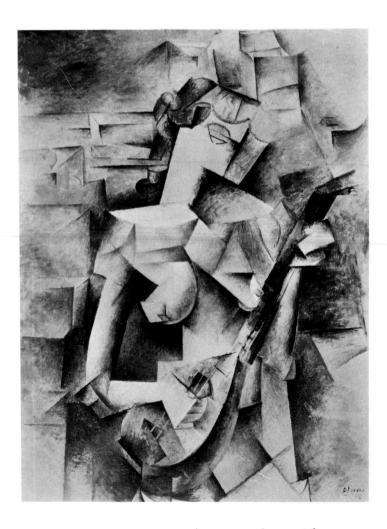

16. GIRL WITH MANDOLIN (FANNY TELLIER). 1910. Oil on canvas, $39^{1/2} \times 29''$. Private collection, New York

17. FEMALE NUDE. 1910. Drawing, charcoal on paper, $19 \times 12^{1/8''}$. The Metropolitan Museum of Art, New York (The Alfred Steiglitz Collection, 1949)

with a child in her arms; this painting, with its long, slender figures, has the same feeling of melancholy tenderness. But *Célestine*, above all, and the canvas representing a blind guitarist (The Art Institute of Chicago), show Picasso's affinity with El Greco and the way he makes use of it to express his solidarity with, his active compassion for, the poor, to whom he belonged himself in that period of his life. At the beginning of the century he, like Rilke, was one of the young artists who felt distressed at the sight of human misery, and expressed this feeling in sober, ascetic, austere works, with a restraint that precluded sentimentality or bathos.

This somber and austere period terminated at the end of 1904, after Picasso had settled permanently in Paris (figure 3). He arrived there in April—this was his fourth trip—and moved into the so-called Bateau-

lavoir, the dilapidated building at 13, Rue Ravignan (now Place Emile-Goudeau), which was one of the centers of artistic bohemia at the time. Two works are characteristic of the Blue Period at its close-Woman Ironing (page 71), an oil, and Frugal Repast, an etching (figure 64). A comparison of the first with Degas' painting entitled The Laundress at once reveals the authenticity of Picasso's austere imagination: Degas observes a laundress at work, wearied by her routine (figure 7); Picasso's laundress is a visionary apparition, bowed under the burden of work, and rendered with the sadness of another oppressed being who sympathizes with her. The Frugal Repast expresses the same ascetic melancholy, not only in its subject, but also in the spareness of its lines and accents, and in its sober and restrained contrasts between black and white. His Blue Period, which extended from 1901 to the end of 1904, shows Picasso in full possession of an artistic individuality based not upon talent-he had proved his talent long before this-but upon an attitude toward human beings, upon an authentic conception of the world.

The following years marked a happy turn in Picasso's life and painting. He made friends. He met Guillaume Apollinaire, who became one of his most loyal companions. He even began to sell his paintings: to two Americans-Gertrude Stein, a daringly independent writer, and her brother Leo, a well-informed art lover-and to a Russian, the wholesale lumber dealer and collector Shchukin. In 1905 he met Fernande Olivier at the well of the Bateau-lavoir; she lived with him until 1911. That summer he went to Holland, to Schoorldam, at the invitation of his friend Schilperoort. The greater brightness of his life was reflected in his work: austere, ascetic melancholy is tempered by a pure and intimate tenderness. Just as with the onset of the Blue Period, the change manifested itself primarily in his palette: the subdued cold blue gave way to brown, red ocher, and rose.

With the new palette came a transformation in subject. The famished, solitary figures shown against a neutral and mythologically vague background were succeeded by comedians, circus and carnival performers, shown in intimate family scenes, calm and relaxed, in an idyllic atmosphere. Once again the artistic metamorphosis reflected a change in the artist's human

attitude: his despair, the pessimism of his years of struggle, yielded to affectionate sympathy, a feeling of warm solidarity with these independent and free people. The new style manifested itself not only in the colors; one of the characteristics of this new period, called the Rose Period, is a different handling of space: the figures are placed amid specific surroundings. They no longer appear in the blue infinite of a limitless void; they have their world. A whole series of canvases treats these circus or carnival subjects, among them the large painting Family of Saltimbanques (page 75) which inspired the opening lines of Rilke's fifth Duino Elegy; and the superb canvas at the Hermitage in Leningrad, in which this idyllic and intimate feeling found its fullest expression. Now, the human contact between the figures becomes sympathetic: the morose atmosphere and loneliness of the Blue Period is a thing of the past. The authenticity of Picasso's feeling is shown by the fact that Rilke's poems about clowns, dating from the

18. MALE HEAD. 1912–13. Drawing, charcoal on paper, $24^{5}/_{8} \times 18^{3}/_{8}^{*}$. Private collection, New York

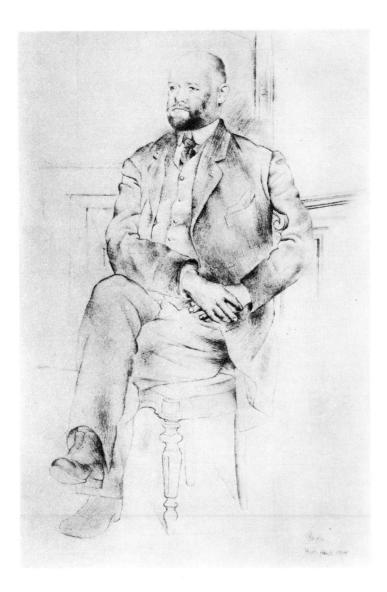

19. AMBRUISE VOLLARD. 1915. Drawing, pencil on paper, $18^3/_8 \times 12^9/_{16}$ ". The Metropolitan Museum of Art, New York (Whittlesey Fund)

same time, express a similar emotion. The same attitude is seen in an important series of etchings, which date from 1904/5, but were published only several years later, in 1913, by Ambroise Vollard. After his trip to Holland Picasso also made his debut as a sculptor. His first work in this medium was a bust of a harlequin, and later a woman's head (figures 9, 15); many others were to follow at various periods of his life. These two early bronzes also reflect the calm and tenderness of his new attitude toward life.

It is very possible that these first sculptures encouraged Picasso to study classical sculpture; the influence of the latter may be discerned in his drawings and watercolors of 1905 and early 1906. Alfred H. Barr, Ir., the most perceptive student of Picasso's art, used the term "First 'Classic' Period" to characterize these works. It is a fact that a concern with compositional values, volumes, and balance began to take precedence over the emotional content of his paintings (figure 10): the similarity between the bodies of his youths (for example, in Boy Leading a Horse; figure 8) and certain Greek kouroi in The Louvre can hardly be accidental. The study of Greek sculpture, the return to the Mediterranean classical tradition, must have had a peculiar significance in the work of Picasso. At the age of twenty-five, entering upon his maturity, he felt the need for objectivity, which from that moment on was to dominate his personal attitude. He borrowed a leaf from the anonymous tradition of pre-classical antiquity, in which he "found"-again his key wordan objective construction of forms and volumes, one that is not influenced by subjective feeling.

20. THE GUITAR PLAYER. 1916. Oil on canvas, $51^{1/8} \times 38^{1/8}$ ". Nationalmuseum, Stockholm

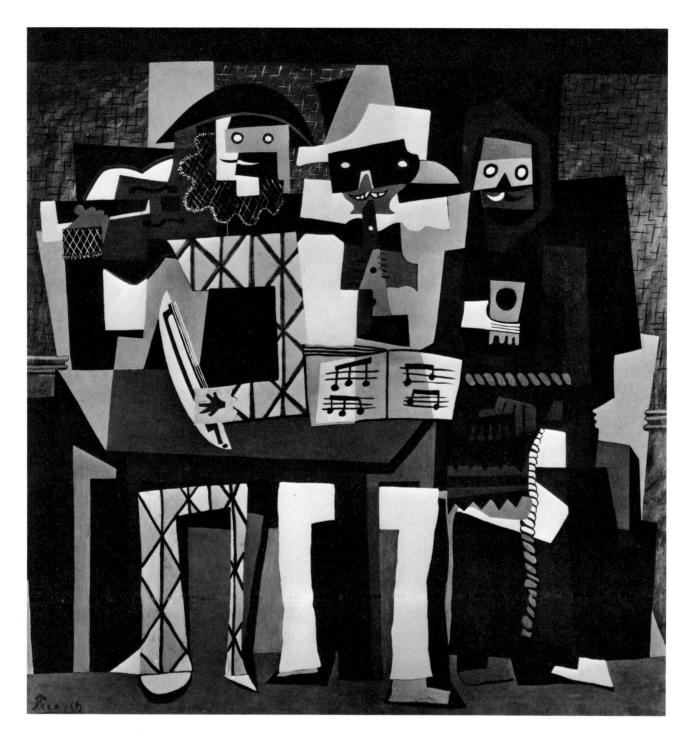

21. THREE MUSICIANS. 1921. Oil on canvas, 80 × 74". Philadelphia Museum of Art (A. E. Gallatin Collection)

This tendency to objectivity, which was to dominate his work for almost twenty years, was further accentuated in 1906, as a result of a trip to Spain. As we have said, almost every change in Picasso's art is inspired by renewed contact with his native land. He spent the summer of 1906 at Gosol in the Urgel valley, a primitive and rustic region in the foothills of the Pyrenees. Fernande Olivier was with him. There his "classic" style was transformed, taking on clearly primitive features: volume, sculptural effects became dominant. In the compositions of his First "Classic" Period the figures were situated in a well-defined harmonious space; in the paintings that followed, in 1906, the volumes themselves create the space surrounding them, by the spatial energy of their plastic values. The portrait of Gertrude Stein marks the transition between the two periods (page 79). Begun early in 1906, it was not finished to the painter's satisfaction before his departure for Spain, although Miss Stein had sat for it eighty times. On his return from Gosol in the fall, Picasso painted the face from memory before seeing his model again. The portrait illustrates the difference between the two styles: the face, treated in a simplified manner, is an example of the new tendency.

The new monumental but compact style, which came to full flowering in the self-portrait painted early in 1907 (figure 12), may have been inspired by Picasso's interest in pre-Roman Iberian sculpture. Important examples of these had been discovered and published early in 1906, and Picasso could have seen them in The Louvre. The simplified and suggestive construction of these heads, the elimination of all irrelevant detail, unquestionably find a parallel in Picasso's paintings of 1906. But it is impossible for a great artist's work to reflect an influence unless a tendency in that direction has already formed within him. Thus Picasso's study of Iberian and perhaps other primitive sculpture can only have urged along a disposition already manifested in his art—the tendency to simplification and greater objectivity of form, to suppression of detail, to a stronger spatial and plastic construction. The two self-portraits of 1906 and 1907, one in Philadelphia (Frontispiece) and one in Prague, testify to the existence of this tendency in Picasso's painting, especially if it is seen as the continuation of the development begun with the face in the portrait of Gertrude Stein. This is the development that in 1907 led to Picasso's most important invention—Cubism.

The year 1907, a major turning point for Picasso and for all European painting, found the artist ensconced in a circle of friends. In 1906 he had met Henri Matisse (they remained close until Matisse's death); through

22. ATELIER OF THE MODISTE. 1925. Oil on canvas, $67^3/_4 \times 104^{"}$. Musée National d'Art Moderne, Paris

23. MUSICAL INSTRUMENTS. 1926. Drawing, India ink on paper, $12^3/_4 \times 9^3/_4$ ". Illustration for Balzac, *Le Chef-d'œuvre inconnu*

Matisse he became a friend of André Derain and Georges Braque, both of whom belonged to the group known as Les Fauves, whose uncontested leader was Matisse. In 1907 he met Daniel-Henry Kahnweiler, who had recently opened a gallery at 28, Rue Vignon, and who became his loyal dealer, and an ardent and intelligent champion of Cubism.

The major event of 1907 for the art world was the retrospective exhibition of Cézanne, held at the Salon d'Automne, showing fifty-seven works by the painter who had gone beyond Impressionism through the discipline of his pictorial construction, and who had dreamed of making his art "a harmony parallel to nature." The need for objectivity that Cézanne had felt so strongly could not have failed to impress Picasso, who was striving toward the same goal. However, the great canvas that marked his breakthrough to a new kind of painting, *Les Demoiselles d'Avignon*, had been virtually completed before the opening of the Cézanne exhibition (page 81). This disconcerting revolutionary work began a new direction in Picasso's painting; it also inaugurated a revolution in European painting, by its resolute abandonment of the traditional norms of classical beauty, by its deliberate barbarization of the human figure. It is the manifesto of the first revolt against sensory perception, of a new vision of the world.

The painting is not a complete unity; it was composed in two or even three stages, and the creative process can be clearly traced. It does not derive its importance from its artistic perfection, but from its revolutionary qualities of boldness and shock. Traditional linear perspective is challenged, space is suggested by new means, traditional beauty is emphatically rejected: the painting is the result of a conception

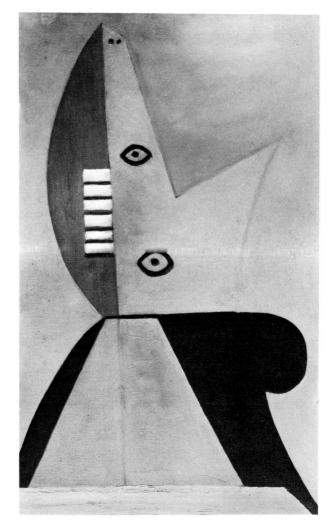

24. HEAD OF A YOUNG GIRL 1929. Oil on canvas, $24 \times 15''$. Kunstmuseum, Basel

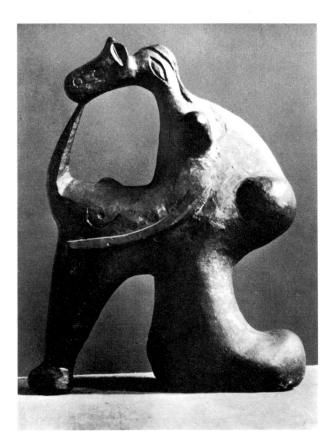

25. METAMORPHOSIS. 1928. Plaster, height 8⁵/₈". Collection the Artist

of the world that no longer rests upon sensory perception, but arises from a magical, intuitive feeling of life. It is a conception parallel to that of Bergson (whose *Creative Evolution* was published the same year); it is, in a word, a declaration of war against positivism, the philosophical system of bourgeois society, which is based upon total acceptance of perceptible reality, upon observation of facts.

Les Demoiselles d'Avignon is a point of departure; thereafter Picasso's path leads through hitherto unknown territory. In this monumental painting space was already being treated as a solid substance, with a solidity equal to that of bodies and drapery. In the following year this painting was further unified, under the increased influence of Cézanne. In other works of the same period, such as *Woman with a Fan*, everything in the picture obeys the same structural laws as the powerful, monumental torso of the figure: under the eyes of the artist who sought to synthesize his experiences, nature became one and indivisible (page 83). Body and space seem sculptured: the simple, strong design suggests an ax or a chisel, and it has nothing in common with the refinement that characterizes Picasso's early sculptures. The colors are reduced to tones of brown and ocher. In the landscapes of that year, which Picasso painted during a stay at La Ruedes-Bois (Oise), these colors are complemented by a saturated green, which brings out the simple harmony of the composition.

In these landscapes the influence of Cézanne is superimposed on the influence of Iberian and African sculpture. We see here a new style being worked out in close collaboration with Georges Braque. Braque's paintings—landscapes solidly constructed according to the precepts of Cézanne—after being rejected by the Salon d'Automne, were exhibited at Kahnweiler's. On that occasion a satirical reviewer coined the term "Cubism," which has since been used to designate this austere style. The year 1908 was also that of the famous

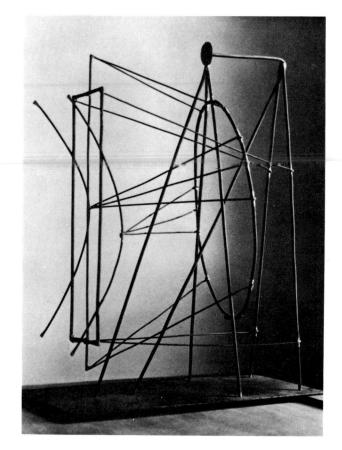

26. CONSTRUCTION. 1930. Iron wire, height 30". Collection the Artist

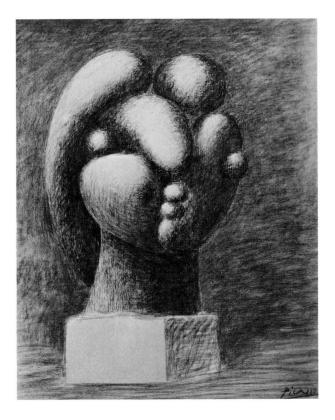

27. PROJECT FOR A SCULPTURE. 1930. Oil on canvas, $36^{1/4} \times 28^{3/4}$ ". Galerie Beyeler, Basel

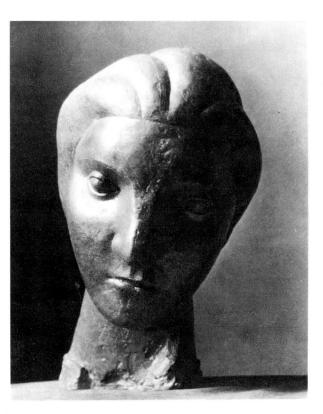

28. HEAD OF A WOMAN. 1931-32. Bronze, height $22^{1}/{2''}$. Collection the Artist

banquet organized by Picasso in honor of the *douanier* Rousseau; this banquet too was an expression of the revolt of the group around Picasso against academic conventions, against a traditional conception of the world

This rebellion was consolidated, once more, in Spain. Picasso spent the summer of 1909 at Horta de Ebro, and his stay in this bright and sunny countryside helped him solve his problem. He reduced his palette, confining himself to ochers and grays, and concentrated on the effects of volume. He proceeded "scientifically"-and the fact is significant-that is to say, by analysis. He reduced forms and volumes to their stereometric elements; renouncing chiaroscuro, he solidified space until it is suggested only through the angularity of the solids and their juxtaposition. The Horta landscapes-for instance, The Reservoir at Horta de Ebro (page 87)-are concrete examples of this analytical vision of the world, which aims at a systematic recreation of reality. The purpose is no longer, as it was in Impressionist paintings, to evoke the fugitive charm of a sun-drenched landscape, but to discover its essential structure, to re-create it by a solid and disciplined architecture in accordance with the laws governing nature and the human mind. A bronze *Woman's Head* exemplifies the same structure as applied to the human figure (figure 15).

Analytic Cubism, as elaborated in the landscapes painted at Horta (together with several portraits and a group of still lifes), was perfected and carried further in the works of 1910, above all in the remarkable portraits of Uhde, of Vollard, and of Kahnweiler (page 89). Whereas in 1909 Picasso's aim had been to create a broad architecture in his painting, in 1910 the faceted, perfect form of the crystal became the symbol of his art. Picasso now meticulously analyzed the forms, breaking them up into small structural planes; these were often rectilinear, like facets of a skillfully cut diamond. This system of "overlapping planes"—which was applied both to the figures and the surrounding space-endows these paintings with a tremendous eloquence: space is created by the viewer's eye just as, in earlier Impressionist paintings, tones were compounded in the viewer's eye by the juxtaposed spots.

29. FIRST COMPOSITION STUDY FOR "GUERNICA." May 1, 1937.

30. COMPOSITION STUDY FOR "GUERNICA." May 1, 1937.

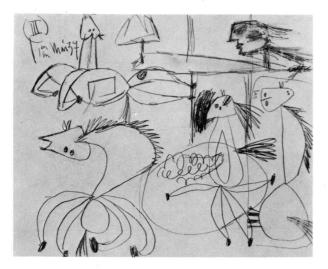

31. COMPOSITION STUDY FOR "GUERNICA." May 1, 1937.

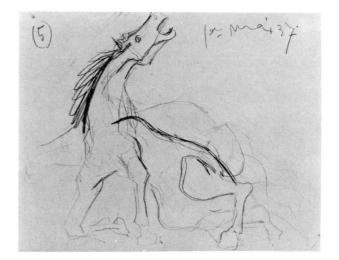

- 32. STUDY FOR A HORSE IN "GUERNICA." May 1, 1937.
- Drawings on this page are in pencil on blue paper, $8^{1/4} \times 10^{5/8''}$. The Museum of Modern Art, New York (on extended loan from the artist)

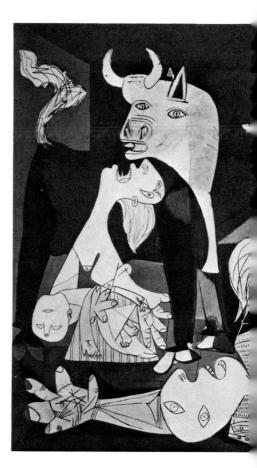

33. COMPOSITION STUDY FOR "GUERNICA." May 9, 1937. Drawing, pencil on white paper, $9^{1/2} \times 17^{7/8''}$. The Museum of Modern Art, New York (on extended loan from the artist)

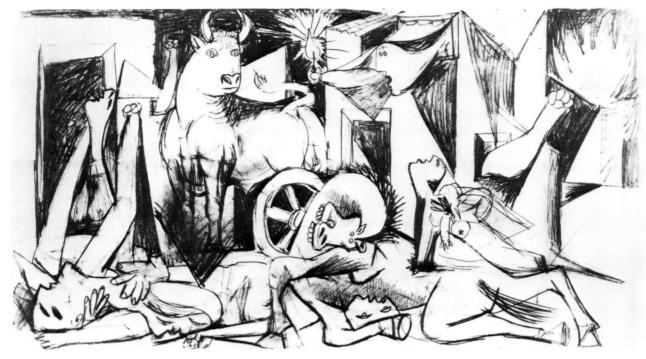

34. GUERNICA. 1937. Oil on canvas, 11' 6" × 25' 8". The Museum of Modern Art, New York (on extended loan from the artist)

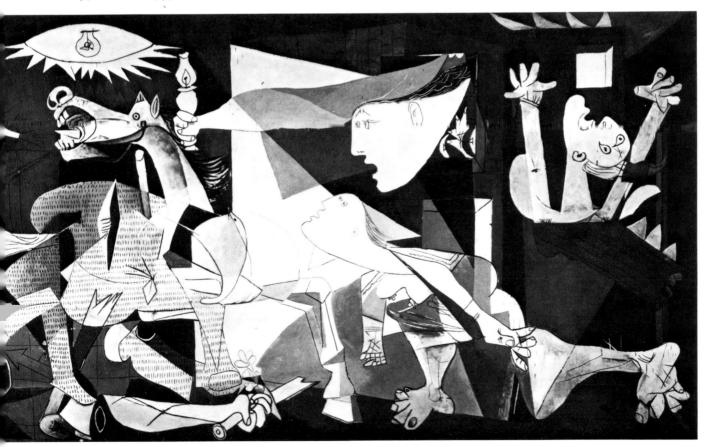

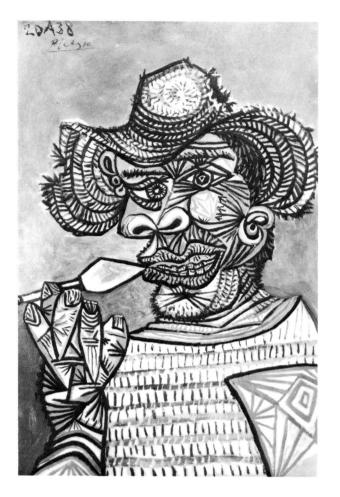

35. MAN WITH AN ALL-DAY SUCKER. 1938. Oil on paper and canvas, 26⁷/₈ × 18". Collection Edward A. Bragaline, New York

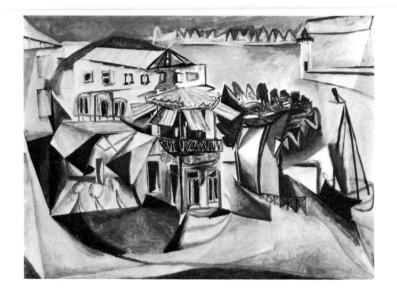

36. CAFE AT ROYAN. 1940. Oil on canvas, $38^{1/2} \times 51^{1/8''}$. Collection the Artist

These methodically and intricately calculated paintings of Picasso's are nonetheless lyrical; their lyricism has little surface charm, but a virile, controlled, and austere discipline that brings to mind Johann Sebastian Bach's The Art of Fugue. The Girl with Mandolin (figure 16; painted shortly before the portraits) introduces this style, which acquires increasing precision, and reaches its apogee in the portrait of Kahnweiler. In 1911, during the summer which he spent in Céret (French Pyrenees) with Fernande Olivier and Braque, this direction was continued in a series of figures and still lifes and, later, in a sequence of etchings in the same sober and crystalline spirit, illustrating Saint Matorel, by his friend Max Jacob-the artist's first venture in book illustration. In the etchings, as in the paintings of this period, Picasso confined himself to a few nuances of gray by way of coloring; the brush strokes, visible until then, tended to disappear.

The disciplined objective Picasso achieved with this analysis of forms and volumes had become a language. Once the outlines of this language had been arrived at, he succeeded in simplifying its message in the works painted at L'Isle-sur-Sorgue (Vaucluse) in the summer of 1912. The large compositions, such as The Aficionado, are constructed out of simpler, less fragmented elements (page 93). At this stage, the implications of the Cubist revolution become apparent: the painter constructs a new world, beginning with geometric elements. He now entirely renounces the stationary point of view, which limits the apprehension of the object to an arbitrary angle of perception or viewpoint; he reconstitutes the object of his painting not on the basis of visual observation, but from his idea of it. Thus he creates a reality which transcends the arbitrary point of view of the accidental viewer, as well as the limited data of perception. This form of Cubism, which was born during the year 1913, is usually called Synthetic in opposition to the preceding Analytic phase.

In the emergence of this advanced style, a new technique—collage—played a great part. In resorting to this technique, Picasso and Braque intended to achieve greater objectivity and impersonality. Braque took the first step in this direction when he introduced printed letters and surfaces painted to resemble wood or marble into his compositions, as a kind of trompe-l'œil. But the purpose was more than illusionistic: the two artists also tried to refer directly to reality in a

way which, by contrast, would accentuate the artificiality of the painting. Medieval masters used the same technique when they emphasized the transcendent nature of their figures by placing real objects in their hands; and contemporary twentieth-century poets were moving in the same direction when they

37. WOMAN WITH ORANGE. 1943. Bronze, height 70⁷/₈". *Collection the Artist*

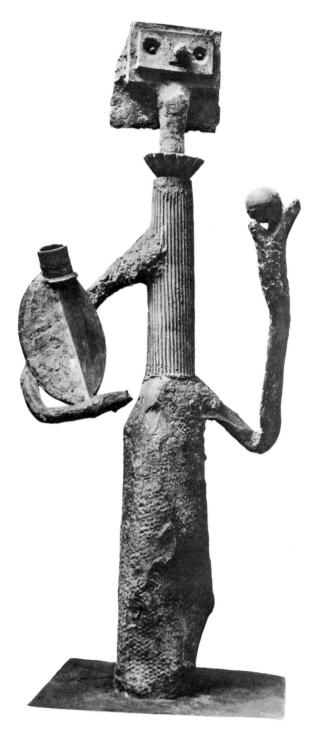

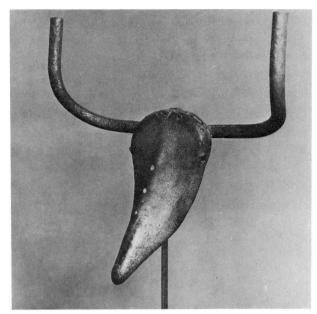

 BULL'S HEAD. 1943. Handlebars and seat of a bicycle, height 16¹/₈". Collection the Artist

included in their poems conversations overheard in the streets. But in painting, this daring innovation has broader implications: having destroyed the unity of the object and the unity of space, the masters of Cubism set out to destroy the unity of the painted surface, the unity of the medium. By introducing "real details"-newsprint, colored paper, etc.-Picasso succeeds in creating signs bearing a new validity: he uses the new materials not as poetic metaphors, but 10 produce a true metamorphosis, a transfiguration. Some still lifes of 1913, for instance, Bottle, Glass, and Violin (page 95), and some heads, illustrate this: Picasso creates signs that represent reality instead of describing it. To give body to this new synthetic language, everyday things can serve, not as relevant objects, but as linguistic and syntactical examples. The technique of collage considerably influenced Picasso's easel paintings: his works of 1913, for example, Woman in an Armchair (page 97), demonstrate the change from an "analytic" to a "synthetic" structure of signs, resulting in a "conceptual painting," as Daniel-H. Kahnweiler calls it. In these works of 1913-Card Player, in the Museum of Modern Art, New York, and others-Picasso achieved monumental simplicity, a striking, definitive formula which was to be the basis of many of his subsequent works.

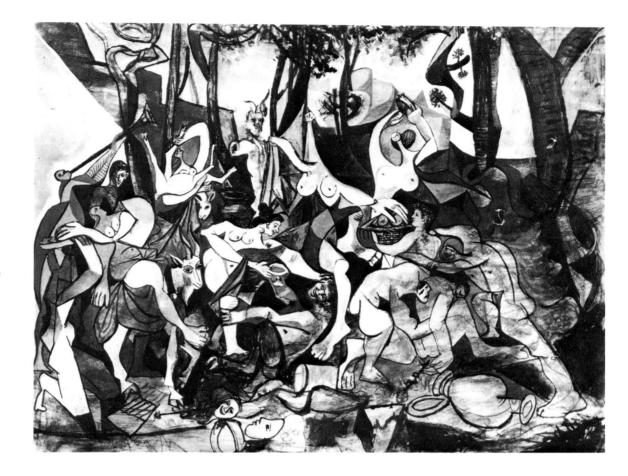

39. BACCHANAL, after Poussin. 1944. Watercolor and gouache, $12^{1}/_{4} \times 16^{1}/_{4}''$. Collection the Artist

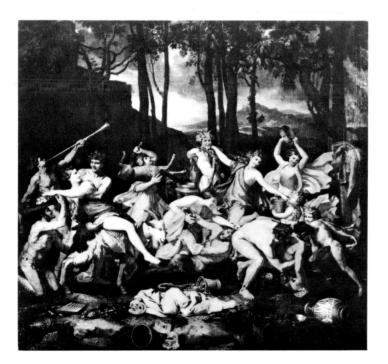

40. Nicolas Poussin: TRIUMPH OF PAN. 1638–39.
Oil on canvas, 54³/₄ × 61³/₄".
The Louvre, Paris (ex-Collection Jamot)

The outbreak of war in 1914 put an end to the collective adventure of Cubism: Braque and Derain, with whom Picasso had spent the summer at Avignon, left for their regiments; Picasso, alone of his group, could continue to work as an artist. His output of 1914 is characterized by a new gracefulness and lightness, which gave rise to Alfred Barr, Jr.'s, expression "Rococo" Cubism. Whereas the works of the preceding period bring to mind the austerity of Bach's music, those of 1914 (for instance, Portrait of a Girl) suggest Mozart's graceful trills: the "dot" or pointilliste treatment, the boa around the shoulders, and a number of other details contribute above all to a reestablishment of color-a development which had been foreshadowed in 1913. Because his friends had been called to war, Picasso was now the only painter to develop this phase of Cubism in the following years, reaching another high point in the Guitar Player of 1916 (figure 20), and terminating in 1921 with the two versions of Three Musicians (figure 21; page 103), incontestable masterpieces, convincing in their clarity.

As we have said, Cubism, the collective attempt at a style characteristic of our time, came to an end in 1914. Although Picasso continued it during the war years, even for him this language, this image of the world (which Cubism is) lost its exclusive validity. In 1915, to the astonishment of his friends, he made two portrait drawings-one of Max Jacob and one of Ambroise Vollard (figure 19)—in a meticulously realistic style. He had not used this style since 1906, and to do a painting based on the data of sensory perception had seemed out of the question after the revolutionary breakthrough of Cubism. Why then did he go back to the old conception of reality which he himself had discarded? Was it because the chaos of the war-the overwhelming concern of all his friends-could not be expressed in the precise and methodical language of Cubism? Or was it because the development of a supra-personal style required after all a collective effort, which was a task beyond the strength of one individual, no matter how gifted and imaginative? Whatever the case may be, since 1915 realistic styles have existed side by side with Cubism in Picasso's work. From that moment on Picasso was committed to no single style, and used many different approaches to express his ideas and feelings.

The first evidence of this newly acquired freedom came in 1917. At the invitation of Jean Cocteau, Picasso went to Rome to execute the stage designs and costumes for Cocteau's ballet, Parade. His drawings and sets reveal for the first time the coexistence of various styles and modes of expression. The curtain was painted in a joyously realistic manner, while the costumes-at least those of the fantastic figures of the "managers"were rigorously Cubist. This juxtaposition was unheard-of in theatrical art. Picasso's friends were amazed when it occurred also in his painting: the same year produced the portrait of Olga Koklova (who later became Picasso's wife), a meticulously realistic work, worthy of the great nineteenth-century masters such as Ingres; and the severely Cubist canvas, Italian Woman. The two styles continued to overlap during the following years, in works in which the human figure, treated in one style or the other, gained increasing importance. This fact is partly accounted for by Picasso's work in the ballet: clowns, dancers, and other such figures played a greater part in his life than even during the Rose Period.

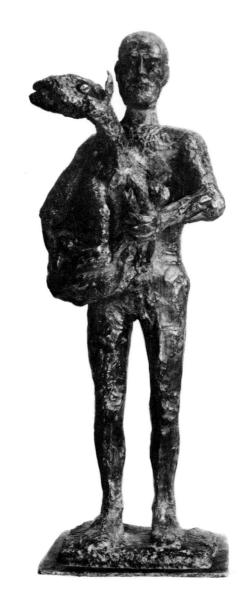

41. SHEPHERD CARRYING A LAMB. 1944. Bronze, height 81¹/4". Collection the Artist

The world of the ballet which inspired a series of drawings and canvases finds its apotheosis in the two versions of *Three Musicians*, the highest expression of Synthetic Cubism (figure 21; page 103). The two versions differ in composition, color, and even in the general feeling of the visual structure; taken together, they constitute a definitive statement of the creative discoveries of Cubism, which they put to full use: simple and geometrically defined forms constitute signs which, by means of this deliberate and enchanting metamorphosis, take on life and a surprising suggestiveness.

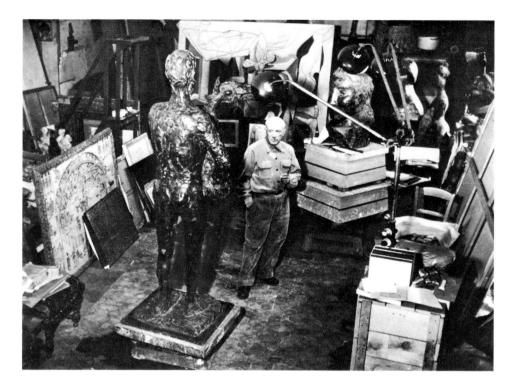

42. Picasso in the Paris studio, 1950

At the opposite pole of Picasso's artistic creation, another series of canvases began to take shape simultaneously: the cycle of heads and figures inspired by classical antiquity. This was continued after 1921 in paintings treating the theme of mother and child. As early as 1920 the influence of Roman sculpture was apparent in these enormous heads and gigantic figures. It reflected the return to antiquity, to tradition, which prevailed in every intellectual area during the first years after the war and was symptomatic of a general reaction against chaos and destruction, and of the attempt to rebuild European culture after the four disastrous years. The music of Stravinsky, Italian painting, poetry throughout Europe-all were part of that movement. But in Picasso's work, another motive intervened, which was to reappear about ten years later—the need to create a mythology for himself.

In 1918 Picasso married Olga Koklova, prima ballerina of the Ballets Russes for which he had worked in Rome. In 1921 their son Paul was born. It was after this that the subject of mother and child, mentioned above, reappears as a major theme in the guise of monumental figures devoid of personal allusion, transported into a realm of mythology (page 107). The painting of 1923 is a telling example of this, doubly remarkable for the restraint of its color (for it is contemporaneous with brilliantly colored works). And just as the mythical figures of the Blue Period had yielded to the emotional compositions of the Rose Period, these gigantic figures of a mythological universe gave way to tender portraits of the young Paul. The painting of Paul sketching, with the blue sky seen through the window behind him, fully expresses the artist's love for his son.

In 1924 we find the opposite pole again predominant: that year began the great series of still lifes, in which Picasso magnificently displayed his feeling for composition and arrangement. He made use of the same simple, everyday objects he had used in the Cubist period—the violin, the guitar, bottles, a bar (page 111). But the forms of the objects are now ample and sumptuous, and the bright colors confer upon them a radiant splendor. In addition to these recapitulations of old themes in a new guise, Picasso returned to the theme of the girl with mandolin (which he had treated as early as 1910) in one of his most harmonious compositions of that time, dated 1925 (page 113).

The same year showed the most surprising divergence in Picasso's art: side by side with the balanced

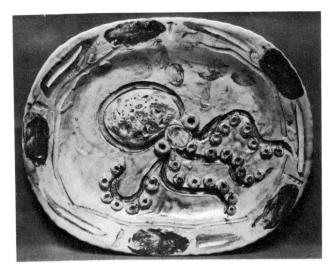

LEFT: 43. THE SQUID. 1948. Ceramic, 12⁵/₈×15". *Galerie Louise Leiris, Paris*

BELOW: 44. LA PIQUE. 1953. Ceramic, $14^{1}/_{8} \times 26''$. Galerie Louise Leiris, Paris

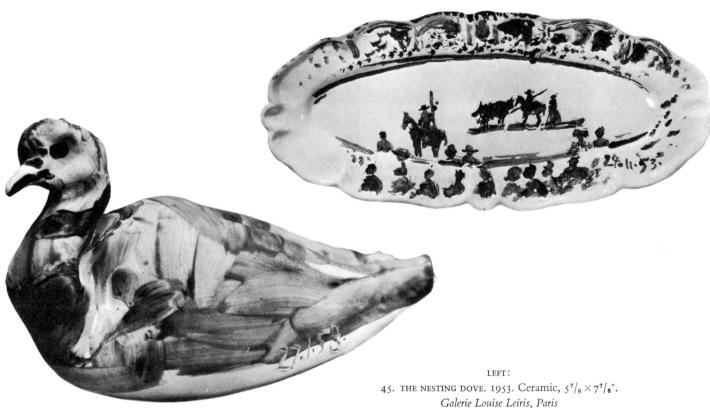

Apollonian masterpiece, *Woman with Mandolin* (page 113), he painted *Three Dancers*, a major example of the Dionysiac and obsessed strain in his art (page 115). Everything in this work—the exaggerated gestures, the fantastic distribution of the limbs of the human body, the distortions—suggests what Rimbaud called "the derangement of the senses," intoxication, ecstasy. Picasso denied that he had been influenced by Surrealism (as had been claimed, on the basis of this painting); and yet it is obvious that he was affected by the state of mind which, around 1925, reflected a loss of faith in the attempts to create order, and which sought salvation in the irrational. In this painting Picasso went farther than the Surrealists, and expressed the Dionysiac aspect of life with unprecedented ardor, at the same time adding a new facet to the richness of his work.

However, this Dionysiac strain reappeared only

intermittently. In 1925 Picasso painted a large composition of figures, *Atelier of the Modiste* (figure 22), which is diametrically opposed to the unbridled ecstasy of *Three Dancers*. Executed in subdued grays, transected by curves in the manner of a jigsaw puzzle, this work suggests calm and order. In 1926 Picasso also produced a number of enigmatic drawings which seem abstract; actually the points and lines form an orderly system, inspired by maps of the sky.

The obsessed, hallucinatory aspect of his work reappears in 1927: the curves of Atelier of the Modiste are used in a different way in the Seated Woman, to produce an eloquent expression of anguish which is further underlined by the strident colors (page 119). Then the Dionysiac strain of 1925 reappears in the small canvases painted at Dinard on the English Channel during the summer of 1928. The lively figures of the bathers in striped swimming suits express a similar arbitrary fantasy, in unexpected contrast with the systematic fragmentation of shapes during the Cubist period. Magical feeling has outstripped intellectual discipline, whose basic concept had proved illusory and utopian in contemporary history. The Projects for Monuments dating from around 1929 most strikingly reveal the anguished and obsessed side of Picasso's art. They show heads of women, conceived as monumental sculptures (they were supposedly intended for the Promenade at Cannes, as symbols of a demonic spirit; figure 27). These "architectural metamorphoses" are reminiscent of Surrealism, but differ from it nonetheless, because in Picasso's art the element of shock, of surprise, lies not in the objects themselves, but in the quality of the forms. The works of those years reflect a consciousness of all impulses as demonic, an awareness of a threat underlying the artist's conception of the world.

At the end of the decade, these metamorphoses were the dominant theme in paintings and small sculptures with ambiguous forms. It is perhaps no accident that in 1930 Picasso felt drawn to illustrate Ovid's *Metamorphoses*: he executed thirty etchings (figure 70) in a flexible and classical linear style, with strongly disciplined form—a true shorthand of the line. With these works he resumed his activity as an illustrator; at the same time they mark the beginning of an attempt to create for himself a new and authentic mythology. During the same year he painted a small *Crucifixion*—

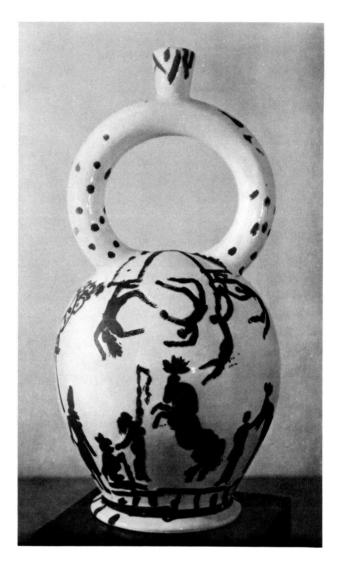

46. THE CIRCUS VASE. 1954. Ceramic, height 22⁷/8".

this too pointing to the artist's need to express preoccupations of a general or even intimately personal kind in the form of timeless symbols. This need inspired his print making and, during the following years, his sculpture; the many attempts in this direction culminated in the monumental *Guernica* of 1937.

In 1930 Picasso purchased the Château du Boisgeloup, near Gisors (Eure). In 1931 he set up a studio there and, with the help of his friend Julio Gonzalez, executed a number of sculptures (figures 26, 28). The large heads of women of a pervasive calm are related to the paintings from 1932 and subsequent years representing a seated or reclining blonde woman absorbed in a blissful dream; the drawing is marked by harmonious curves, and the colors are primary and brilliant. The model for these paintings was Marie-Thérèse Walter, who, in 1935, gave birth to his daughter Maia. This series of works was continued until 1935 (during the "season in hell" which he went through because of his divorce from Olga Koklova) in the paintings such as *Young Woman Drawing* (page131). In them, a feeling of quiet is dominant over the artist's personal troubles and the anxieties caused by the state of the world at the time.

These anxieties constitute the undercurrent of his activities in 1930s; they account for his attempts to create a modern mythology. After the great retrospective exhibitions of his work in Paris and Zurich, 1932, Picasso began to treat mythological themes. The cycle had begun with Ovid's Metamorphoses of 1930 (figure 70) and it continued with his illustrations for Lysistrata in 1934 (figure 72). In the same year, on a long visit to Spain, he came upon a new means of satisfying his need to create mythological signs expressing the obsessions of our epoch: the theme of tauromachy-the bullfight-which had been familiar to him since his youth. As so often before, it was the contact with Spain that had brought into focus this new style, this freshly acquired aspect of his art. The bull appeared for the first time in some sketches of 1934, as the plastic sign of demonic fury (figure 73). In 1935, the mysterious, masterful etching Minotauromachy introduced the enigmatic figure of the Minotaur (figure 75). In 1936 these mythological attempts acquired a poignant basis in reality: civil war broke out in Spain, where Picasso's work had been exhibited in the spring under the sponsorship of his friend Paul Eluard. Picasso wholeheartedly embraced the republican cause, and was appointed director of The Prado. Early in 1937 he composed his first work dealing with the civil war, a series of etchings entitled The Dream and Lie of Franco. He was commissioned to paint a large canvas for the Spanish Republic's pavilion at the Paris World's Fair that was to open in the summer of 1937. He had not yet begun it when he was roused by the news of the bombing, on April 28, 1937, of the small, unprotected town of Guernica, by German planes in the service of Franco. By May 1 he was making the first sketches for the immense canvas which marks the high point of his mythological creations, and which is

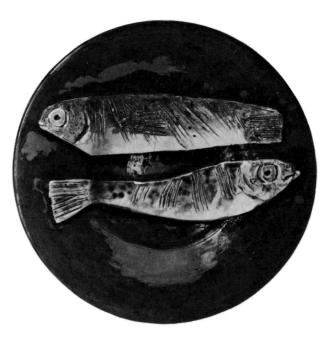

47. FISH. 1957. Ceramic relief, diameter 16⁷/₈". Galerie Louise Leiris, Paris

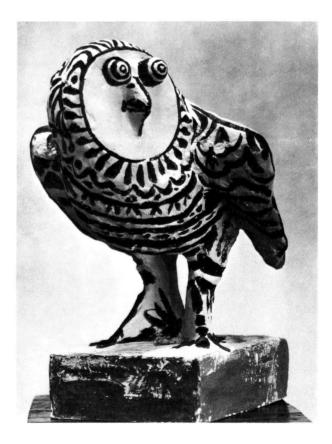

48. THE WHITE OWL. 1952. Ceramic, height 13". Galerie Louise Leiris, Paris

49. Picasso with his children, Claude and Paloma, 1957

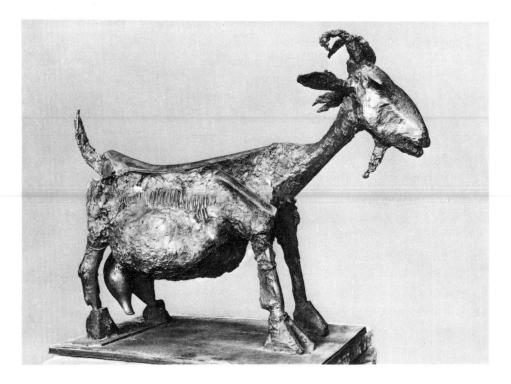

50. GOAT. 1950. Bronze, $47^{1/4} \times 55^{1/8''}$. Collection the Artist

one of the masterpieces of twentieth-century painting, its most distilled, most passionate expression (figures 29-32).

A long series of sketches followed those of May 1 (figure 33); the composition was completed early in June. The principal elements were present in the first

sketch and took definitive form in the drawing of May 9. The subsequent work led to a condensation, however, a more effective concentration of the signs; the final version brings together within the austere framework of a triangular composition, the bull, the horse, the woman with the lamp—motifs used pre-

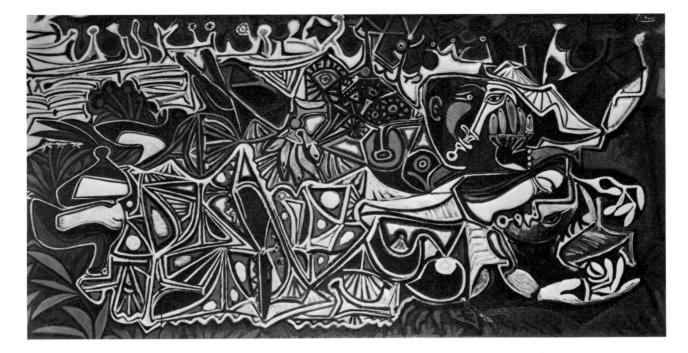

51. GIRLS ON THE BANKS OF THE SEINE, after Courbet. 1950. Oil on canvas, 393/8×733/4". Kunstmuseum Basel

viously in the *Minotauromachy*. But the meaning, the emotional expressiveness of the signs, has become more tense and explosive: the horse and the bull are graven more deeply on the viewer's memory than are the human figures; thus it is the mythological signs of suffering and ruthless brute force that dominate the work. In this great painting Picasso created a poignant monument against barbarian aggressive force; though it contains no allusion to the specific event for which it is named, it constitutes a warning to mankind against the implications of unleashing the forces of darkness. History proved Picasso right: Warsaw, Rotterdam, Coventry, Smolensk, and Hiroshima are stations along the road which began at Guernica.

In addition to *Guernica*, the year 1937 was filled with works that the critic Alfred H. Barr, Jr., calls "postscripts" to *Guernica*—canvases in which the same feelings of rage, indignation, and impotent revolt were expressed in the faces of women, as in *Weeping Woman*; in these the suffering and distress are manifested dramatically, in a manner that goes beyond the anecdotal (page 133). This strain continued in 1938 with several heads of men crowned with thorns, with tormented expressions, painted at Mougins during the summer. But this dramatic and tragic series was counterbalanced by a series of aquatints dating from the same period, illustrating Buffon's *Histoire naturelle;* these were executed in a flexible, realistic style, and enriched by subtly graduated grays (figure 76).

In 1939 a large number of Picasso's canvases were brought to the United States for a retrospective exhibition organized in New York by The Museum of

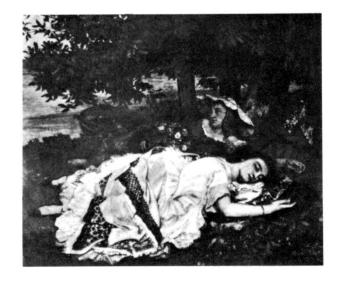

52. Gustave Courbet: Les DEMOISELLES AUX BORDS DE LA SEINE. 1856. Oil on canvas, $19^{1}/_{4} \times 20^{7}/_{8}"$. Petit Palais, Paris

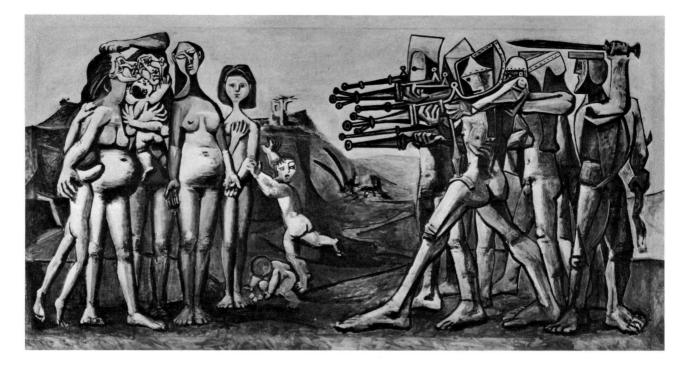

53. MASSACRE IN KOREA. 1951. Oil on canvas, $43^{1/4} \times 82^{3/4}$ ". Collection the Artist

Modern Art. During the months preceding the declaration of the Second World War Picasso worked at Antibes. The little Mediterranean port provided the background for the masterpiece of that period, *Night Fishing at Antibes*—a nocturne in stained-glass-window colors—in which the peaceful details at the periphery clash with the ferocity of the scene at the center, unconsciously symbolizing the months of suspense before the outbreak of the world conflict (page 137).

After war was declared Picasso left Antibes for Paris, where he stayed only a few days, and then went to Royan, a fishing village and summer resort at the

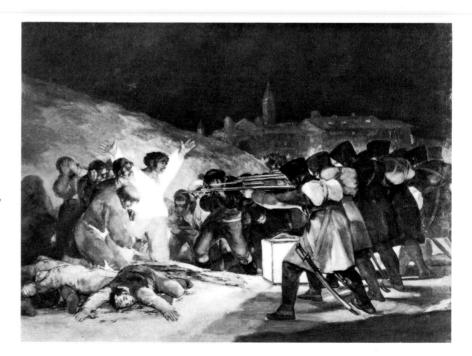

54. Francisco Goya: THE THIRD OF MAY, 1808. 1814–15. Oil on canvas, 104³/₄×135⁶/₈". *The Prado, Madrid*

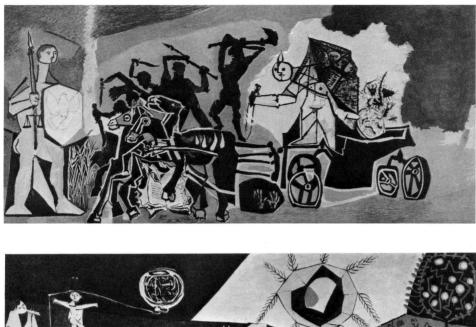

55. WAR. 1952. Oil on isorel, 15′ 5″ × 33′ 7″. *Chapel, Vallauris*

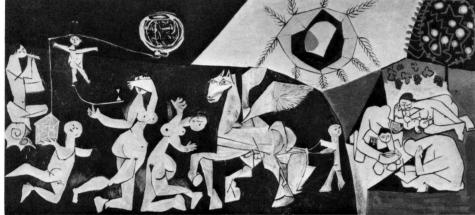

56. PEACE. 1952. Oil on isorel, 15' 5" × 33' 7". *Chapel, Vallauris*

mouth of the Gironde. It was there that he painted one of his most terrifying works—*Nude Dressing Her Hair*, a hard, sculptural work which rises like a true sphinx, enigmatic and frightening. But even this anguished creation was counterbalanced by graceful, pleasing paintings from the same year, 1940, such as *Café at Royan*, done in bright and sparkling colors (figure 36).

However, the atmosphere of anguish expressed in *Nude Dressing Her Hair* was to haunt Picasso's work during the war years, which he spent in Paris, shut up in his studio in the Rue des Grands-Augustins. His obsessions were expressed primarily in paintings of the half-figure of a woman seated in an armchair in a small room. *Seated Woman in Blue* (1944; Musée Nationale d'Art Moderne, Paris) is an eloquent example, one of the least aggressive: the color harmony is in deliberate contrast with the attitude of the figure, which is, so to speak, imprisoned by the arms of the armchair. In this and the other paintings of the series, a plastic device

recurs continually: the fusion of the profile with the front view of the face. This suggestive artifice originated in the Cubism of the years around 1914 (Italian Woman of 1917 is one of the earliest examples), reappeared in the series of dreaming women of 1932, and then became more frequent from 1937 on. It is a mode of definition which began with the delineation of inanimate objects in the Cubist period, and was applied to the human figure after the latter had assumed a central expressive value in Picasso's painting. His Woman with Fish Hat, the other example from the wartime series, combines a satire on food rationing (the hat with the fish, quarter of a lemon, knife and fork) with the obsessive pose of the figure, hands clenched, in an empty and hallucinated space (page 139). The faces and figures of the women are evidence of an immensely inventive intensity; they are plastic symbols, always different and always expressive, for a wide variety of states of mind of the artist. His self-contained inner

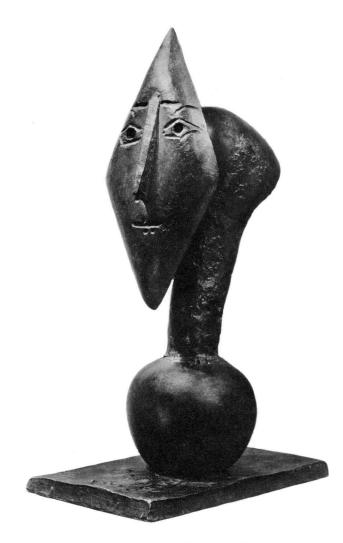

57. HEAD OF A WOMAN. 1951. Bronze, height 21¹/8". The Museum of Modern Art, New York (Benjamin and David Scharps Fund)

life was also expressed, during the war years, in still lifes, in sculptures, and in poetry. In 1941, Picasso wrote a Surrealist play, *Desire Trapped by the Tail*, which was performed by a group of friends in the apartment of the Leirises in 1944. In it we find the same authenticity of invention which enchantingly metamorphoses objects into human figures. The same may be said of the *Bull's Head*, made with the handlebars and seat of a bicycle combined in a new, suggestive manner (figure 38).

With the liberation of Paris (August 25, 1944), a profound change took place in Picasso's life. He emerged from his wartime isolation as the universally acclaimed master, the symbol of the artist who had succeeded in outwitting the brutality and cunning of the Nazi occupiers. The day of liberation found him busy making a free copy of a Bacchanal by Poussin, *Tri-umph of Pan* (figures 39, 40)—the first of his adaptations of old master paintings. But his reply to the years of oppression was manifested not only in paintings: his joining the French Communist Party was also part of this reply. This political act by a man whose art had largely kept clear of politics was indirectly connected with his feeling of solidarity with the poor, with his social attitude during the period of *Arte Joven* in Madrid, in 1901. The bronze sculpture *Shepherd Holding a Lamb* (figures 41, 42), a secular variation on the theme of the Good Shepherd, expresses this theme in modern terms, suitable to 1944.

The world of art displayed the greatest admiration for Picasso. At the Salon de la Libération, held in the fall of 1944, a large hall was reserved for his works seventy-four paintings and five sculptures. This was

58. BABOON AND YOUNG. 1951. Bronze, height 21". The Museum of Modern Art, New York (Mrs. Simon Guggenheim Fund)

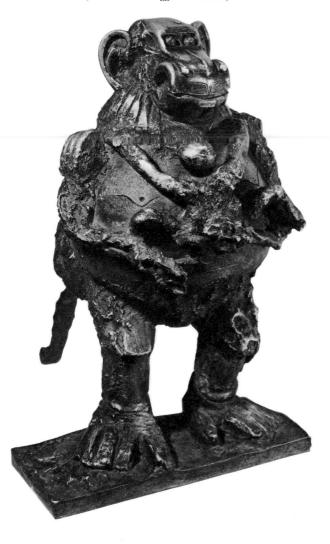

59. MODEL UNDRESSING. 1953. Drawing, ink on paper, $9^3/_8 \times 7''$. Private collection, Stockholm

the first time Picasso had taken part in the Salon d'Automne, and it was the first time his enormous production from the war years had been shown to the public. But in the years following his wartime isolation he produced works of a new sort-views of Paris painted in tribute to the heroic city, composed like stained-glass windows of bits of color framed in thick black lines. The same style, inspired by stainedglass windows, with their emphatic contours, characterizes the still lifes of 1945; the most outstanding example is Still Life with Pitcher, Candle, and Enamel Pot (page 141). Side by side with this monumental style, Picasso the same year began to develop an entirely free and occasionally playful art in his lithographs. The series of variations on the theme of the Bull shows him capable of developing a form taken from nature to the point where it is reduced to a bare sign.

In 1946 Picasso found a new climate of life on the Mediterranean coast, which led to a rejuvenation in his art: he discovered there a cheerful paganism, the

60. TWO WOMEN ON THE BEACH. 1956. Oil on canvas, $76^3/_4 \times 102^3/_8$ ". Private collection, Paris

idyllic carefree spirit of ancient mythology. This gave rise to a series of paintings and lithographs peopled with fauns, centaurs, and ancient figures, culminating in the large composition La Joie de vivre, a mythological apotheosis of a life relaxed in the sun, symbol of a harmony rediscovered after years of terror (page 143). This whole joyous world came into being at the museum of Antibes, whose curator put at Picasso's disposal the spacious halls of the Palais Grimaldi. And this world of fauns and bacchantes continued in the work of Picasso, but in a new ambiance: it spills over from painting into ceramics. Picasso discovered pottery in 1946, thanks to Suzanne and Georges Ramié, managers of the Madoura factory in Vallauris. He moved there in October, 1947, and devoted himself to ceramics for almost a year. In that period he produced works of the most varied kinds-dishes lightly painted, platters on which this mythological world appears, as well as vases which, thanks to the magic of his imagination, were metamorphosed into owls, women, or head of fauns (figures 43-48). This feverish activity was interrupted by only one trip, to Poland, to attend the Congress for Peace-an act of faith which coincided with his regained optimism. In 1949 he drew for the same Congress, held that year in Paris, his dove of peace, to fly across the world (figure 84).

After his work in ceramic, Picasso began to explore

61. Picasso with his pigeons, on the top floor of La Californie, 1957

a territory on which he had set foot only a little earlier: the "translation" of the paintings of old masters. After painting his variation on the theme of Poussin's *Bacchanal* on the day of the liberation, he took Courbet's *Girls on the Banks of the Seine* as his subject in

62. BULLFIGHT. 1957. Drawing, ink on paper, $19^3/_4 \times 25^3/_4$ ". Formerly Galerie Louise Leiris, Paris

1950 (figures 51, 52), and later, El Greco's *Portrait of a Painter* (page 145). These works are actual translations of classics into Picasso's language and style. But events in the outside world did not permit him to continue this confrontation with works of his choice: the Korean war broke out, and he felt obliged once more to raise his voice against barbarism: he painted the *Massacre in Korea* (figures 53, 54). He was faced once again with the dilemma between harmony and horror, a fact attested by his two big compositions, *War* and *Peace* (figures 55, 56). The distressing, torn aspect of his art reappeared after so many years, for instance, in the still life *Goat's Skull, Bottle, and Candle*, which contrasts so bitterly with his sculpture of a goat, a subtle and moving work by a magician of forms (figure 50).

In the course of the last ten years, we find an alternation between two themes and two styles: on the one hand, the affectionate, uninhibited signs of his personal life (figure 49), on the other, the confrontation with the works of old masters. The first category includes works such as *The Meal* of 1953, whose subject is his two youngest children, Claude and Paloma, with their mother; the rich and varied series of portraits of Sylvette (1954) which transforms the head of a girl with a pony-tail into an emblem; more recent works, like the Studio of 1956, which distills the sun-drenched space of the big studio at Cannes into an arabesque (page 151); and finally the still life of 1959, in which the old furniture of his new residence at Vauvenargnes becomes the symbol of the peaceful calm of the house. Between these works and the "translations" there is inserted a brutal and disturbing painting, Two Women on the Beach (figure 60), which brings to mind again his disquieting fantasies of the years around 1928. On the other hand, his dialogue with the old masters continues to be enriched. In 1955 he began a series of fifteen variations on Delacroix' Femmes d'Alger; in 1957 he tackled the Maids of Honor (Las Meninas) by Velázquez, and in 1960/61 he had his confrontation with Manet's Déjeuner sur l'herbe (page 157). These translations are not mere stylistic exercises, they are like true "musical variations," comparable to the magnificent variations which composers create from the themes of other composers: they serve to strengthen Picasso's own authentic, personal style. He displays in them an incomparable freedom—a freedom that only one who is the equal of the great painters can permit himself. Thus, by his own free will, he rejoins the chain of the great masters, in which he deserves a place by his mastery, his richness, and his authenticity.

No one will doubt Picasso's mastery. But his richness, the variety of his work, never ceases to confound even the lovers of his painting. His enormous virtuosity, his ability to do whatever he wants to, in one way or another, contributes to the bewilderment of viewers: they see no connection, no coherence, between works as remote from one another as are the faithful and lovingly naturalistic portraits on the one hand, and the fantastic monsters on the other. The opinion is sometimes expressed that a historian of the future, confront-

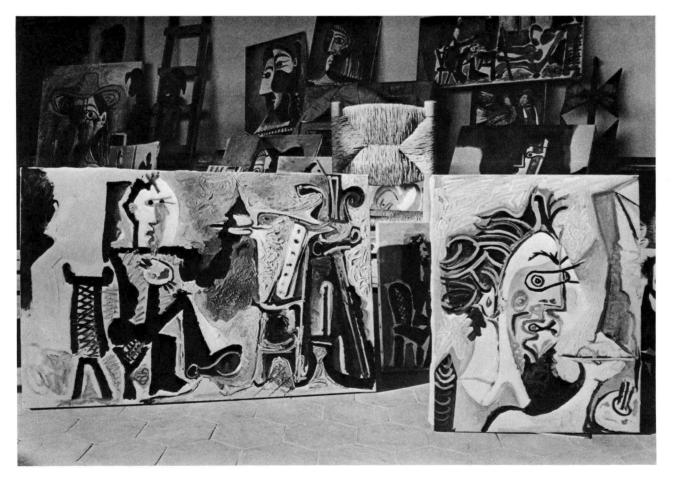

63. In the studio at Mougins, 1963

ed with Picasso's work in the absence of any documentation, could never believe that all this was created by one man, one mind.

And yet it is this seemingly so disparate creativity that constitutes Picasso's authenticity, his contribution to painting, to art in general. He refuses to be frozen into a historical monument by practicing only one style, making that his specialty: he would call such self-limitation a betrayal of life. Nor does he aspire to the absolute perfection of the masterpiece. "In former times," he said, "paintings approached perfection by degrees. Every day added something new. A painting was the result of additions. For me, the painting is the result of destructions. I make a painting, then I destroy it. But in the end nothing has been lost." He rejects perfection, the consummation of a picture, because he attaches too much importance to variety, to the flexibility of life. He might have entered history as the great master of Cubism, or even of the melancholy realism of the Blue Period-but he refused to do so. In his boundless faith in life he refuses to let his art be frozen into styles or laws; he believes only in authenticity, the undiluted expression of sincerity. In his work as a whole, in his manner of creating, he has remained essentially an anarchist. This is why classical compositions appear side by side with compositions in shorthand, and at the same time austere works of Cubist inspiration are followed by monsters of an unleashed fantasy. His courage, which makes him prefer sincerity to perfection, has given him a previously unknown freedom.

But it would be erroneous to see in Picasso the haughtily aloof artist, who creates only for the sake of recording his own sensations, who produces merely a

painted autobiography. He has always been able to transcend the small domain of his personal adventures; from the outset he raised them to the universally human level. This is why he has created his hallucinating monsters and at the same time the classical figures which he sees with an affectionate eye. He has not hesitated to give to classical idealization its counterpart of whimsical and ugly demonism. Aside from being a great creator of forms and language, he is a powerful creator of myths, of beauty, and ugliness, of life in everything. Because he truly committed himself to the current of life, his art succeeds in encompassing this life in its totality. This fact has earned him the reputation of a split personality, an errant soul. He is an errant soul, but only in the sense of his fellow countryman, Don Quixote, the Knight Errant, who prefers adventure to barren security. He has devoted himself to the adventure of authenticity, and thanks to his prodigious, magical imagination, has succeeded in turning his adventures into plastic signs. His lifework, whose richness is not confined by any preconceived system, presents a surprising, unexpected variety; it reveals to his contemporaries a new conception of man, man who refuses to become slave to any system, even his own, but rather who dedicates himself to life with all its ups and downs, its hopes and disappointments, and hence to sincerity, to absolute authenticity. It is through this authenticity that Picasso exemplifies the amor fati about which Nietzsche wrote; it is through his love of life, which he lived to intensely, that he has been, during more than seventy years of his artistic career, and in the sum total of his immense painted, sculptured, and graphic work, a guide to his contemporaries and to our century.

DRAWINGS AND PRINTS

Graphic techniques have long been important to Picasso: to his paintings, ceramics, and sculptures we must add his drawings, etchings, lithographs, linoleum cuts, and related works. They reveal just how many octaves and registers the artists has at his disposal, with which to build up the astonishing polyphony of his life's work.

It is especially typical of Picasso's graphic style, no doubt, that his drawings constitute a voice of their own within his work as a whole. The drawings are not just preliminary studies, mere preludes to works executed in other mediums. On the contrary, Picasso's drawings are entirely independent of his other works, and in many periods of his rich creative career-above all, when he was sacrificing color to his concentration on form-we find him most inventive in his drawings. He does not apply his new discoveries to paintings, at least not right away: for instance, the realistic drawings of 1915 precede by three years the paintings in a similar style. And he continued to develop the flexible, clear linear style of his "Ingres period" for years in drawings and prints, although he abandoned it in painting around 1925. Many more such examples could be cited.

Thus, Picasso's graphic works—prints as well as drawings—form an entirely autonomous domain within the broad panorama of his œuvre. And it is proper to observe that within this domain we find the same richness and diversity as in the other domains of Picasso's art. This is not only true of techniques, but also of conceptions. Technically, the artist makes himself master of all the graphic methods, in addition to drawing—etching (which he practiced at an early date), lithography, and linoleum cuts (a fairly late development). At the same time, he masters the whole range of rich expressive means—from the most austere stiff-pen drawings to dynamic, painterly brush drawings. For this reason we must not be surprised that his drawings quite often go beyond the bounds that set them off from painting: we must not underestimate the part played by drawing in the collages of 1913. The richness of Picasso's graphic work comes not only from the variety of techniques and expressive means, but above all from the use Picasso makes of these techniques and means. Each technique provides him with a new method for discovering things hitherto unrealized, merely latent, in another technique. Picasso's "playing with" the various techniques is a process of experimentation that stops only when he has exhausted the potentialities of a new medium. Thus his production of graphic works tends to be bunched at particular periods of his life and creative career. For instance, the rich and varied series of lithographs executed in Mourlot's workshop date from the period between 1945 and the spring of 1949: before, Picasso had not exhibited great interest in the medium.

Besides the drawings and engravings proper, there are Picasso's book illustrations. Except for one etching of 1905, he did not attempt this type of work until 1911, when he illustrated Max Jacob's *Saint Matorel*. He has never wholly abandoned it ever since. What strikes us in this field is the richness, not only of technical execution, but still more of artistic conception.

A characteristic feature of Picasso's graphic work is that many fall into a cycle or series—the series *The Painter and His Model*, for instance, and *Bullfights*. In such sequences, an underlying theme is varied in most surprising ways, ever with fresh invention. One of the finest examples of how these variations on a theme lead to the discovery of new creative solutions is the group of drawings for *Guernica* (a few of which are shown in figures 29-33) and the series of such prints as *The Dream and Lie of Franco*, which preceded them. Here we see that Picasso, far from looking upon drawings as purely preliminary studies, never carries over into painting the literal results of his graphic researches. Rather, drawing and engraving have for him the same creative dignity that he acknowledges in the other domains of his art.

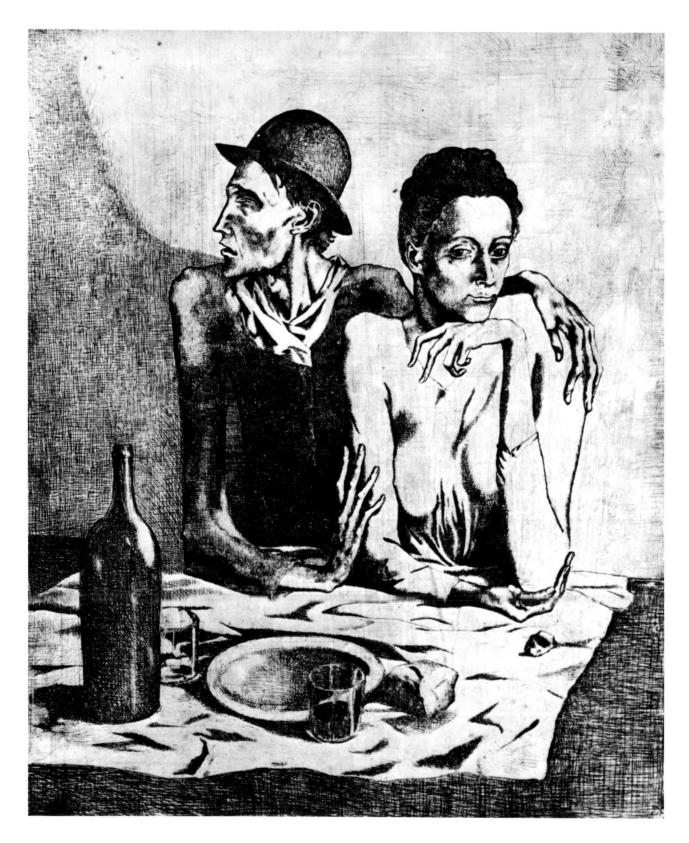

64. Frugal repast. 1904. Etching, $18^{1/4} \times 14^{3/4''}$

65. Salome. 1905. Etching, $15^3/_4 \times 13^5/_8{''}$

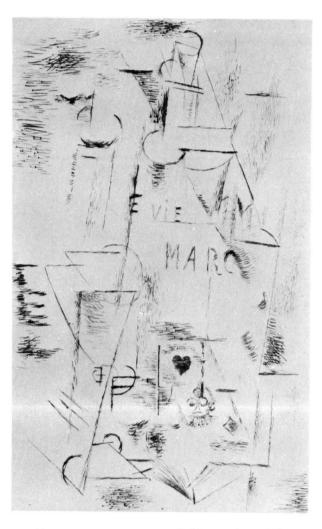

66. The brandy bottle. 1912. Etching, $19^{1}/_{2} \times 12^{1}/_{8}''$

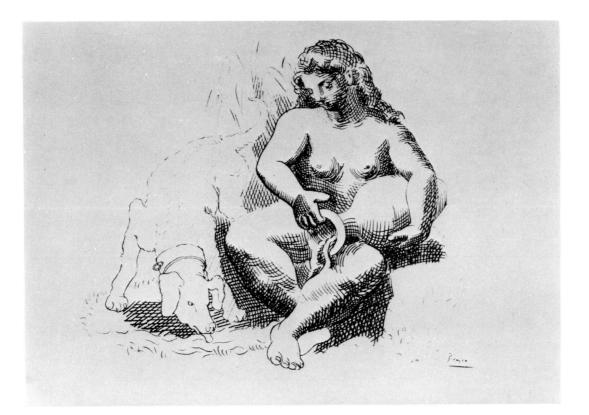

ABOVE: 67. WOMAN WITH DOG. 1921. Drawing, ink on paper, $\mathfrak{g}^3/_1 \times \mathfrak{T2}^1/\mathfrak{g}'' \quad Whereabouts unknown$

RIGHT: 68. FIGURE. 1929. Etching, $9^{5/16} \times 5^{7/16''}$

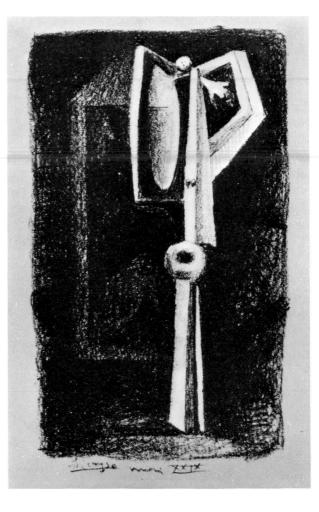

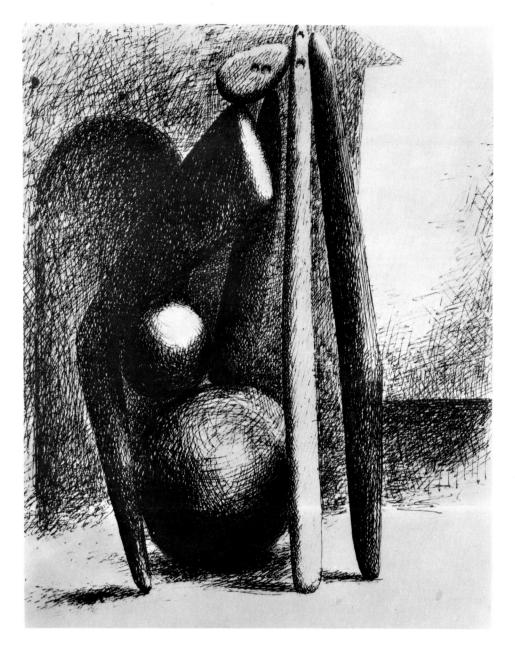

69. PROJECT FOR A MONUMENT. Dinard. 1928. Drawing, pen and ink on paper, 113/4 \times 85/8". Whereabouts unknown

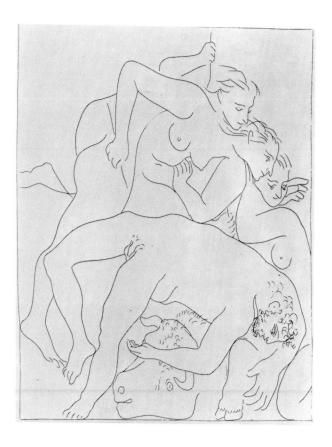

70. Death of orpheus. 1930. Etching, $8^7/_8 \times 6^5/_8$ " Illustration for Ovid, Les Métamorphoses

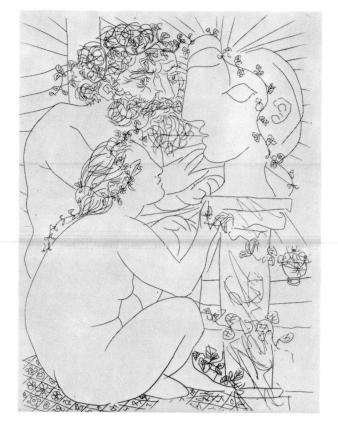

71. The sculptor's studio. 1933. Etching, $10^{1}\!/_{2}\!\times7^{5}/_{8}{}''$

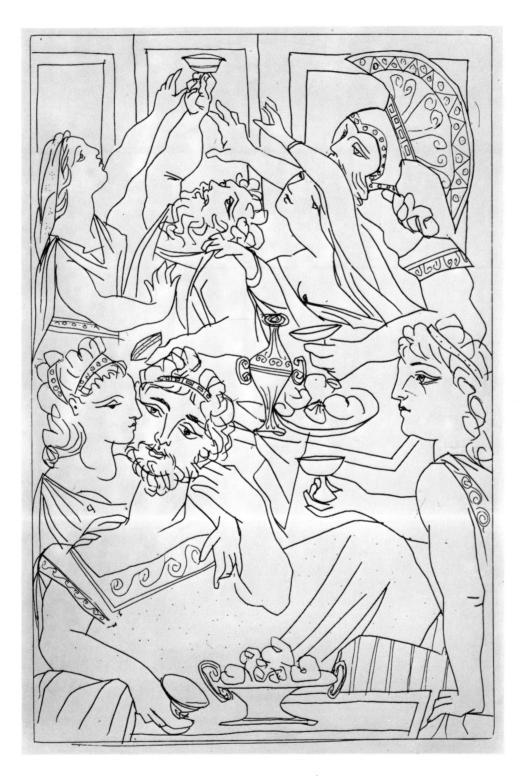

72. Celebration of peace. 1934. Etching, $8^3/_4 \times 5^1/_2$ ". Illustration for Aristophanes, Lysistrata

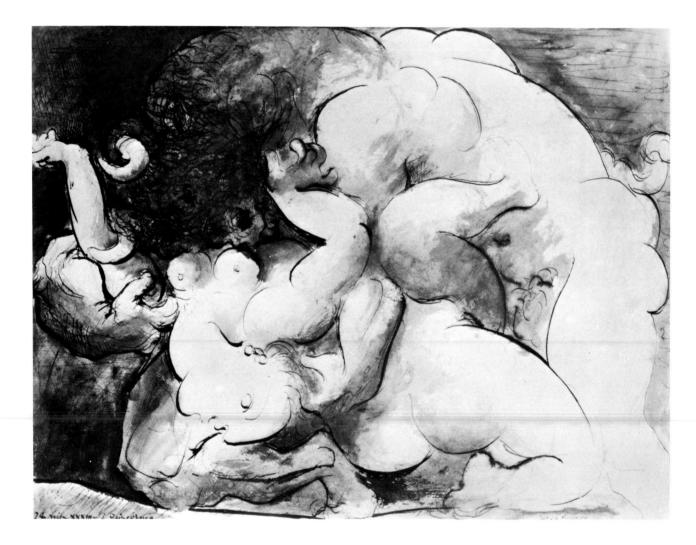

73. THE MINOTAUR. 1934. Drawing, pen and ink wash, 18⁷/₈ × 24³/₄". Collection Sylvester W. Labrot, Jr., Hobe Sound, Florida

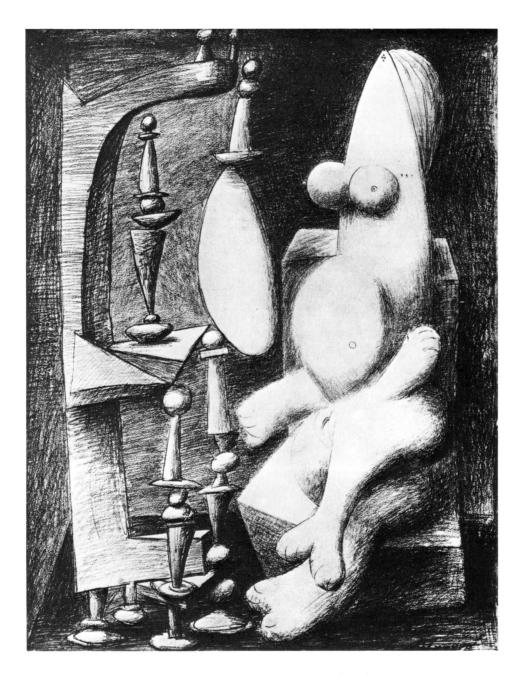

74. NUDE AT HER DRESSING TABLE. 1936. Drawing, pencil on paper, $25 \times 18^3/4''$. Whereabouts unknown

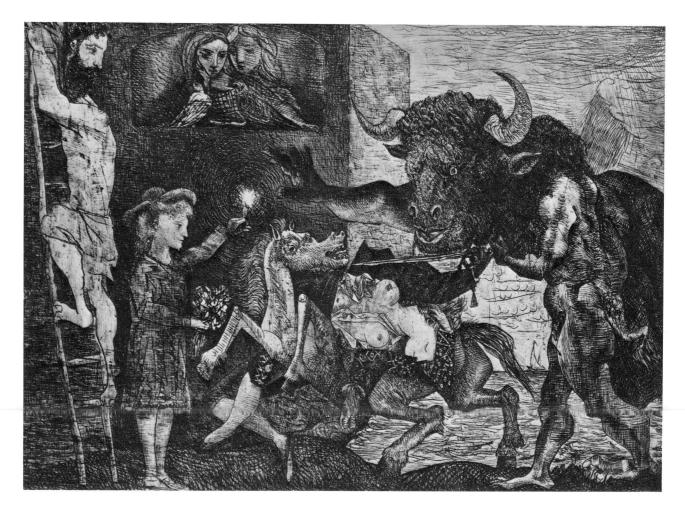

75. MINOTAUROMACHY. 1935. Etching, $19^{9}/_{16} \times 27^{5}/_{16}$ "

76. WASP. 1937. Aquatint, $14^{1/2} \times 10^{7/8''}$. Illustration for Buffon, *Histoire naturelle*

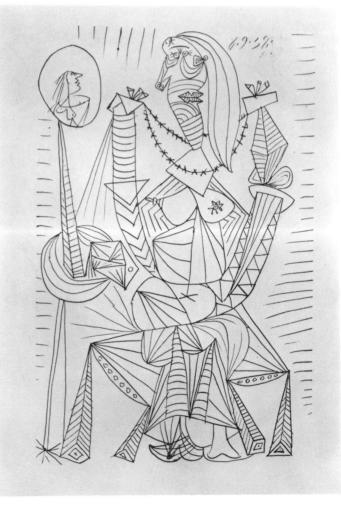

77. SEATED NUDE WOMAN PUTTING ON A NECKLACE. 1938. Drawing, ink on paper, 26¹/₈×17³/₈". *Private collection, Paris*

78. NUDES IN PROFILE. 1946. Drawing, pencil on paper, $5^{1}/_{4} \times 7^{1}/_{4}$ ". Whereabouts unknown

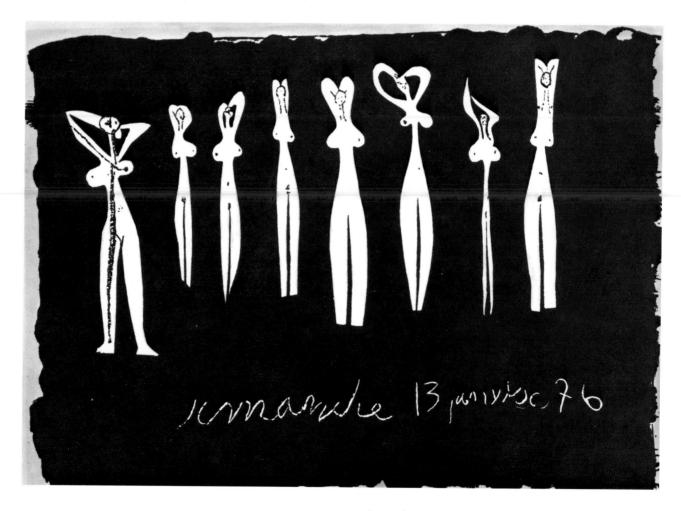

79. EIGHT SILHOUETTES. 1946. Lithograph, $12^5/_8 \times 16^7/_8$ "

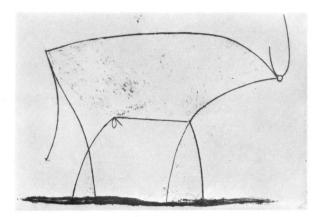

80. THE BULL, XI. 1946. Lithograph, $\text{II}^3/_8 \times \text{I4}^3/_4{}''$

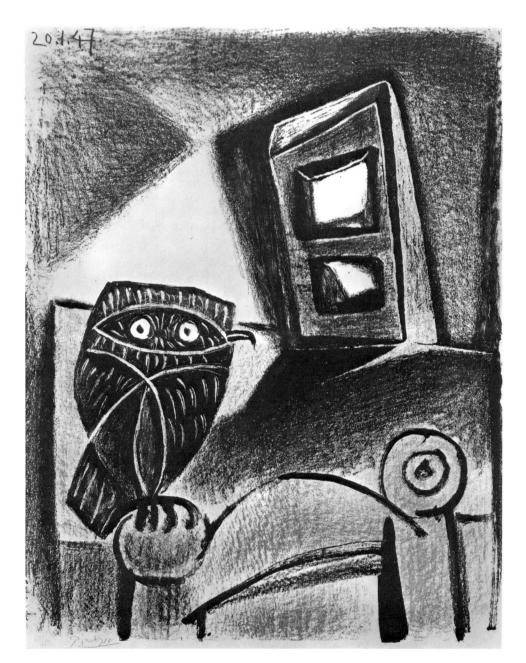

81. OWL 1947. Color lithograph, $25^{1/2} \times 19^{1/2''}$. The Museum of Modern Art, New York (Curt Valentin Bequest)

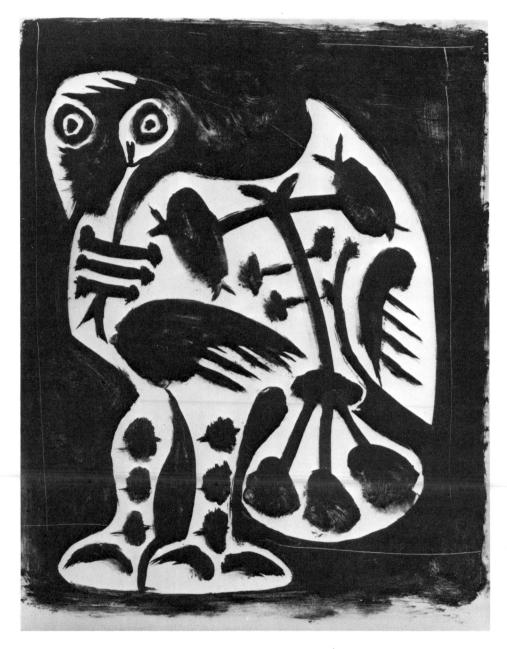

82. The Big owl. 1948. Lithograph, $26^3/_4 \times 20^7/_8''$

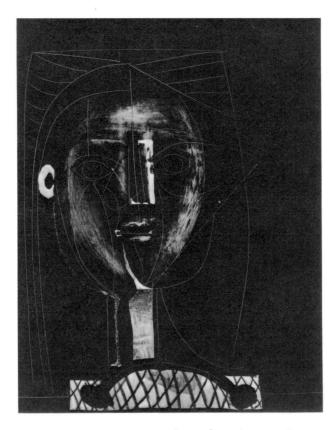

83. BLACK HEAD. 1948. Lithograph, $25^{5}/_{16} \times 19^{9}/_{16}''$. The Museum of Modern Art. New York (Abby Aldrich Rockefeller Fund)

84. The dove. 1949. Lithograph, $211/_2 \times 27^9/_{16}$ "

85. BACCHANAL WITH BLACK BULL. 1959. Color linoleum cut, $20^3/_4 \times 25^1/_4''$

BIOGRAPHICAL OUTLINE

- 1881 October 25, Malaga. Birth of Pablo Ruiz Picasso, son of Maria Picasso Lopez and José Ruiz Blasco, an artist and teacher at San Telmo school of arts and industrial design.
- 1891 Father appointed teacher at the Da Guarda art school in La Coruña.
- 1893–94 Pablo's debut as an artist, under his father's guidance.
- 1895 Father appointed to the La Lonja academy in Barcelona. Family moves to Barcelona, spends summer in Malaga.
- 1896 Admitted to the drawing class at La Lonja after passing examination with flying colors.
- 1897 Member of bohemian group in Barcelona; first exhibition in the café Els Quatre Gats, the group's headquarters; first review of his work in *La Vanguardia*. Makes friends with Jaime Sabartés and other young artists and intellectuals, who introduce him to modern currents in painting (Toulouse-Lautrec, Steinlen, etc.). His painting *Ciencia y Caridad (Science and Charity)* awarded Honorable Mention in Madrid. In the fall, admitted to painting class at the Royal Academy of San Fernando in Madrid.
- 1898 Leaves the academy; goes for rest to Horta de Ebro. His painting *Costumbres de Aragon (Aragonese Customs)* wins medals in Madrid and Malaga.
- 1900 Drawings published in the magazine *Joventut* (Barcelona). First trip to Paris with Casagemas; sells three sketches to Berthe Weill; returns to Barcelona at the end of December.
- 1901 In the spring, in Madrid; founds with Fr. Soler the magazine Arte Joven; its first issue entirely illustrated by him. Second trip to Paris with Jaime Andreu; stays with P. Mañach, 130, Boulevard Clichy. Exhibition of pastels at the Salon Parés (Barcelona); favorable reviews in Pel y Ploma; exhibition at Vollard's in Paris; favorable review in La Revue Blanche. Meets Max Jacob and Gustave Coquiot. Beginning of Blue Period; now signs his works "Picasso" instead of "Pablo Ruiz y Picasso," etc. At the end of the year returns to Barcelona.

- 1902 Exhibits thirty works at Berthe Weill's, Paris; second exhibition at Vollard's; third trip to Paris with Seb. Junyer. Shares a room with Max Jacob, Boulevard Voltaire.
- 1903 Returns to Barcelona; shares studio with A. F. de Soto.
- 1904 Settles in Paris; moves to the Bateau-lavoir, No. 13, Rue Ravignan. End of Blue Period.
- 1905 Meets Guillaume Apollinaire, Leo and Gertrude Stein, etc. Shchukin and Leo Stein buy paintings. Meets Fernande Olivier. In the summer, trip to Holland, at invitation of Tom Schilperoort. Beginning of Rose Period; earliest sculptures and engravings.
- 1906 Meets Matisse, who with the Fauves shocked the public at the Salon d'Automne the year before. Summer in Gosol,

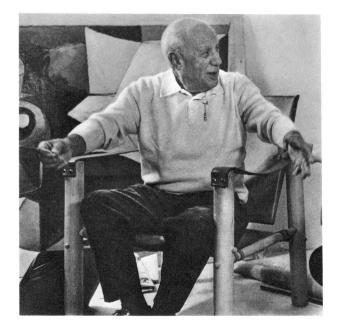

northern Spain, with Fernande Olivier; transition to sculptural style.

- 1907 Meets D.-H. Kahnweiler, who opens a gallery and becomes Picasso's dealer and close friend. Meets Braque and Derain; visits the Cézanne exhibition in the Salon d'Automme. Beginning of Cubism with *Les Demoiselles d'Avignon*.
- 1908 Summer in La Rue-des-Bois (near Amiens); paints a number of landscapes. Banquet in honor of Henri Rousseau in Picasso's studio.
- 1909 Summer at Horta de Ebro with Fernande Olivier; first clearly Cubist landscapes. Moves to 11, Boulevard de Clichy. First exhibition in Germany (Gallery Thannhauser, Munich).
- 1910 Summer at Cadaqués, with Fernande Olivier and André Derain. Flowering of Cubism, portraits of Vollard, Ulide, Kahnweiler.
- 1911 Summer in Céret with Fernande Olivier, Braque, and Mariolo. First exhibited in the U.S. (Photo-Secession Gallery, New York). Kahnweiler publishes Max Jacob's *Saint Matorel*, illustrated with etchings by Picasso. Breaking up of surfaces and volumes into facets.
- 1912 Friendship with Marcelle Humbert ("Eva"); summer in Avignon, Céret, L'Isle-sur-Sorgue. Moves to 242, Boulevard Raspail. First exhibition in England (Stafford Gallery, London); exhibition in Barcelona (Galleries Dalman). First collages.
- 1913 Summer in Céret with Braque and Juan Gris. Death of Picasso's father in Barcelona. Moves to 5bis, Rue Schoelcher. Beginning of Synthetic Cubism.
- 1914 Summer in Avignon with Braque and Derain.
- 1915 Realistic portrait drawings of Vollard and Max Jacob.
- 1916 Moves to Montrouge (22, Rue Victor Hugo).
- 1917 Goes to Rome with Cocteau to design sets for ballet *Parade*, staged by Diaghilev's Ballets Russes. Contact with the theater world; meets Stravinsky and Picasso's future wife, Olga Koklova. Sees ancient and Renaissance art in Rome,

Naples, Pompeii, Florence. Summer in Barcelona and Madrid.

- 1918 Marries Olga Koklova. Moves to 23, Rue La Boétie. Summer in Barcelona and Biarritz.
- 1919 Visits London, designs for *Le Tricorne*. Summer at Saint-Raphaël.
- 1920 Designs for Stravinsky's *Pulcinella*. Summer at Juan-les-Pins. Appearance of classical themes.
- 1921 Birth of Paul; numerous mother-and-son paintings. Designs for ballet *Cuadro Flamenco*. Summer in Fontainebleau: the two versions of *Three Musicians*, and *Three Women at the Spring*. Works in several styles.
- 1922 Summer at Dinard; helps Cocteau with designs for Antigone.
- 1923 Summer at Cap d'Antibes.
- 1924 Summer at Juan-les-Pins. Designs for ballet *Le Mercure*; curtain for *Le Train bleu*. Begins series of large still lifes.
- 1925 Spring at Monte Carlo, summer at Juan-les-Pins. Takes part in first Surrealist exhibition, Galerie Pierre, Paris. Besides classical works, produces first works of unleashed violence.
- 1926 Summer at Juan-les-Pins.
- 1927 Summer at Cannes.
- 1928 Summer at Dinard. Series of small, strongly colored paintings, with boldly simplified forms. Beginning of new period of sculptural works.
- 1930 Summer at Juan-les-Pins; acquires Château du Boisgeloup near Gisors and sets up sculpture studio there.

- 1931 Publication of Balzac's *Le Chef-d'oeuvre inconnu* (Vollard) and Ovid's *Métamorphoses* (Skira), both illustrated with etchings by Picasso.
- 1932 Retrospective exhibitions in Paris (Galerie Georges Petit) and Zurich (Kunsthaus). A new model, Marie-Thérèse Walter, makes her appearance in Picasso's paintings.
- 1933 Trip to Barcelona.
- 1934 Extended trip to Spain; treats subject of bullfight.
- Maia to Marie-Thérèse Walter; lives at Boisgeloup where he composes a number of poems.
- 1936 Outbreak of Spanish Civil War; traveling exhibition in Spain; named director of The Prado. Summer at Juan-les Pins and Mougins. Friendship with Dora Maar.
- 1937 Studio in Grenier de Barrault (7, Rue des Grands-Augustins). Publishes etching *Sueño y Mentira de Franco (The Dream and Lie of Franco)* with his own satirical text. After air raid on Guernica (April 28) paints the mural for the Spanish Republic's pavilion (Paris World's Fair).
- 1939 Large retrospective exhibition in New York (Museum of Modern Art). Picasso's mother dies in Barcelona. Summer at Antibes. After outbreak of Second World War returns to Paris, then goes to Royan near Bordeaux.
- 1941 Writes a Surrealist play, *Desire Caught by the Tail*. Begins series of Woman in Armchair.
- 1942 Publication of illustrations in etching with aquatint for Buffon's *Historie naturelle*.
- 1944 Liberation of Paris; special Picasso room in the Salon d'Automne. Joins the Communist Party.
- 1945 Exhibition in London (Victoria and Albert Museum). Resumes lithography in Mourlot's workshop.

- 1946 Long stay on the French Riviera. Meets Françoise Gilot. In the fall, works at Antibes, Musée Grimaldi; series of paintings on theme of the joy of living.
- 1947 Birth of son Claude. Lithographic work with Mourlot; takes up ceramics in the Madoura factory owned by the Ramié family, in Vallauris.
- 1948 Attends Peace Congress in Wroclaw, Poland; moves to house in Vallauris; exhibition of ceramics at Maison de la Pensée Française (Paris).
- 1949 Birth of daughter Paloma. Exhibition of work since the war, Maison de la Pensée Française. Picasso's *Dove*, used as a poster for Peace Congress in Paris, becomes universal symbol.
- 1950 Special exhibition, Venice Biennale.
- 1951 Moves to 9, Rue Gay-Lussac. Exhibition of sculptures, Maison de la Pensée Française; retrospective exhibition in Tokyo. Paints Massacre in Korea.
- 1952 Paints War and Peace, in Vallauris.
- 1953 Retrospective exhibitions: Lyons, Rome, Milan, São Paulo. Separation from Françoise Gilot.
- 1954 Summer in Collioure and Perpignan. Paints Sylvette series. Begins series of variations on Delacroix' *Femmes d'Alger* (*Women of Algiers*).
- 1955 Ex-wife Olga Koklova dies. Acquires villa, La Californie, at Cannes. Exhibitions at Musée des Arts Décoratifs and Bibliothèque Nationale (Paris), and in Germany.
- 1956 Series of studio interiors.
- 1957 Retrospective exhibition in New York. Series of variations on Velázquez' *Las Meninas (Maids of Honor).*
- 1958 Mural for UNESCO building (Paris). Acquires Château de Vauvenargues near Aix.
- 1959 Exhibition of linoleum cuts and drawings at Galerie Louise Leiris, Paris.
- 1960 Still lifes and interiors of Spanish inspiration.
- 1961 Variations on Manet's *Déjeuner sur l'herbe*. Marries Jacqueline Roque.
- 1061 Series on theme of Bane of the Sahines
- 1963 Series on theme of Painter and His Model.
- 1964 Series on theme of Painter at His Easel.
- 1965 Publication of Pierre Reverdy's *Sable mouvant* with aquatints by Picasso.
- 1966 Eighty-fifth birthday commemorated with three simultaneous exhibitions in Paris.
- 1967 Commemorative exhibitions in London and the United States. Recurrence of mythological themes.
- 1968 Between March and October completes *Suite* 347—347 etchings largely on erotic themes. After death of secretary and confidant, Jaime Sabartés, donates series of *Las Meninas* to Picasso Museum in Barcelona.
- 1969 Paints 140 canvases, shown next year at Palace of the Popes, Avignon.
- 1970 Donates 2,000 early oils and drawings to Picasso Museum.
- 1971 Ninetieth birthday commemorated with exhibition in Grande Galerie of the Louvre; becomes first living artist so honored.
- 1972 Works chiefly in black and white—in drawings and prints.
- 1973 Dies (April 8) at his villa in Mougins. First posthumous exhibition (work of 1970–72) at Palace of the Popes (May).

SELF-PORTRAIT

Oil on canvas, 36¹/₂× 28³/₄" Philadelphia Museum of Art (A.E. Gallatin Collection)

Picasso incorporated his own features in a number of early works, though seldom in the form of explicit self-portraits. Aside from the self-portrait in the National Gallery in Prague (figure 12), which dates from 1907, the one shown here is the last he ever painted. It is hard to say why, but one reason is surely the fact that around 1906 Picasso lost interest in human psychology and turned all his attention to problems of form.

Thus, the self-portrait of 1906 stands between two periods of Picasso's art: it heralds a new style aiming at spatial values. A clear indication of this new tendency is the fact that in this painting he almost entirely renounces color, restricting it largely to the triad of gray, white, and ocher. Only the palette that Picasso holds in his left hand shows a bit of red and a darker ocher tone.

Precisely because of this near-absence of color, the forms in space and the volumes of the body are brought out the more strongly. The figure of the artist is projected into space and creates its own field of spatial energy by the impact of its three-dimensionality. As a result, the fact that Picasso did not achieve this effect through modeling but through the suggestion of a few sharp outlines, is all the more striking. Nor is there any question of light effects in this all-hut-colorless portrait: Picasso is aiming at the essential characteristics of the surfaces, trying to paraphrase them in the same way as the plastic values. The gripping effect of the portrait rests primarily on its spatial structure.

Here the twenty-five-year-old Picasso displays complete mastery of his means. At the same time, we catch a hint that he is no longer satisfied with these means, that he is groping toward new ones in view of attaining another goal. The revolution in painting that he was to touch off in the next few years is already anticipated in this work. All attempts at psychological treatment of the human figure have been abandoned, and the artist is no longer primarily aiming at producing a likeness. The painting has a supra-personal order, a firmly knit structure in its own right. It is noteworthy that this same year Picasso produced a sculpture—a bronze head—which realizes the same idea of form, and also anticipates future developments.

The figure that confronts the viewer in this work is more than just a portrait of the young artist: it is a work in which Picasso sums up his achievements to date and readies himself for the fresh start that will lead him ever farther afield—the exploration of a new world of space, volume, and order.

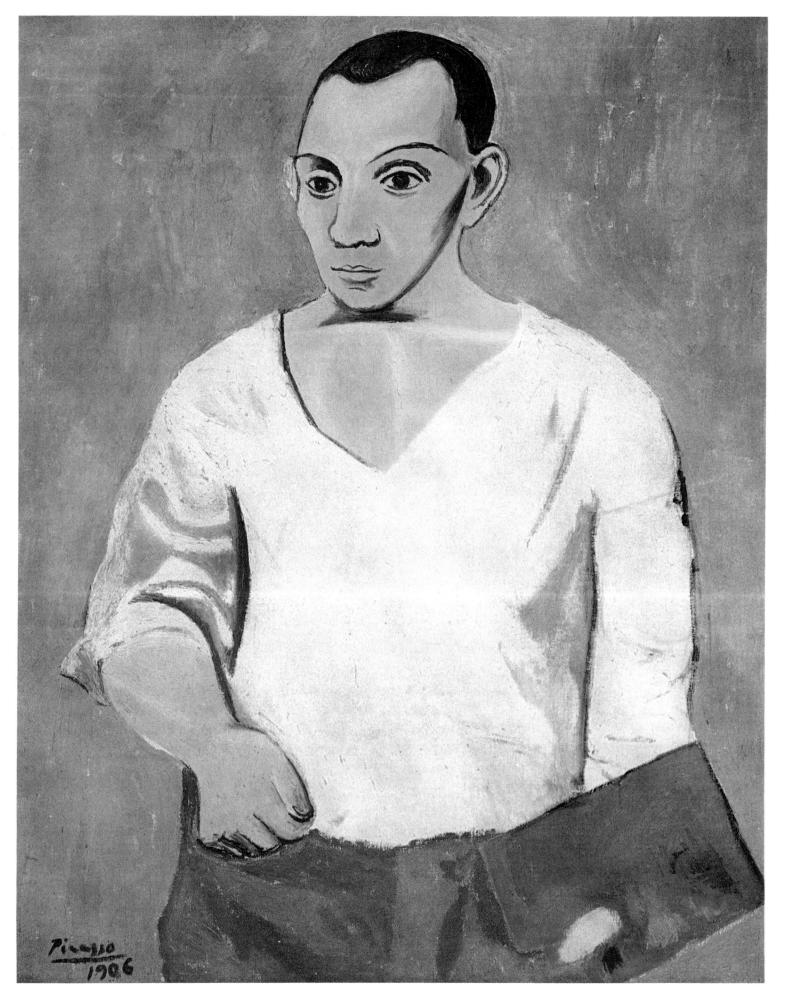

CHILD WITH A DOVE

Oil on canvas, $28^{3}|_{4} \times 21^{1}|_{4}^{"}$ Collection Lady Aberconway, London

This is one of Picasso's earliest works: he was twenty-one, or even less, but his own style is already apparent. He probably painted it in Paris during his second visit, when he was staying with Spanish friends. By that time he had seen, studied, and assimilated contemporary French painting: he had taken Toulouse-Lautrec's way of rendering a visual impression rapidly with a few forceful lines and shrill spots of color, and made it his own. Also, he had learned from Degas how to observe a figure sharply and with detachment. In *Child with a Dove*, we see a new thoughtfulness, a poetic sympathy with the subject, qualities that were to dominate his work in the years that followed.

The masters who served as Picasso's mentors in the early years of his career —Toulouse-Lautrec and Degas—had observed and set down the figures they painted with cool objectivity. Picasso had followed their example in his earliest works; but here, a new relationship is introduced between the figure observed and the observer: a relationship of empathy, of human sympathy. And in this early work we find a feature of Picasso's painting that was to characterize his subsequent work: the painter is deeply involved, wholeheartedly caught up in the object represented.

Possibly the reason for so intimate an approach to the subject lies in the subject of this particular work. Picasso's father, Don José Ruiz, had made pigeons a particularly favored subject of his paintings, and as a boy Picasso must often have seen pigeons, as well as his father's pictures of them. Childhood memories must surely be involved.

The pictorial technique, however, is also new, and it too is interesting for all that was to happen later. The forms are rendered in simple sweeping lines, and the colors are keyed to an untroubled three-tone scale in which greenish tones dominate. The shimmering Impressionist palette which Picasso had brought to Paris, and which he had used up to now, is here discarded. The colors are subdued, controlled by an austere swoop of line.

This painting comes well before Picasso's Blue Period—and it is perhaps the earliest of his works in which he appears as a clearly defined individuality. He seems to have left his apprenticeship behind, giving us for the first time an expression of his own, not very gay vision of the world. It was a vision he shared with others of his generation at the turn of the century, to whom the world they saw around them seemed a paradise lost.

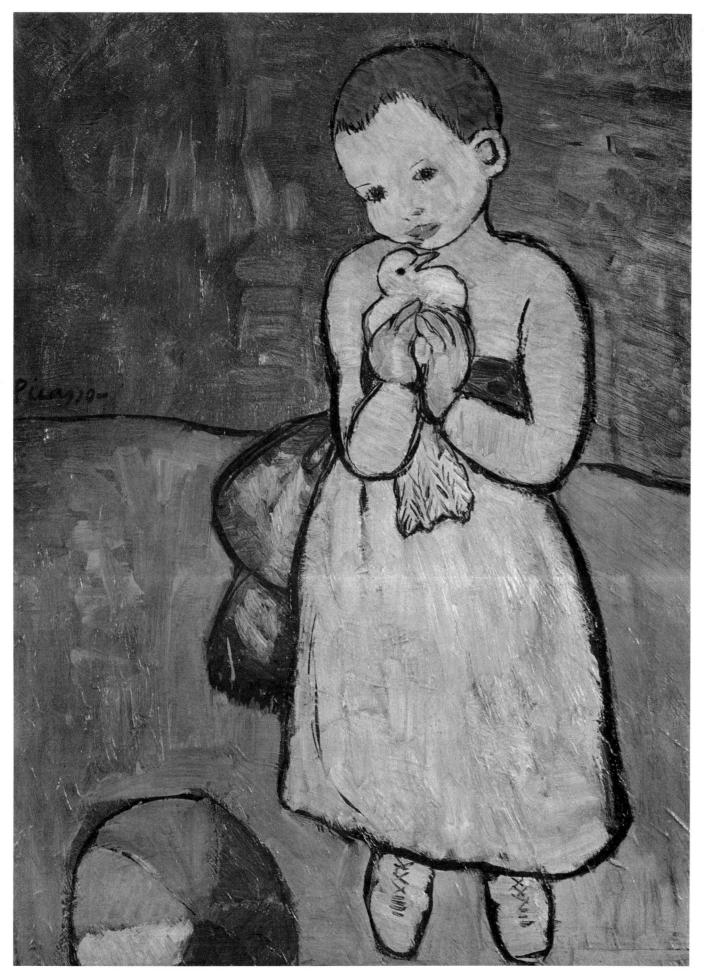

CHILD WITH A DOVE

LA VIE

Oil on canvas, $77^{8}|_{8} \times 50^{7}|_{8}''$ The Cleveland Museum of Art (Gift of the Hanna Fund)

This allegorical painting is the largest single work Picasso produced in his Blue Period, so-called from the melancholy cold blue tones that dominate his work during the years 1901–1904. His paintings throughout this period express social pessimism, dejection, and despair, almost unrelievedly. The subjects are mostly the destitute—beggars, blind men, street musicians, lost women. The portrayal of their misery is further accentuated by the spare austerity of the drawing, and by a palette restricted to the gloomiest, coldest colors.

La Vie is an allegorical summing-up of the artist's vision of life in those years. For all its pictorial and symbolic qualities, it remains, as Alfred H. Barr, Jr., has said, "a problematical" work. It challenges interpretation, but the emotional content comes through unmistakably. Two nude figures—a man and a young woman—stand at the left, facing a clothed female at the right edge of the canvas, who holds a little child in the folds of her cape. Between them two sketches hang above one another on the back wall of the room. The top one shows a nude couple huddled together in gloomy dejection; the lower one represents a nude female figure crouching listlessly on the ground, her head on her knees. The picture as a whole is deeply disturbing.

There are unmistakable autobiographical references in this painting. Preliminary sketches show beyond a doubt that the male figure is a self-portrait of the artist. Yet somehow the artist is already transcending his personal fate, creating a work of universal significance.

In its thematic material, the work is akin to similar allegorizations of daily life which the Jugendstil (Art Nouveau) had made fashionable. What Picasso has in common with these other artists is a pessimistic outlook, expressed not only in the symbolism of the figures, but also—primarily—in the desolate blues of the painting. It is a sense of the hopelessness of life, which is socially determined something like what Rilke expressed in his poems in the same years. What makes the canvas so unequivocally Picasso's is the terseness with which he has said what he has to say. All the works of his Blue Period raise the features of human misery and social despair to classical terms. The austerity of the figures is perfectly matched in the color quality of the palette.

As we have said, *La Vie* is the most important work of these years. Although interpretations of given details may vary, it is certain that this allegory evokes life as it must have been or seemed at the beginning of our century, and this Picasso expressed magnificently in the works of his Blue Period.

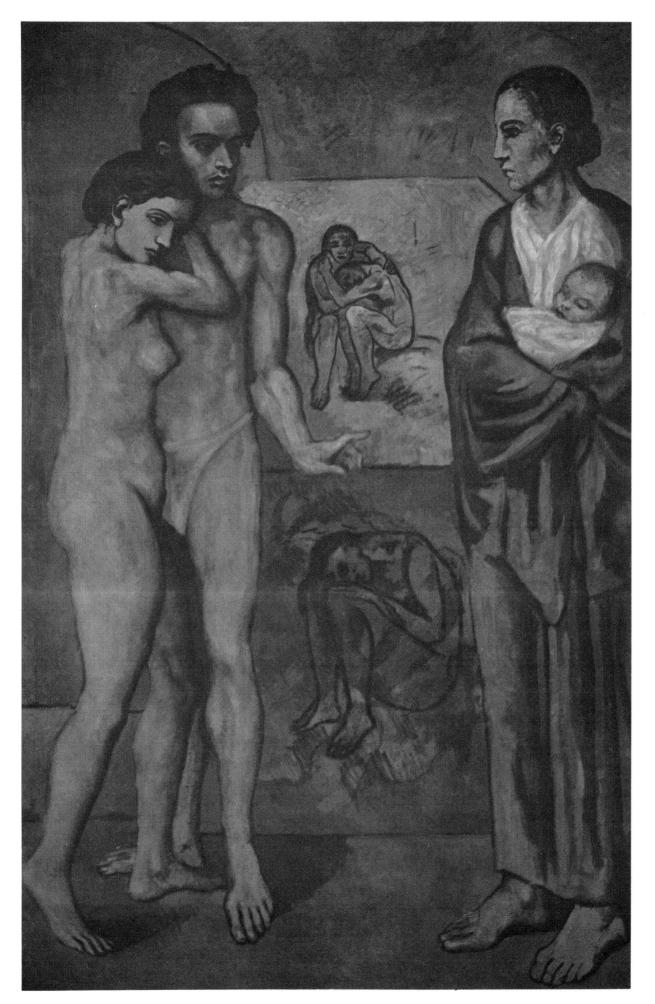

LA REPASSEUSE (WOMAN IRONING)

Oil on canvas, $46^{1/8} \times 29^{1/8''}$ Collection J.K. Thannhauser, New York

In this work a single figure conveys the misery and tragedy which Picasso treated more allegorically in the big canvas *La Vie*. The originality of *La Repasseuse* becomes clearer when we compare it with Degas' treatment of the same subject, in a different spirit (figure 7).

In Degas' painting a woman is caught yawning and stretching after a long day's ironing. The picture's astonishing power comes primarily from the unconventional boldness of observation, but this keeps it within the realm of genre painting. Picasso's work, on the other hand, is as far from a genre scene as one can get. The figure rises above her sphere of everyday life like a saint's image. She symbolizes all the women like her who have labored for ages. The artist has gone far beyond mere observation, immediate perception. He has distilled the very emblem of a workaday life, transcending its accidental character, expressing its essence.

The austere, hieratic quality of this painting shows an influence of El Greco 1 the elongated limbs and the stark silhouette go back to the great Spanish painter whom Picasso admired very early. Here some of El Greco's stylistic devices are turned to use in a contemporary subject, the servitude of modern labor. Picasso sees the woman ironing as "a revered martyr of human society," no less sublime than El Greco's saints and martyrs.

The austerity and spareness of the forms and colors in this painting are admirably in tune with the subject; defined in a few lines, the figure is set against a simple background distinguished only by its coloring. This spareness of means characterizes much of Picasso's art in the early years of the century. Scornful of easy effects, the artist realizes his deeper intentions, to portray human misery not just in its tragic implications, but also in its ennobling power. Picasso's figure becomes a symbol of humanity spiritualized, enduring the servitude of labor with resignation but also with dignity. Picasso's image of man in these years reflects an attitude that was not unusual at the beginning of the century—assigning greater weight to spiritual values than to the observation of visible reality. In his works of the Blue Period, Picasso was paving the way for a wholly spiritual kind of painting, no longer limited by contingencies of perception.

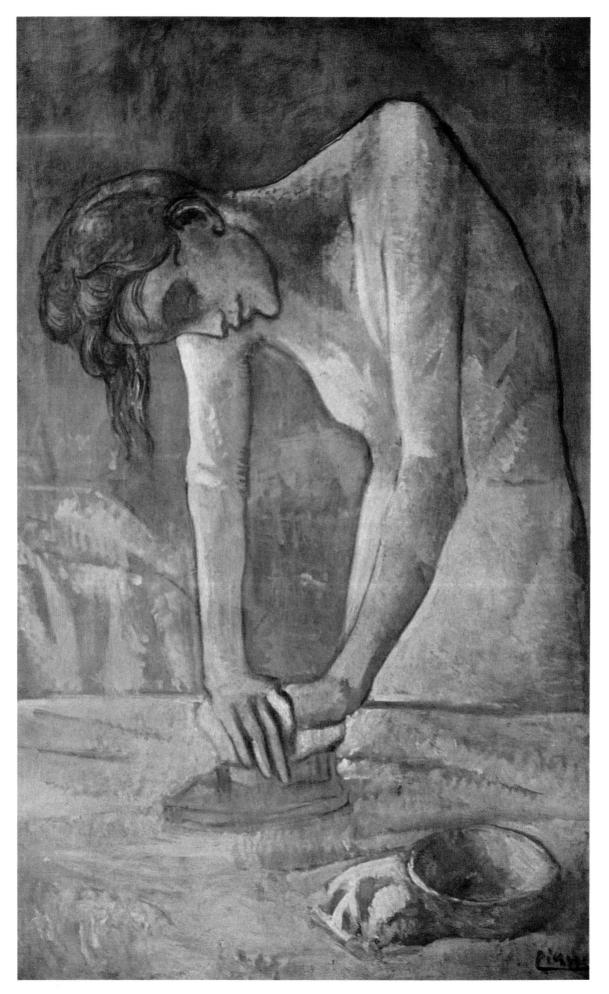

FAMILY OF SALTIMBANQUES

Oil on canvas, $83^3|_4 \times 90^3|_8''$

National Gallery of Art, Washington, D.C. (Chester Dale Collection)

This large composition required a long period of preparation. It was Picasso's main work of 1905, and marks a transition to his Rose Period. The gloomy images of human misery have given way to paintings in which pale rose is the dominant tonality, and the life of circus performers is the theme. Picasso at this time lived not very far from the Paris circus, and it deeply impressed him. The segregation, the loneliness, the gentleness of these people disclosed new aspects of human society to him.

Picasso's paintings of 1905 turn away from social pessimism their dominant color suggests a lyrical, personal sadness rather than pessimistic despair. The figures exhibit a certain life in common, though the psychological relationships are not clear. As it was in *La Vie* (page 69), the unity of the composition lies in the emotional content more than in the legible details. The over-all sense of restraint is more striking here than in the earlier work: it is accentuated by the fact that the two figures closest to the viewer are seen from the back. The colors, which range from terracotta pink and ocher to gray and bright blue, suggest the same restraint. The color effects are everywhere subdued, reduced to a discreet, unobtrusive harmony. The drawing and the colors endow this painting with a quiet, oddly elegiac charm.

The mood of this work inspired the opening lines of Rainer Maria Rilke's fifth Duino Elegy:

But tell me, who are they, these travellers, even a little | more fleeting than we ourselves,—so urgently, ever since childhood, | wrung by an (oh, for the sake of whom?) | never-contented will? That keeps on wringing them, bending them, slinging them, swinging them, | throwing them and catching them back: as though from an oilv. | smoother air, they come down on the threadbare carpet, thinned by their everlasting | upspringing, this carpet forlornly | lost in the cosmos. | Laid on like a plaster, as though the suburban sky | had injured the earth there.*

Although this work reveals the artist's new sense of kinship with his environment, it continues the meditative mood of the previous years. Here, as in the earlier works, the figures are not unified as a group by the performance of some common action; any similarity to a genre scene is excluded by the spirituality of the figures, expressing melancholy tenderness rather than resigned despair. This tenderness is clearly conveyed—precisely because the colors are subdued—by the flowing lines, so very different from the harsh, angular lines of the preceding period. Now Picasso becomes increasingly interested in drawing; we have a few etchings from these same years, and his first sculpture, *Head of a Harlequin*, also dates from this time (figure 9). Concentration on the possibilities of line ushers in a new period in Picasso's art, one in striking contrast to his Fauve and earliest Expressionist works, in which color predominated over line.

* Rainer Maria Rilke, *The Duino Elegies*, translated by J. B. Leishman and Stephen Spender. The Hogarth Press, London, 1963 (4th edition, revised).

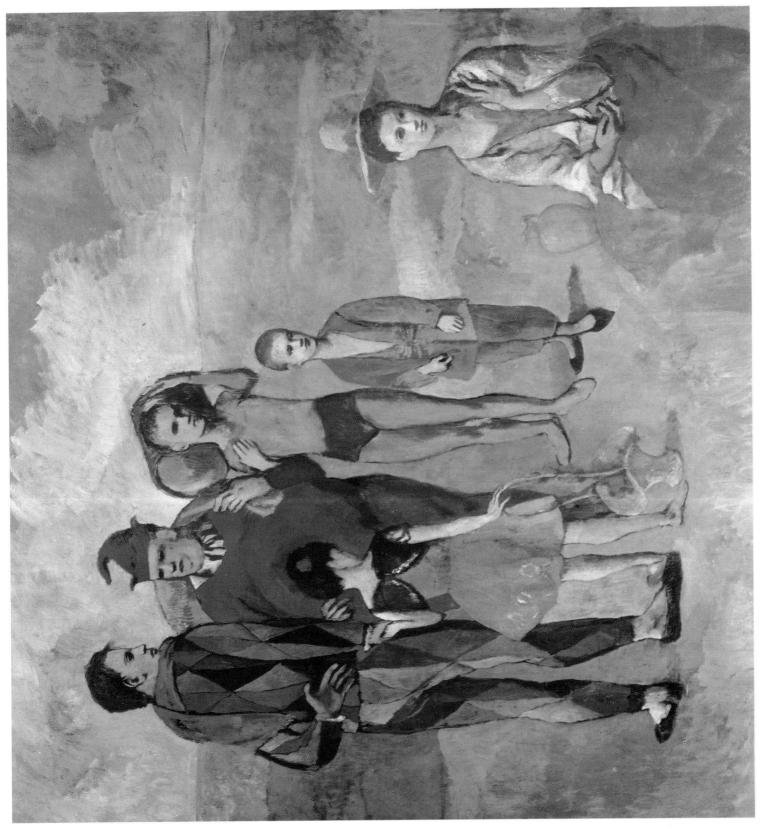

FAMILY OF SALTIMBANQUES

LA COIFFURE

Oil on canvas, $68^7/_8 \times 39^1/_4$ "

The Metropolitan Museum of Art, New York (Wolfe Fund)

In 1905 Picasso's style discloses a new development which, however, arises naturally enough out of his work in the years just preceding. Composition or structure take on greater importance, and produce an almost classical restraint and unity.

La Coiffure is one of the finest works of this period, outstanding in its classical calm and objectivity. The three figures form a pyramid, in keeping with the concept of figure composition which had been current in classical painting since Leonardo. This rigorously ordered work may have been inspired by Picasso's study of classical painting in The Louvre. The young artist may also have been influenced by the art of Cézanne, represented at the Salon d'Automne in 1905 by ten important paintings in which compositional values are deliberately emphasized. Even earlier, while still a student in Spain, Picasso had been greatly drawn to the classical current in French painting, and admired its leading living representative, Puvis de Chavannes.

It is to the classical spirit of such masters that Picasso's work in the second half of 1905 comes close. Among these works *La Coiffure* stands out most prominently. The calm and balance of the composition overshadows psychological and lyrical elements: the figures are subordinated to the part they play in the compositional arrangement. Moreover—perhaps for the first time in Picasso's career—the composition takes account of spatial values. The pyramidal pattern and the volumes of the bodies suggest depth to a degree never seen before in Picasso's paintings: the artist had made little attempt to represent it before. Now, having made his first sculptures—the *Head of a Harlequin* dates from this same year (figure 9)— Picasso is more aware of the potentialities of plastic effects, and these contribute to the unity and dignity of his paintings in the classical manner.

In the first years of the century Picasso's development led him from sympathy for the wretched plight of his subjects to a less troubled spirit of acceptance, a feeling that he shares their fate. The virile maturity of paintings like *La Coiffure* is very different from the youthful sentimentality expressed in some earlier works. It is remarkable that Picasso achieved such maturity so early—before his twentyfifth birthday. At the same time, for all their clearly marked individuality, these works are a preparation for the works of the subsequent years—works in which he will achieve mastery of the means of traditional painting, so as to be able to turn his back on it and launch his journey of discovery into hitherto unknown domains of painting. *La Coiffure* marks the point where mastery was finally reached, and will soon be left behind.

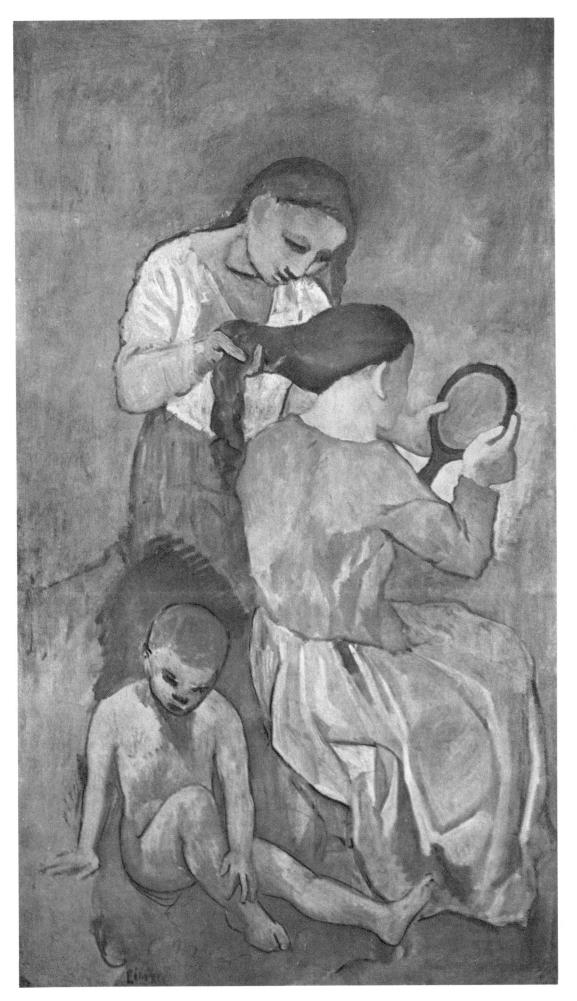

LA COIFFURE

GERTRUDE STEIN

Oil on canvas, $39^{1}/_{4} \times 32''$

The Metropolitan Museum of Art, New York (Gertrude Stein Bequest)

This work ushers in a new phase in Picasso's art. It also represents a gesture of friendly gratitude to one of his earliest patrons and purchasers, a tribute to Miss Stein's imposing personality. Gertrude Stein and her brother Leo belonged to the first generation of Americans who took an active part in the twentieth century's artistic revolutions in Europe—especially in Paris. The Steins' house in Paris became a meeting place for European and American intellectuals. As early as 1905 the Steins bought a painting by Picasso; they had already demonstrated their open-mindedness to new departures in art by buying a Matisse. It was at their house that Picasso met Matisse, a meeting that was the beginning of a long friendship between the two masters which ended only with Matisse's death in 1953.

Picasso began this portrait of Gertrude Stein in the spring of 1906. He asked her to sit for him, and she tells us herself how long he worked at it—there were at least eighty sittings—and how far from satisfied he was at every stage. It is characteristic of his conception of art—this applies generally to all the new painting at that time—that in the course of this experience he reached the conviction that the presence of the sitter was really unnecessary.

Toward the end of spring Picasso stopped worked on the portrait and took a trip to Gosol in northern Spain. There his style began to change: perhaps he was influenced by the stark, treeless mountain surroundings. Alone and hard at work, Picasso turned away from the classical balanced treatment he had evolved, and let himself be inspired by primitive, archaic forms. The plasticity of the bodies had been becoming pronounced in the works done immediately before, and it now took on further emphasis: he abandoned the meticulous treatment of details for a broader, synthetic conception of form. As has been justly observed, Picasso was encouraged in his new tendency by the early Iberian sculptures exhibited for the first time at The Louvre in 1906.

Back in Paris at the end of the summer, Picasso resumed work on this portrait. Without seeing his sitter again he painted the face—nearly all the rest had been completed before. It is in the face, whose mask-like starkness contrasts so sharply with the treatment of the rest of the portrait, that we see the new development in Picasso's style. Instead of reproducing visible appearances, he is now moving toward the magical re-creation of reality. To those who criticized this portrait, Picasso replied: "Nobody thinks it is a good likeness, but never mind, in the end she is going to look just like that." For the first time in Picasso's art, the artist's vision has triumphed over sense perception.

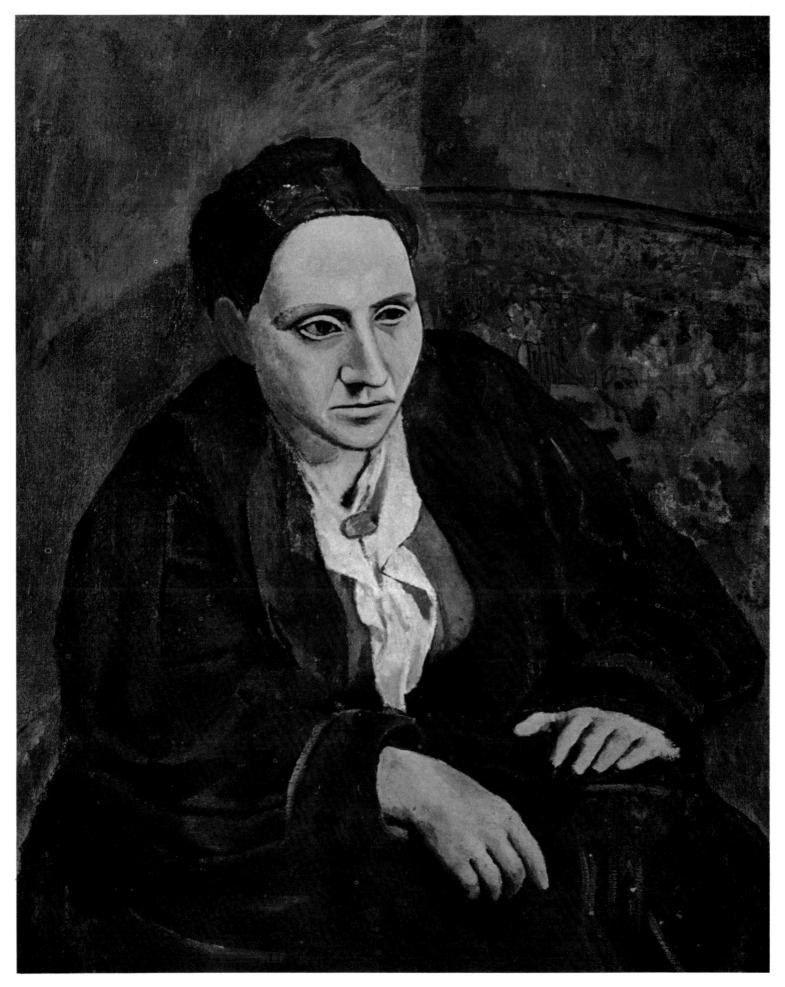

GERTRUDE STEIN

LES DEMOISELLES D'AVIGNON

Oil on canvas, $96 \times 92''$

The Museum of Modern Art, New York (Lillie P. Bliss Bequest)

This large enigmatic canvas marks a turning point, and not merely in Picasso's development. It is more than a painting, it is a revolutionary breakthrough in the history of modern art. Picasso worked a very long time on it, making many sketches, and it reflects the struggle of the artist in arriving at a new style. While the central figures still bear witness to the stage when the painting was first conceived, the nudes that frame the composition disclose an entirely new, revolutionary step forward.

The painting shows a figurative composition of five nudes grouped around a still life in the foreground. In structure, it harks back to Cézanne's figurative works, in which nudes are arranged as an architecture of bodies. The title of the painting—it was probably named by André Salmon some time after it had been completed—suggests some brothel scene. The earliest preliminary sketches, however, suggest that originally the artist intended an allegory of transitory life, a subject similar to that of *LaVie*, painted in 1903 (page 69). But as Picasso went on working, the anecdotal and allegorical details were eliminated one by one, and in its final stage the painting owes its overwhelming effect not to any eloquence of literary association, but to the compelling force of the pictorial idiom.

Just what has happened? In this great composition Picasso follows up the new line of development which had started with Cézanne's rigorous nude compositions, but extends still further back to primitive humanity's earliest, most rudimentary experiments with form. All the secondary elements, including all allegorical associations, were gradually sloughed off as the painter kept working on this picture. The large forms of the bodies contront the viewer in all their angular, grandiosely conceived ponderousness. How the new style evolved can be traced in the picture itself: the central figures disclose the simplified structure of the paintings done the year before, and in their masklike repose the heads are reminiscent of the portrait of Gertrude Stein; but the figures at either side, especially their heads, disclose a new treatment. They have been built up out of large, firmly defined planes, which are no longer modeled by light and by the contours that light reveals, but are as though hacked out with knife and chisel. Especially do the heads of the two nudes at the right reveal the will to new form: the most dramatic contrasts supplant ordinary transitions, and thus in magic violence the new pictorial idiom is born. Even the space in which the figures stand seems to be sculptured-it is not an atmosphere, as in the earlier works, but a volume, a mass. It is still an open question whether Picasso was aided in this crucial advance by examples of African Negro sculpture, which was just being discovered in these years. At all events, he achieved here a style which raises the sculptural structure of the work to magical significance. With this exploit he pointed the way to the Cubist revolution.

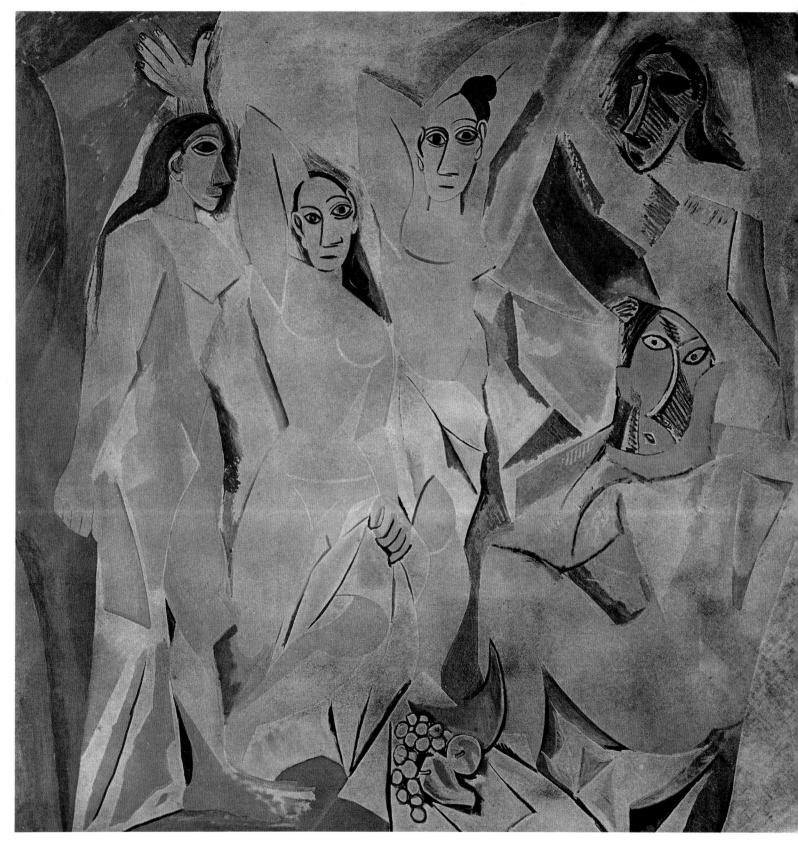

LES DEMOISELLES D'AVIGNON

WOMAN WITH A FAN

Oil on canvas, 59⁵/₈ × 39³/₈" The Hermitage, Leningrad

After completing the revolutionary work, *Les Demoiselles d'Avignon*, Picasso was for some time busy solving the many problems it had raised. In his search for new ways adequate to reflect the contemporary vision of the world, he was almost alone. In time, Georges Braque joined him, a fellow artist whose work had gone beyond the paintings of his Fauve period with their joyful colors. And Picasso was to find an understanding advisor and lifelong friend in Daniel-Henry Kahnweiler, who in 1907 opened a gallery in the Rue Vignon. Apart from these two men, however, Picasso was entirely alone with his daring innovations.

This work is one of a number in which Picasso develops and enriches all he had learned from painting the *Demoiselles*. Unlike the *Dryad*, also of 1908, *Woman with a Fan* is very much the work in which his development toward plasticity, the magic of firmly built self-contained forms, reaches its culmination. Picasso drew inspiration for this sculptural treatment from the masks and sculptures of primitive Negro cultures, from which he derived the expressive value of great plastic masses. The presence of volume becomes an expressive means for him, but he does not produce sculpture; rather, he treats bodies in his paintings as simply carved masses. This is why he limits his palette to a few red-brown and ocher tones—the colors of tropical wood or burnt clay which do not divert the eye from the impact of plastic forms. Plastic, three-dimensional treatment now occupies a central place in his art, and all other means of expression are subordinated to it. However, the three-dimensional effect is not an end in itself—rather, it serves as a vehicle for the artist's increasingly spiritual outlook.

Woman with a Fan illustrates this approach. The dignity and nobility that seem to radiate from the figure have been achieved by a reduction of the forms to rigorous geometric elements. All detail has been eliminated, the structure of the figure on the chair being the sole point of emphasis. As a result the woman suggests some ancient goddess, dignified and imperturbable. The painting's remarkable austerity is wholly magical in its effect; Picasso achieved it by going back to the elemental plasticity of art.

This work logically continues the development initiated with *Les Demoiselles d'Avignon:* the problems that were raised by the magical effect of large compact masses, and formulated in the revolutionary composition of 1907, have been treated more thoroughly in 1908. Instead of the carefully calculated balance characteristic of earlier works, in which classical inspiration predominated, Picasso now concentrates on the expressive power of massive forms. Primitive art helped him find his way to a spatially cogent formula for expressing the basic emotions of mankind.

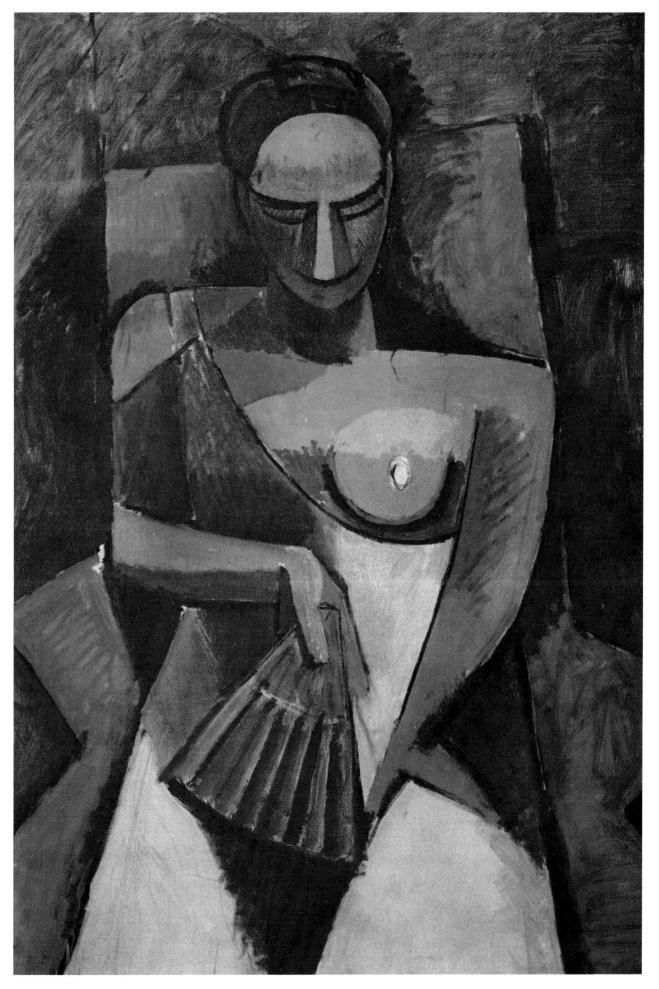

WOMAN WITH A FAN

DRYAD

Oil on canvas, $73 \times 42^{1/2''}$ The Hermitage, Leningrad

This figure, a nude among trees, marks a further advance in the direction Picasso had been taking ever since *Les Demoiselles d'Avignon*. He painted it in the summer of 1908 while staying at La Rue-des-Bois on the Oise, near Paris. The work is redolent of carefree holidays.

For the first time in Picasso's new phase, landscape—man's natural environment—plays a part in the composition: trees and other greenery surround the central figure. The world of plants and trees, hitherto almost wholly absent from Picasso's painting, is treated in the same way as the human figure: the foliage becomes compact masses, and, like the figure, the over-all effect is sculptural. And so Picasso achieves a new kind of synthesis between man and nature—in contrast with Impressionist art, in which trees, plants, and the human figure tended to be dissolved in a shimmer of atmospheric color. Now, in Picasso's newer works, a new conception of landscape is making itself felt: the things of nature become solid and tangible, fill up the pictorial space, and in their spatial aspects are treated as equals of the human figure.

Not only trees, plants, and the forms of nature have become more solid; space itself has become solid and tangible. The painter treats it in the same sculptural manner as the human figure and the natural forms. As a result the painting becomes a firm architectonic unit. Picasso builds up his painting with pieces of space, with the figure, and with the forms of nature. Even the stones are made to obey the same law.

Yet Picasso's paintings during these months, for all the rigidity of their structure, clearly reflect the rest and relaxation of a stay in the country. Color—the color of the Ile de France, the saturated, luscious green—once again appears in these works. To be sure, Picasso's palette is extremely restricted: just as he renounces transitions between forms, and builds compositions out of the simplest formal elements, so he imposes strict limits on color: he confines himself to brown, ocher, and green. They clarify the formal structure, while conceding precedence to form. Nevertheless, it is the color in these works that gives them a freer, broader sense of life. Having lingered in a world primarily determined by the human figure, Picasso has come out of doors at last. Physical rest and relaxation seem to be at work in this development, which led the artist to magnificent paintings that give the synthesis between man and nature this new universal form.

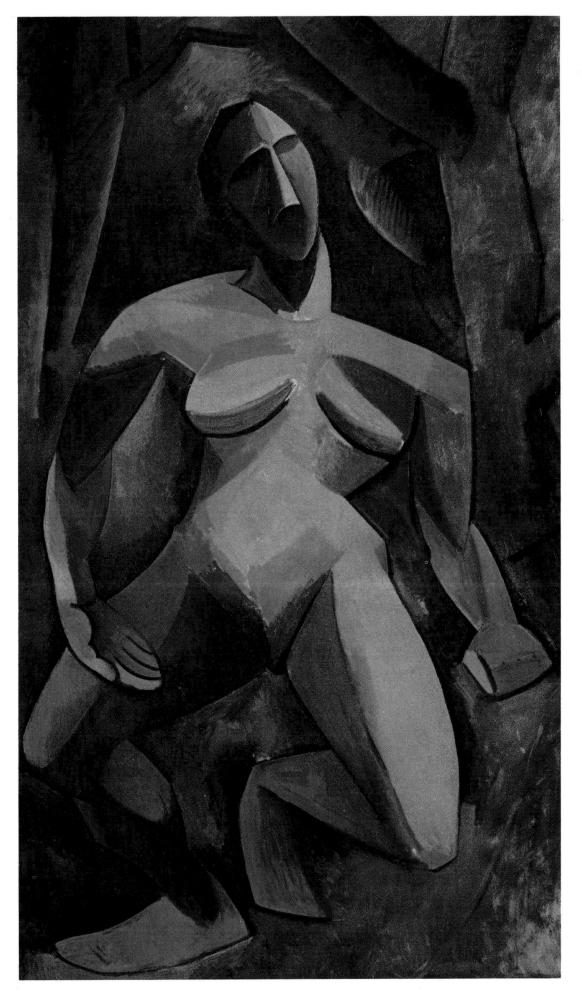

THE RESERVOIR AT HORTA DE EBRO

Oil on canvas, $31^7/_8 \times 25^1/_4^{"}$ Private collection, Paris

The pictorial conquest of nature that began in 1908 reaches its high point the following year. Picasso spent the summer at Horta de Ebro, and the austere bare forms of the local landscape inspired a number of magnificent paintings; the one shown here is perhaps the best.

This work is distinguished from the works of the preceding years, above all, by the ruthless logic of its composition. Whereas in 1907 and 1908 Picasso was primarily inspired by the massive compactness of primitive sculpture, his ideapattern has here become the crystal, that most geometric of all nature's formations. Cézanne's tremendous attempt to reduce natural form to the simplest geometric bodies and thus to create "a harmony parallel to nature" was probably what set Picasso on the road to this new conception of nature. The landscapes painted by his friend Braque at L'Estaque, near Marseilles, in 1908 may have been a still more immediate stimulus to Picasso, who here applies his newly acquired grammar of vision to landscape. It was these landscapes by Braque—and probably also those by Picasso—which led contemporary art critics, sometimes jeeringly yet not inaptly, to coin the term "Cubist."

The rigor with which the parts of the picture are joined together to form a regular whole at once suggests the structure of a crystal. Color plays a subordinate role, being confined to a few shades of yellow, ocher, and green; form wholly predominates. Obeying the laws of a clear, spiritualized syntax, the forms constitute a unity which is no longer derived from sense perception but is governed by the inner law of the painting, by its own pictorial language. As in a fugue, the individual themes overlap and follow one another; the predominantly mathematical basis, too, relates these paintings to the fugue in music. Their effect is just as classical and austere, and rests entirely upon the rigorous application of a clear, intellectually rigorous principle of composition.

The self-sufficiency of this painting is further stressed by the fact that color and light no longer serve to render the visible forms of the object, but solely to strengthen the unity and architectonic structure of the work as a whole. In paintings such as this one, Picasso shows what inflexible self-discipline is required to create a new pictorial language. With these landscapes he also took another step away from dependence upon the object, and toward the autonomous work of art, conceived of as a harmony parallel to nature.

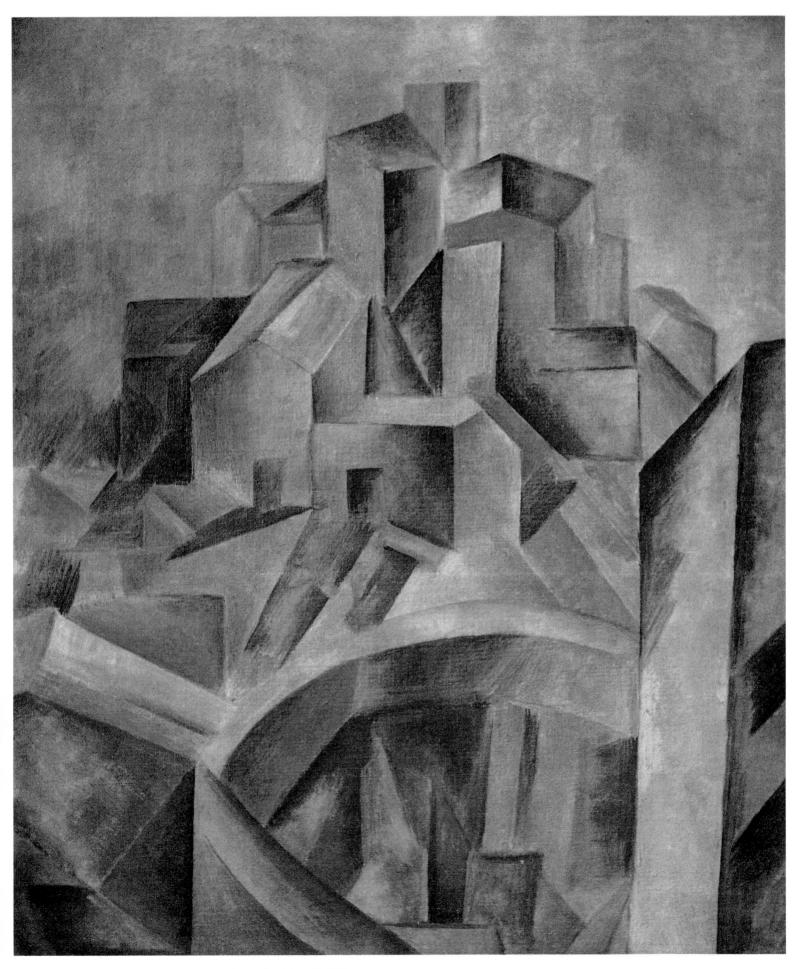

THE RESERVOIR AT HORTA DE EBRO

PORTRAIT OF Daniel-Henry Kahnweiler

Oil on canvas, $39^{5}|_{8} \times 28^{5}|_{8}''$

The Art Institute of Chicago (Gift of Mrs. Gilbert W. Chapman)

This portrait of Picasso's friend, advisor, and dealer is the most striking example of how the artist applied his newly created artistic language to the portrait; that is to say, to the characterization of an individual human being. It also shows what great progress he has made since the year before in mastery of the Cubist idiom, here handled with sureness and conciseness.

In 1910 Picasso went back to the human figure. Besides several female figures, he painted three portraits that year, in which he explores the potentialities of the Cubist style—his portraits of Wilhelm Uhde, Ambroise Vollard, and finally, this one of Daniel-Henry Kahnweiler, which shows most fully the new treatment of form. The work is at the same time a tribute to the man who not only helped him to sell his paintings but also introduced him to contemporary philosophy—a friend who recognized from the outset the importance of the Cubist idiom and has ever since faithfully defended it. Picasso's portrait of Kahnweiler would deserve to be included here if only for his considerable contribution to the development of Cubism.

In this work Picasso has gone a long way in the direction that he had taken when he painted Les Demoiselles d'Avignon, farther and farther away from the object, ever more concerned with consolidating the pictorial order. Here he is a long way, too, from the landscapes painted at Horta de Ebro in 1909, in which geometrical order predominates. In the portraits of 1910, especially this one of Kahnweiler, the artist puts his subject through a rigorous, unsparing analysis, beaking up the forms into their elements in a manner not unrelated to contemporary developments in the natural sciences. He breaks up the closed volumes, and arrives at a pattern of overlapping, tiny planes which evoke a three-dimensional plastic order similar to that of a faceted gem. In this shallow stratum of small, elementary planes superimposed upon one another (plans superposés), the head and hand of the sitter are individually characterized as centers of gravity. Details such as the watch chain are also incorporated in the pattern of facet-like planes. The colors-blue, ocher, and gray-violet-play a subordinate part; for here Picasso is primarily interested in the analysis of form, the systematic breaking up of volumes into their elements, an objective order of forms in space. He achieved this aim convincingly and masterfully in the portrait of his friend Kahnweiler, who sat for it about twenty times.

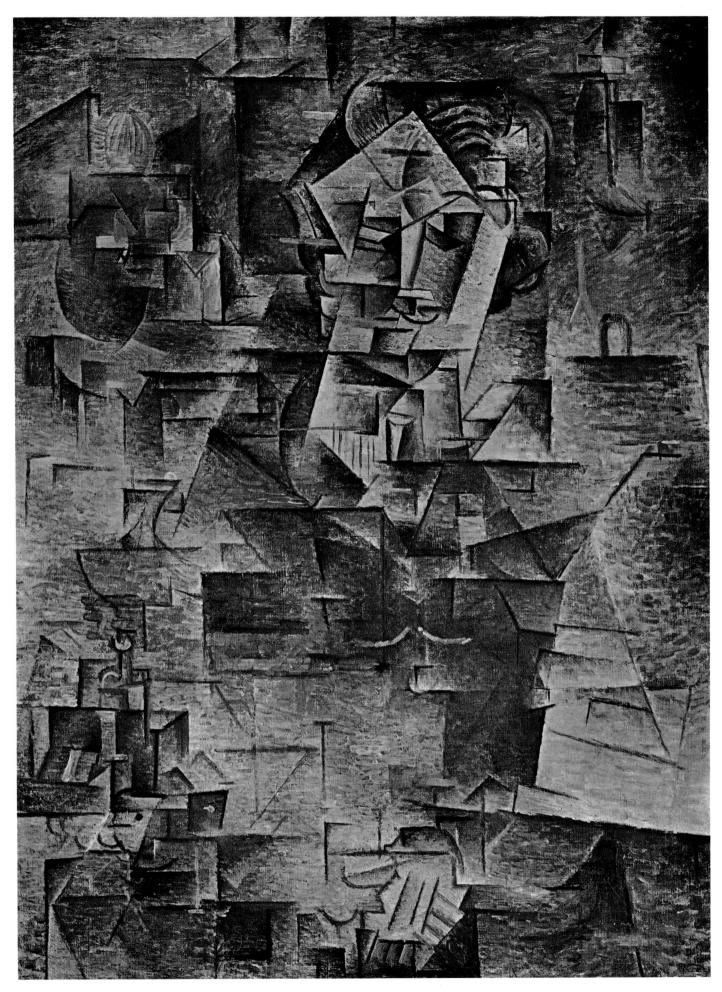

PORTRAIT OF DANIEL-HENRY KAHNWEILER

MAN WITH A PIPE

Oil on canvas, $37^{1/2} \times 28^{3/8''}$ Private collection, Paris

During the summer of 1911 Picasso brought his Cubist style to a new peak in several large, firmly constructed figurative paintings. For these paintings he used a new, at that time unprecedented—truly revolutionary—format: the oval. About three dozen paintings dating from 1911 and the two following years make use of the new shape, which takes on compelling meaning from the inner structures of the works.

The works painted during the summer of 1911—which Picasso spent with Braque at Céret (Pyrénées Orientales)—continue the breaking up of bodies into facets, going farther in this direction than the works of 1910, including the portraits of Uhde, Vollard, and Kahnweiler, had done. This development may have been induced by Picasso's recent work with sculpture—including the woman's head in bronze (figure 15). Similarly, Picasso's interest in still life—which comes to the fore at this time—surely furthered his concentration on the architectonic structure of form. Whether it be a portrait, a still life, or a landscape, his subject seems much less important than the formal structure. In these paintings a powerful sense of the world's underlying unity asserts itself: man, things, and space are equally facets of a vast, architectonic reality, and the painting's subject is conceived of as an occasion for the artist to make a statement defining this reality. Each of these works, whatever its subject, is thus in its structure, in its syntax, a metaphor of the world's physical structure, the reality around us.

Precisely because of these fundamental innovations, the oval format takes on fresh and more comprehensive significance. The painting is no longer a segment of reality, but a world in itself, separate and self-contained. The Cubist compositions from 1911 on are turned in on their own points of focus, the effect of internal repose being ever more tightly knit. At the edges, the paintings are empty, the whole energy of each work turned inward to the center.

Man with a Pipe is no doubt the masterpiece, the classic in this series of works in which the crystalline structure of form achieves monumental clarity. The two pyramids of small, facet-like planes fitted into one another appear as one architectonic entity to the viewer. And yet, not all reference to objects has been sacrificed: the man's head, his shirt sleeves, the newspaper in his hand—such details have not just been reduced to formula, but are still clearly "denoted," i.e., translated into legible signs. Color is there only for the sake of form: in this world, whose significance lies so completely in the structure of form, color plays a very subordinate part. The essential element in all these paintings is the statement made concerning the structure of reality, and it is only the austerity of the Cubist idiom, rather than the object, which has any importance in relation to it.

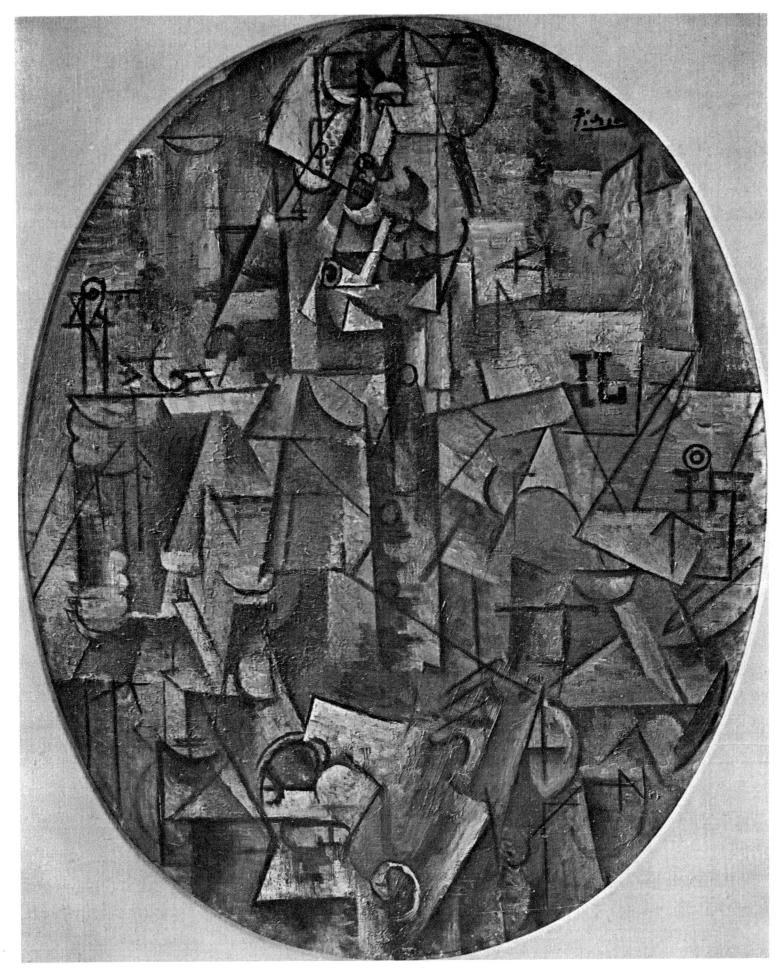

THE AFICIONADO

Oil on canvas, $53^{1}|_{4} \times 32^{3}|_{8}''$ Kunstmuseum, Basel '

In the summer of 1912, which was spent at L'Isle-sur-Sorgue near Avignon, Picasso completed his development of that part of the Cubist style which aimed at breaking up form into its elements, and for this reason has become known as Analytical Cubism in the history of modern art. *The Aficionado*, which shows the figure of a man seated at a café table, is probably the most representative work of this period; in it five years of penetrating explorations are brought to their conclusion.

In this work, which is painted in restrained and subdued colors, we are immediately struck by the strongly vertical structure of the composition. It is based on a rigid system of vertical and horizontal lines, with the vertical axis clearly dominating. This distinguishes it from those works of the preceding years in which the compositional pattern was the oval or the lozenge. With this new system of composing in straight lines Picasso further stresses the depersonalization of his subjects; his sitters become mere pretexts for exemplifying methodically a rigorous grammar of form. The works done in the summer of 1912 show the same sternly logical coherence which characterizes the Latin language. They bring to mind the clarity and objectivity of Descartes' *Discourse on Method*.

In such a systematically balanced whole, a composition that derives its eloquence from the rigor of its intellectual discipline, Picasso incorporates the characteristic detail of the individual case: the hat, the little flag with the inscription "Nîmes," the collar and necktie, the carafe, and the newspaper with the title *Le Torero*. By such means he relates the supra-personal order, to which his painting gives form, to the everyday human environment. This fact shows that even during these years of high intellectual tension Picasso attached too much value to reality to banish it entirely from his works. It is significant that, although this is one of the works in which he helped pave the way for nonobjective painting, he has never himself painted in that style.

His purpose in this period is not the creation of a nonobjective art, but the complete objectification and depersonalization of the object as a spatial fact in the real world. In the works of 1912 Picasso frees painting not from the existence of the object, but from its momentary appearance. The composition based on rigorous straight lines certainly contributes to this result; moreover the sensory charm of the object is played down by the subdued colors so as to emphasize the spirituality of the conception. Only in the brush stroke do we still find a shade of personality. During this same year Picasso was to find yet another new technique.

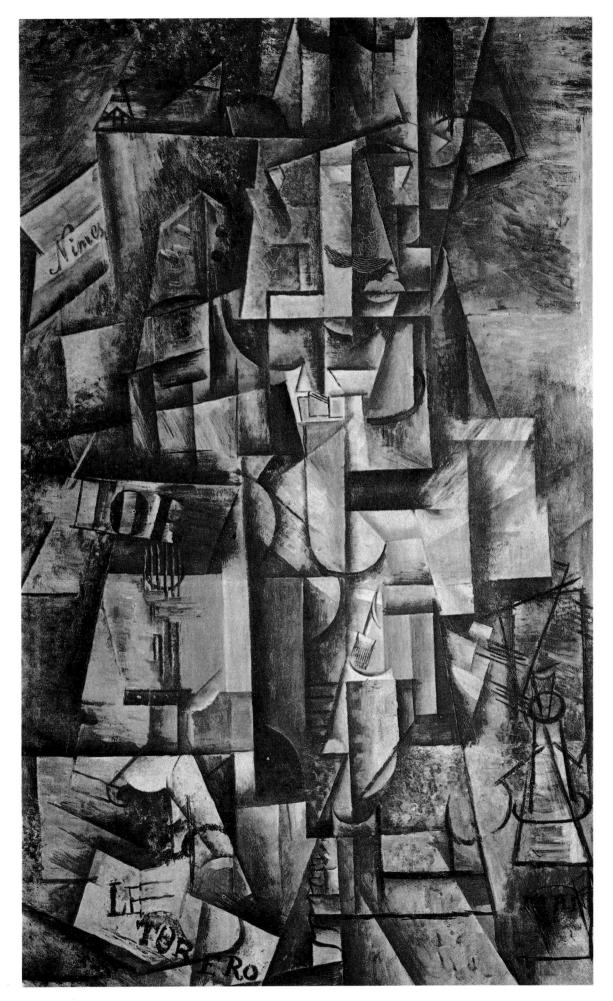

BOTTLE, GLASS, AND VIOLIN

Charcoal and pastel paper, $18^{1/2} \times 24^{5/8''}$ Formerly Collection Tristan Tzara, Paris

With the collages, or pasted papers, that Picasso began to produce in 1912, he embarked on the path that was to take him beyond Analytical Cubism. The composition shown here is perhaps the most accomplished and freest in this series of collages. It clearly illustrates the features of the new technique and defines the aims Picasso set for himself in these works.

What we have here is a still life based on the shapes of quite ordinary things—a bottle, a glass, a violin—and using actual pieces of newspaper. It is noteworthy that Picasso used this new style mainly for still lifes and, occasionally, heads. Here, once again, the problem of elementary form is at the center of his interest.

But the problem is treated in a fundamentally new manner. In the works of Analytical Cubism, Picasso reduced the forms to their elements; breaking them up into small components, into many facets, and using them as building blocks, he created a new order of things in space on the picture surface. By juxtaposing and interlocking the planes in short, rapid brush strokes, he obtained a structure of crystalline clarity, reflecting rigorous intellectual discipline. Now, at the end of Cubism's analytical phase, he follows exactly the opposite procedure: the elements of form serve as starting points for works still rigorous, but at the same time much more lyrical.

Instead of breaking up forms into their elements, he begins with the elements themselves, transforming them into things—the ordinary objects of everyday life. And he achieves even greater objectivity by renouncing brush strokes and the laying on of color; instead, the elements of form appear in his compositions as fragments of ready-made things: newspaper clippings, pieces of wall paper, papers with printed veined-wood patterns, and the like. These fragments, borrowed from everyday reality, represent the world outside the picture and show that the composition can be so autonomous, so well knit, that it can even incorporate extraneous materials. In other words, as Kahnweiler put it, "He can do without his own skill at wielding the brush." Thus, a piece of newsprint at the left can serve for a bottle, and the paper printed like veined wood makes a violin. A few firm lines traced with charcoal complete the transformation and bring the extraneous materials together into a whole.

During these same years, poetry was taking a similar turn in its development, beginning to employ the most ordinary, everyday words *(les mots de la rue)* in poetic composition. This combination of the crudest reality with the most elementary, impersonal forms launched the next phase of Picasso's development: these pasted papers are the first step toward Synthetic Cubism.

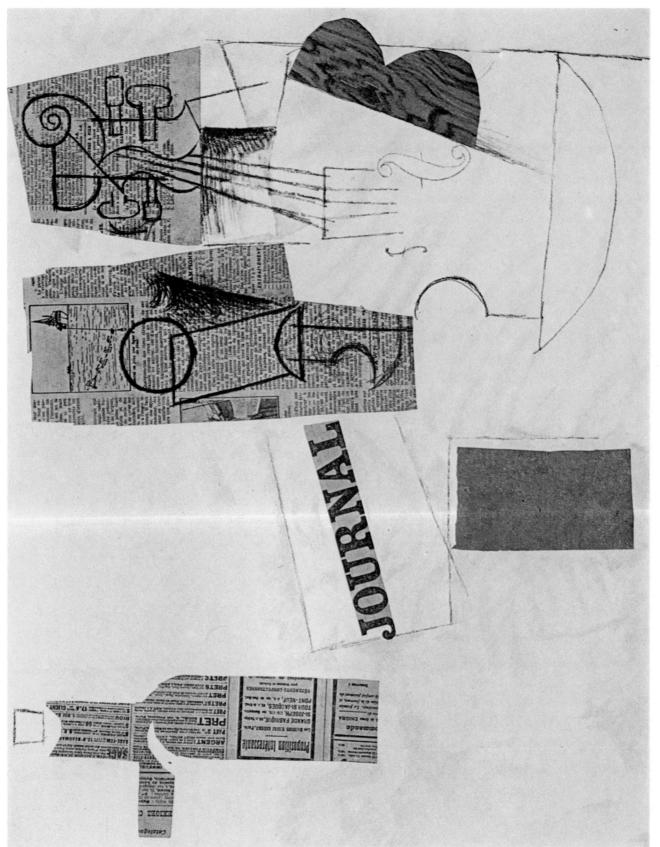

BOTTLE, GLASS, AND VIOLIN

WOMAN IN AN ARMCHAIR

Oil on canvas, 59¹/₄ × 39¹/₂" Kunsthaus, Zurich (Mrs. I. Pudelko Collection)

After experimenting with the new synthesis of form in still lifes incorporating bits of paper, Picasso applied in this monumental work his newly discovered formal idiom to the human figure. Here the real subject of the painting is no longer broken up into facet-like elements, but stated with great force in a new idiom.

Picasso treats the essential reality, whose transformed image is presented to the viewer, with the utmost seriousness. In his will to objectivity-which was at the center of his art throughout the Cubist phase-he supplies us with information about many details: the arm-rests and the tassels of the chair, the scalloped border of the shirt, the hair, and so on. But he is not interested in the outward appearance of things-he is aiming at their essential qualities. For this reason, just as he did in his earlier Cubist works, he avoids the one-sided contingency of perspective, and represents things not as they appear to us, but as they are, as we experience them. Thus he shows the chair not only in frontal view, but also as seen from above, and the breasts of the figure are shown both frontally and laterally, the two views being juxtaposed. By translating reality into this sign language, he achieves a new type of vision, a statement about the world of things which is no longer dependent upon the momentary, or accidental point of view. He makes a radical break with the traditional relationship between subject and object. Reality itself is at the center of this art, and the painter becomes the impersonal instrument of our cognition, our measurement of reality. A sign language made up of formal elements is employed by the artist to formulate his statement about reality as objectively as possible, to bring together all the object's characteristic details in a factual statement.

Precisely because of the hardness and objectivity of this vision of reality, the work has a dramatic quality that had not appeared in any of Picasso's earlier works. The immediacy of the statement untempered by any lyrical sensibility, the renunciation of an individual point of view, the objective sign language—all these characteristics of the work testify to a vision purged of the lyrical subjectivism prevalent at the turn of the century. With this vision, the artist is equipped to make a fresh conquest of reality, to report the artistic experience without bias or sentimentality.

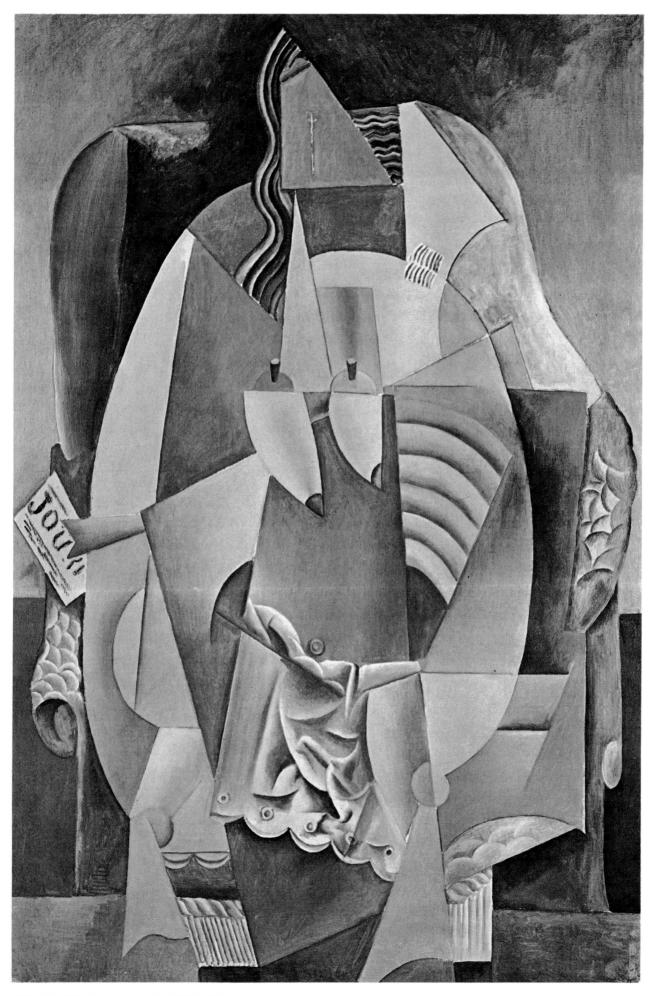

VIVE LA FRANCE

Oil on canvas, $21 \frac{1}{4} \times 25 \frac{5}{8}''$ Collection Mr and Mrs. Leigh B, Block, Chicago

With this work Picasso resumed his series of still life compositions, in 1914. It stands in clear contrast to the dramatic austerity of his 1913 works: it is a painting of playful, casual cheerfulness. He executed it the summer of 1914, at Avignon, where he had gone with his friends Braque and Derain—his last summer in the country before the outbreak of the First World War. Like a few other works dating from the same year, this one conveys the carefree mood of the period—the last such summer Europe was to enjoy for several years to come.

It is not only the bright colors that strike the cheerful note; despite the rigorous over-all structure, the pictorial treatment of the forms is marked by many playful and witty ideas. We can scarcely be surprised that the term Rococo Cubism has been proposed to indicate the character of these paintings.

The witty idea upon which this still life of ordinary everyday objects is based, clearly informed other new works by Picasso of 1914. The idea is simply to translate a collage into the traditional technique of oil painting. A number of details reveal this: the wallpaper pattern in the background, the playing cards at the left, and the way the bit of newspaper has been worked into the composition. It was an original idea at the time, and Picasso developed it painstakingly.

Moreover, the painting technique employed here derives from Picasso's experiments with pasted papers. Whole areas are treated with a pattern of colored dots, or they are coarsened by the addition of other materials, such as sand or sawdust, to the paint. These firmly outlined areas, because of their different textures, stand out as independent units, like the separate bits of paper in a collage; these, too, take on a new and distinct objective meaning, but without giving up their own consistency and "extraneous" character. It was by such means that Picasso—together with Georges Braque—endowed painting with a new dimension. The tangible treatment of the picture surface added new possibilities of expression to the sign language of Synthetic Cubism and greatly enhanced its attractiveness.

In respect of its over-all structure, however, *Vive la France* has more in common with the compositions of the preceding years than appears at first glance. Picasso is still very much concerned with creating an objective image of reality, freed from the contingencies of sense perception and yet capturing the essential features of the object represented. The sign language of Synthetic Cubism, which defines and explains reality with a few formal elements, made it possible for the artist, after the rigorous and dramatic works of 1913, to do justice to such sprightly, lighthearted subjects as the one presented here in *Vive la France*.

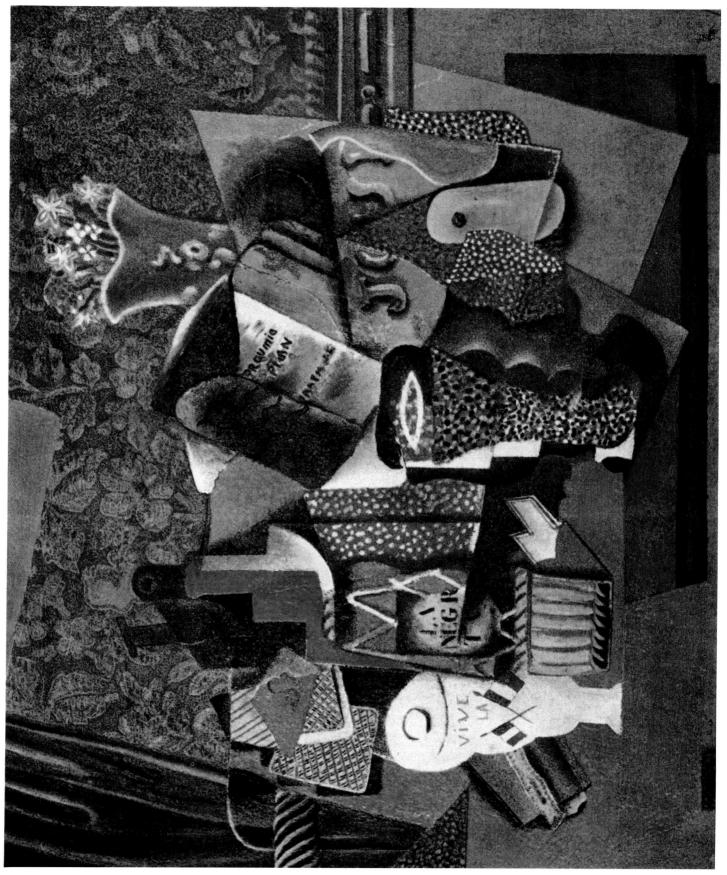

PIERROT

Oil on canvas, $36^{1/2} \times 28^{8/4}$ " The Museum of Modern Art, New York (Sam A. Lewisohn Bequest)

After the systematic development of Cubism from 1907 to 1914, the series of paintings begun in 1917 comes as a surprising throwback. These paintings are entirely realistic in spirit—they seem almost traditional.

The return to the language of realistic art—i.e., sense perception as the basis for portraying reality—began as early as 1915, when Picasso made two strictly realistic portraits, in pencil drawing, of Ambroise Vollard and of Max Jacob (figure 19). The masterful realism of these drawings aroused both admiration and indignation, but their production did not interrupt the evolution of the Cubist style. The figurative paintings of 1915 and 1916 are among the most accomplished of Picasso's strictly Cubist creations.

What then are we to make of the artist's working simultaneously in two styles, Cubism on the one hand, and the realistic idiom on the other? Had not Picasso abandoned the latter, back in 1906? It is noteworthy that at first he employed the traditional realistic treatment solely to portray persons with whom he was closely connected and of whom he was especially fond. He reverted to the earlier style, we may assume, because his models were psychologically close to him; they were part of his personal life, thus separate and apart from the objectively constructed works of the Cubist period. The realistic drawings and portraits are not really incompatible with the Cubist works; they are personal notations, a sort of diary that Picasso kept while his main artistic preoccupations were caught up in the exploration and conquest of a new reality.

The painting shown here is one of the most accomplished and most important of the series. During his trip to Italy with Jean Cocteau to design the sets and costumes for Cocteau's ballet *Parade* (which was first staged in Rome), he became acquainted with the *commedia dell'arte*, its characters and traditional costumes. As he grew to be more familiar with the world of the ballet (he married Olga Koklova, a dancer, in 1918), Picasso was inspired to execute a series of paintings and drawings which, like this painting, bring out a certain melancholy and other psychological aspects of the milieu in a newly developed realistic language of form.

The clarity of the drawing, the plastic treatment of the forms, and the brightness of the colors in this painting (as also in the portraits of the artist's wife and the drawings of friends that he did around this time) recall the classical works of Ingres; and their tight discipline reveals the underlying closeness of these works to his Cubist production, in which Picasso was reaching the classical high point during these same years.

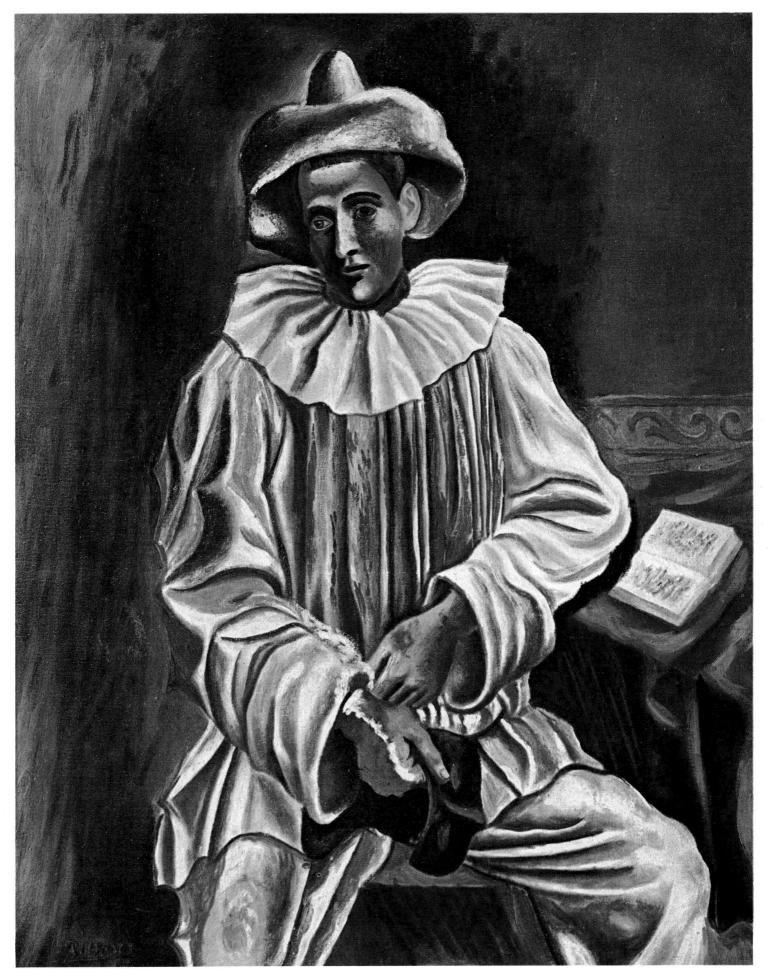

THREE MUSICIANS

Oil on canvas, $80^{1/4} \times 88^{1/2"}$

The Museum of Modern Art, New York (Mrs. Simon Guggenheim Fund)

Picasso painted the two versions of this large composition in Fontainebleau during the summer of 1921 (figure 21). Both versions, particularly the earlier one in the Museum of Modern Art in New York, must be regarded as the culmination of his Cubist style. After he created his first works in the style of Synthetic Cubism, his idiom underwent monumental simplification. Color, moreover, was at last assigned a role in the harmonious order of Cubist composition. Picasso no longer confined himself to pastel tones, but employed bright, primary colors.

Both versions of the painting show three figures—Pierrot, Harlequin, and a Monk, each of whom is playing a musical instrument. In the first version, Pierrot with the clarinet is at the left, Harlequin with the guitar at the center, and the Monk holding the music at the right. In the second version, which is in Philadelphia, Pierrot and Harlequin have exchanged places, and Pierrot in his white costume is at the center. The first version convinces by its tightly knit composition and its classical clarity; the second is more showy and more richly articulated, but lacks the striking conciseness of the painting in New York.

In these works Picasso summed up his experience of the Cubist period: out of simple, almost geometrical elements he has created a lyrically expressive group that is often loose in details, yet firmly composed.

The subject of the composition—three figures from the *commedia dell'arte*—was inspired by his work for the ballet during the preceding years. After *Parade* he had done the sets for the ballets *Three-Cornered Hat, Cuadro Flamenco,* and *Pulcinella,* all staged by Diaghilev. The atmosphere of the theater makes itself felt in both versions of *Three Musicians;* it is directly evoked by the contrasts in costume pattern, the crisp stenographic characterization of the figures, and similar details.

Picasso succeeded, however, in transforming these theatrical elements into a true painting by translating them into the language of Synthetic Cubism. Large simple planes articulate the work but they are repeatedly transformed into objective elements, so that their significance becomes clearly legible. Here and there—for instance, in the lozenge pattern of Harlequin's costume or in the Monk's beard—the treatment calls again to mind the technique of collage, which is indeed at the origin of this monumental composition. The forms and colors in this painting have become signs that not only serve to denote a reality but also convey a spiritual situation in musical terms. Not only by its dimensions is this work the masterpiece of Picasso's Cubist phase: the richness of his pictorial language was never so concentrated as here, nor its validity so clearly demonstrated.

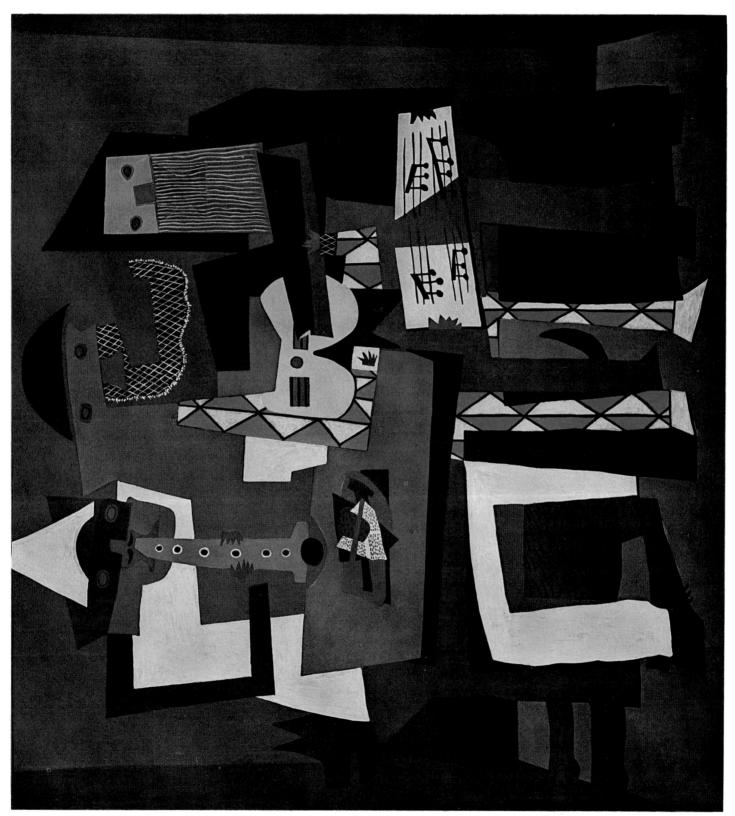

THREE MUSICIANS

THREE WOMEN AT THE SPRING

Oil on canvas, $80^{1}/_{4} \times 68^{1}/_{2}$ "

The Museum of Modern Art, New York (Gift of Mr. and Mrs. Allan D. Emil)

In the same year as the two versions of *Three Musicians*, compositions which truly evoke music, Picasso painted another large canvas in which three figures appear three women at a spring. But the contrast between these works discloses the rich elasticity of Picasso's art: it is as though, between these big compositions, he were comprising the full range of his creative powers.

Both versions of *Three Musicians* are permeated with the spirit of music; quite apart from the subject, the treatment is thoroughly musical, and the effect of the paintings, especially in the first version, is that of a polyphonic work with contrapuntally interlaced themes.

There is no trace of the spirit of music, however, in *Three Women at the Spring*, of the same year. The inspiration comes wholly from sculpture, from the spatial properties of the bodies. In this work, into which the powerful bodies of three colossal women are compressed, Picasso harks back to his studies of 1906, that is, to the period when the plasticity of bodies, their three-dimensional existence, was at the center of his interest.

The artist's predilection for plastic volumes in the treatment of the human figure—which during the years of Cubist formal analysis had been set aside in favor of a different conception of space—was revived by a trip to Italy and the artist's contact with Roman sculpture. The "classic" phase which came about from this exposure to works of antiquity was above all inspired by sculpture. The treatment of the drapery in this painting brings to mind Roman sculpture, not to mention the fluting of Roman columns. Everything in the painting, including the subdued fresco-like colors, aims at the effect of volume, of majestic corporeality. There is no psychological interest exhibited in this composition: the artist has confined himself to representing the Arcadian, unproblematical presence of these powerful bodies.

This unselfconsciously sculptural treatment no doubt reflects one feature of contemporary history: the relief experienced by mankind after the years of the First World War, the hope that a new Arcadia might be born from Europe's ruins. Always sensitive to spiritual currents, Picasso gives expression in this and in similar works to ideas very much in the air at the time. It is a masterful painting at the very opposite pole from *Three Musicans*. For some years to come, we will find him running the gamut between these two opposite extremes, as it were, of his inspiration.

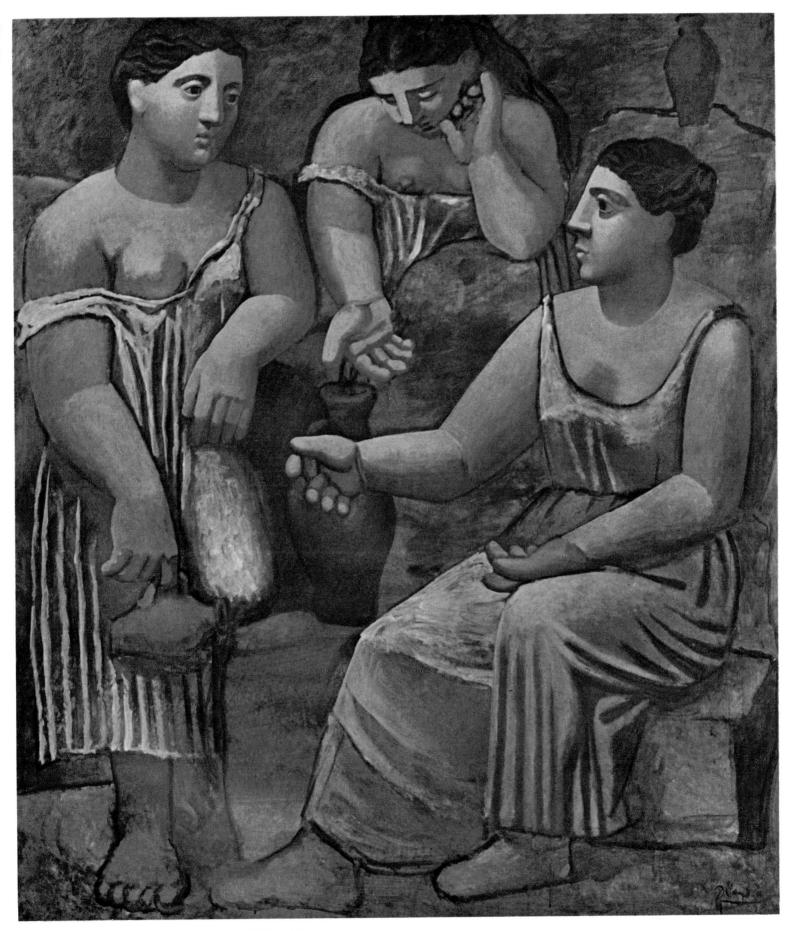

THREE WOMEN AT THE SPRING

MOTHER AND CHILD

Oil on canvas, $38^{1/4} \times 28''$ Collection the Alex Hillman Corporation, New York

The subject that dominates Picasso's work in 1922, and marks a new phase in his Classical style, is motherhood. In 1921 his wife Olga had given birth to their son Paul. The subject of the mother with the little boy thus arose naturally in Picasso's personal life at the time. He treated the subject in many paintings; this one is perhaps the most accomplished, the one which best illustrates Picasso's style in these years.

A typical touch is the impression we are given of larger-than-life dimensions. The figures of the young mother and the child do not seem to belong to the ordinary human race, but to some race of mythical heroes. This is achieved primarily by pictorial means: the figures fill the picture surface to such a degree that it seems almost cut off by the frame. The viewer has the feeling that the woman's forms are too massive for the size of the canvas, that they threaten to burst out of the picture. Body volumes and the pictorial space are here set in opposition, the result being exactly this impression of gigantic dimensions. This is further stressed by the contrasts among the colors, which range from pink to violet and from gray to blue-gray. Picatto here raises the subject of motherhood so far above his personal observation as to attain the monumentality of myth. To achieve this end he had only to draw on the Classical style which he had employed the preceding year for the painting *Three Women at the Spring*.

The close kinship of both works may be seen in the gigantic proportions of the figures, the voluminous limbs, and the classical rigidity of the heads. The difference between the two lies in the psychological treatment: whereas the figures in *Three Women*, of 1921, merely express bodily presence and fill the canvas with their statuesque calm, those in *Mother and Child*, of 1922, are expressive of the artist's own participation in the action. Moreover, the figures are linked by internal relationships. The mother and child form a single plastic group, but their unity is not only plastic, it is also and above all psychological, emotional. This renewed interest in emotional relationships—renewed in the sense that more than fifteen years separate this painting from the works of the Rose Period—of course grew out of Picasso's personal life. Yet his work is never autobiographical in the ordinary sense of the term. He has always raised personal experience to a level of universality and objectivity, as here, where the birth of his first son is rendered in terms of some modern mythology.

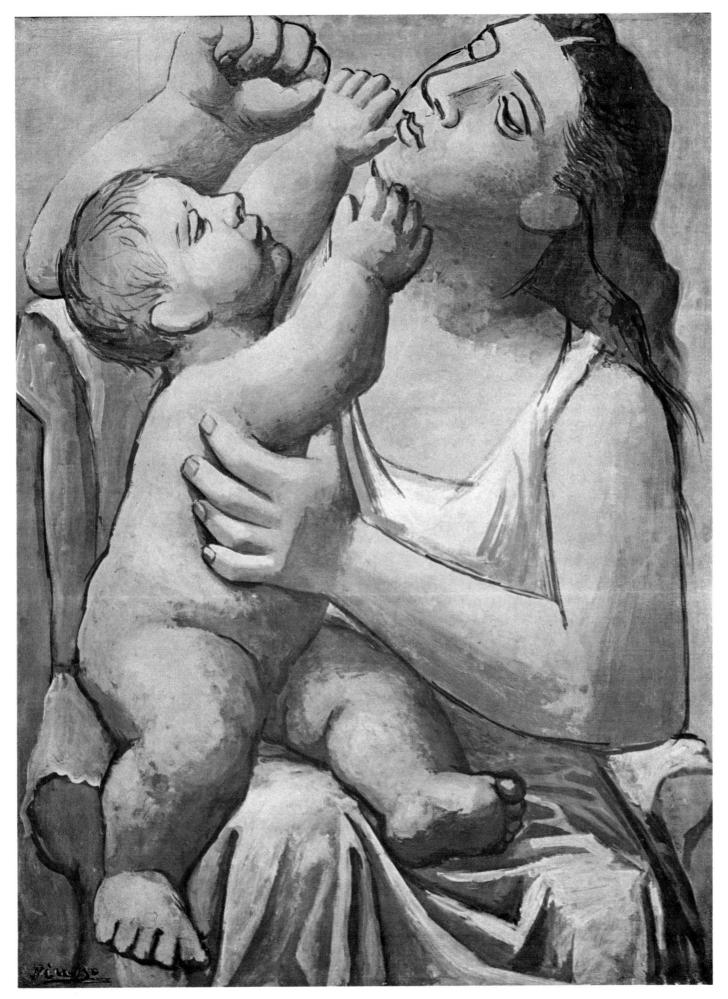

MOTHER AND CHILD

PAUL IN A CLOWN SUIT

Oil on canvas, $51^{1/8} \times 38^{1/8}$ " Collection the Artist

During the early 1920s Picasso's production alternates between Cubism and a Classical style. Side by side with Cubist still lifes of the utmost structural refinement we find figural paintings in his Classical style, mostly with subjects drawn from mythology. A large number of drawings—usually pen drawings—also date from those years. In addition there are pictures of dancers and harlequins, often quite realistic, which testify to Picasso's continuing interest in the world of the ballet and the stage (which was especially kindled by his commissions for the Ballets Russes). Picasso had reached the age of forty and was now in full possession of his creative powers; the most various impulses of his artistic will found their outlet in different styles.

In addition to these works, a new kind of picture begins to appear in these same years, and Picasso discloses yet another aspect of his complex personality: the portraits and sketches of his young son Paul. With them we discover a new facet of the artist's many-sided genius. These works lay no claim to raise or to solve new artistic problems: they belong wholly to the artist's personal life, and he has kept nearly all of them.

Precisely because these works were not intended to solve any formal problems but were produced casually, almost playfully, they disclose the full breadth of Picasso's technical mastery. It is precisely in the works where his eyes and hands are freest that the richness of his creative ideas is most clearly and fully disclosed.

In the various portraits of Paul—in Pierrot costume, dressed up as bullfighter, or simply a child playing—Picasso shows his facility in handling composition, color, and the arrangement of space. As much at his ease as if he were making an entry in his diary, he places the figure and establishes its space on the picture surface, he animates the sparse harmony with some lively accent and articulates the large color areas with a few rapid lines or brush strokes.

Looking at a portrait such as this, no one would suspect how much of Picasso's experiments with pasted papers, how much Cubist discipline has gone into these casually tossed-off little works. And yet it is these features that account for the portrait's sure mastery and raise it high above most artists' realistic portraits. Picasso's affection for his little boy is merely the painting's starting point; what makes it a masterpiece is Picasso's creative sureness.

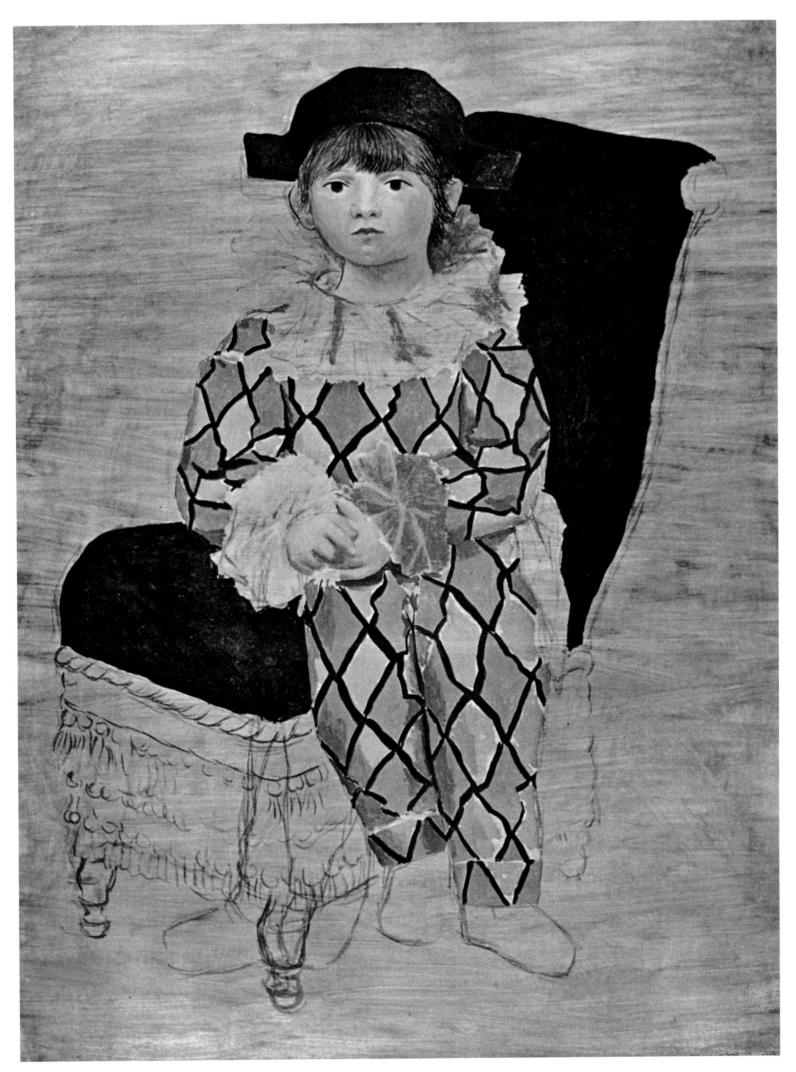

PAUL IN A CLOWN SUIT

MANDOLIN AND GUITAR

Oil with sand on canvas, $56^{1}/_{8} \times 79^{3}/_{d}''$ The Solomon R. Guggenheim Museum, New York

The theme of the still life occurs repeatedly in Picasso's work. It reflects his need for tightly knit formal composition. Already in his early Cubist period Picasso frequently used the still life to sum up his experiences. In a number of paintings of the 1920s he treats the theme of a table in front of an open window with ever new variations. The motif appears for the first time in a gouache done at Saint-Raphaël in 1919 and for the last time in 1925, a little later than the work reproduced here.

This is the most mature and most accomplished of the still lifes Picasso painted in these years. It combines a great richness of conception with formal solutions of clear, classical mastery. Both in its structure and in the sovereign use of all the pictorial means it is equal to the first version of *Three Musicians*, though the forms are richer and more Baroque in the still life.

The starting point for this painting is in any case found in the Cubist style of the early 1920s: this is suggested not only by the strong, lively colors, but also by the addition of sand to the pigment here and there so as to make certain planes stand out as rougher than others. We are also reminded of Cubist compositions by the use of fabric patterns that contrast with one another in the manner of musical motifs, enhancing the contrapuntal richness of the composition. The overlapping planes point back to the collage technique: these planes are first of all independent elements of form, and have only subsequently been transformed into the forms of given things. Similarly, the manner in which space is articulated by lines running into infinity—these merely suggested, and by no means in correct perspective—was prefigured in earlier Cubist compositions (e. g., *Three Musicians*). The same is true of the way the frontal view is combined with the view from above.

What is new in this painting is the rich, sumptuous orchestration, if a musical term may be borrowed to refer to so musical a work. The number of voices making up the polyphony has increased, their timbres are more distinctly differentiated and more carefully contrasted or harmonized: the broad areas consecrated to the musical instruments contrast with the lively pattern in the tablecloth, which brings to mind rapid trills. This is one of the most sumptuous and yet most cheerful of Picasso's works, summing up in its richness and mastery all that he had learned in the preceding years.

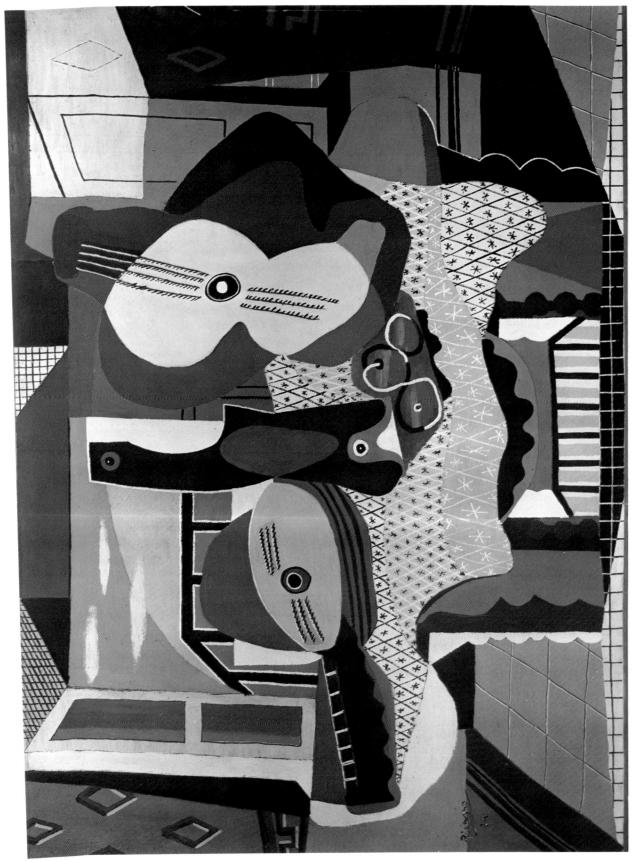

MANDOLIN AND GUITAR

THREE DANCERS

Oil on canvas, $85^{1}/_{4} \times 56^{1}/_{2}$ " Collection the Artist

The broken-up forms and shrill, dissonant colors of this work are in sharp contrast to the serene forms and clear chromatism of the *Woman with Mandolin*, executed the same year. The classical harmony of the latter has been annihilated by an outburst of Dionysiac exuberance, a wild unleashing of instinctual forces that sweeps ordinary conventions before it.

Some elements of the technique Picasso employs in this painting are traceable to earlier works, but the effect here is utterly new and surprising. Every device in he arsenal of his formal language is put to new use and the forms and colors are thereby endowed with different meaning. The distortions and arbitrary breakingup of the human figure no longer serve to build a spatially existing reality: everything is subordinated to the over-all effect of psychological shock, the expression of an orgy of the senses. For all its mastery, this painting should not be evaluated as a formal composition, but as a riot of violent, dissonant energies.

With reference to this painting and the new orientation of Picasso's art that it rignals, a number of critics have pointed to its affinity with Surrealism. an artistic movement emerging under the leadership of André Breton in 1924. It has been suggested that the disquieting, baffling, convulsive features, which play such an important part in *Three Dancers*, are prominent in Surrealist philosophy and aesthetics. Such interpretations would imply that Picasso's work in 1925 was influenced by Surrealism; but although he was at the time seeing a good deal of André Breton, Picasso has always disavowed any connection with that movement.

Actually, *Three Dancers* is fundamentally different from Surrealist works of the period, and there can be no question of any influence. However, Picasso's painting may well have originated in the same preoccupations as the Surrealist works of that period: anxiety at the course of current affairs in Europe during the years following the First World War. Picasso has always been extremely sensitive to contemporary history, and it is not surprising that he should early have grasped and projected the premonitions of upheavals still to come. That is what he has done in this painting, which no longer attempts to formulate an orderly reality (the artist has ceased to believe in any such order), but is entirely bent on expressing drunken abandonment to unleashed instincts.

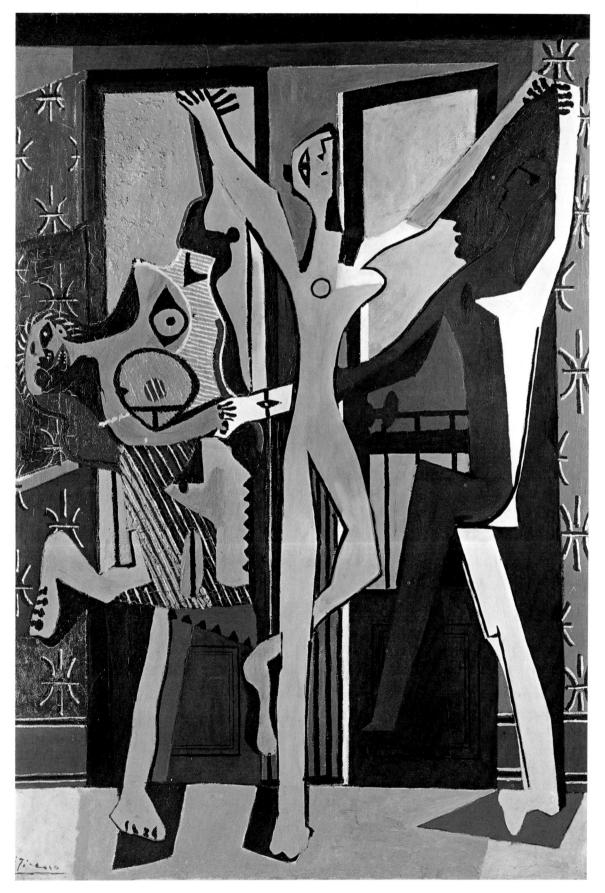

THREE DANCERS

THE STUDIO

Oil on canvas, $38^{5}/_{8} \times 51^{5}/_{8}''$ Collection Sean Sweeney, New York

Still lifes have always played an important role in Picasso's work, but exactly at the midpoint of the 1920s they began to overshadow the rest of his production. It is in still lifes that the artist tests his means and records his achievements and conquests. The great still lifes of these years thus provide not only a survey of his technical mastery, but also of the whole range of his interests and problems.

The work shown here, sometimes referred to as "The Studio with Classical Bust," may almost be regarded as a summary of all that Picasso had learned down to this moment. Thanks to this work we can see clearly how he could go back to his Cubist style in 1925. The origin of a number of his pictorial motives—above all his treatment of the tablecloth—in the collages of the years before 1914 requires no further explanation. The manner in which space has been made visible—and almost tangible—without resort to any illusionistic devices, likewise harks back to Picasso's intensive concern with spatial construction at an earlier time. The strong bright colors here disclose a more recent conquest: the new joy in color, which was first evidenced in the paintings (including some landscapes) executed at Juan-les-Pins.

This work, however, also discloses some features which do not reflect previous achievements, but rather point toward new possibilities in the artist's eventual development. Thus, the treatment of the bust in this still life clearly shows the combination of frontal and profile views. This method of suggesting volume will be much more completely developed in later works, in which the full complexity of the human face will be so vividly revealed.

There are other motives here, too, that point to the future. For instance, the bearded classical head, which is the most important detail of the composition, foreshadows the interest in Graeco-Roman art and mythology which will come to the fore only in 1930, in the illustrations of Ovid's *Metamorphoses*. Finally, the fragments of arms and hands on the table with the head in this still life, point toward the *Guernica* of 1937 where the same motive is very similarly treated, though with entirely different meaning.

This great still life of 1925 sums up Picasso's art at a crucial moment: past and future acquisitions are here found side by side. The juxtaposition of the carpenter's square with the branch of a tree should perhaps be interpreted along the same lines—namely, that the two symbolize order and growth, the two poles of artistic activity. The work sums up these two aspects of Picasso's art in a monumental synthesis, and at the same time it marks an essential turning point.

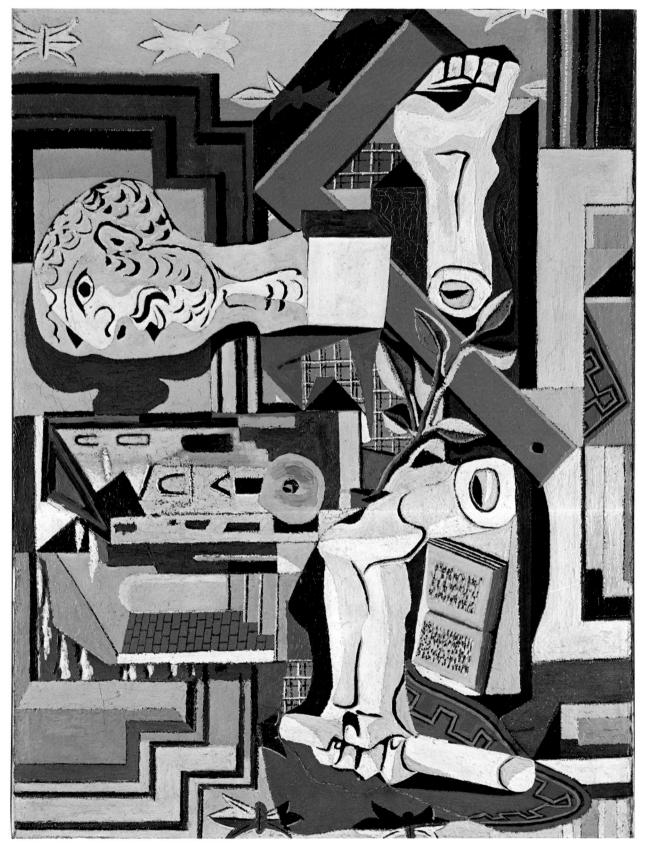

THE STUDIO

SEATED WOMAN

Oil on panel, $51^{1}/_{8} \times 38^{1}/_{4}$ " Collection James Thrall Soby, New Canaan

This painting returns to a theme of interlacing lines which had the year before provided the basic idea for *Atelier of the Modiste* (figure 22). But here it takes on entirely different meaning, for the network of lines does not, as before, support a few scattered colors, but on the contrary it has become the skeleton for a strident flat chromatic composition.

The subject, a seated woman whose body is seen frontally, is not unlike Woman with Mandolin of 1925. However, it would be hard to imagine a greater contrast than that between these two works, only two years apart. Everything in the 1925 work expresses classical repose, serenity, harmony-the triad of colors, the flowing lines, the impression of spaciousness. Not so in this Seated Woman; every single part of the work helps to evoke a feeling of oppressive terror. Instead of harmonizing, the colors form dissonances between shrillness and dullness, between the strident and the subdued. Space does not encompass the figure as in the 1925 painting and similar works, but it compresses her, boxes her in, produces the choking effect of nightmare. The drawing maintains this effect: compare the free-flowing arabesque which defines the breasts of the girlish figure in the 1925 work, with the harsh, violent curve which performs the same function in Seated Woman. But the emotional impact of the painting is strongest in the face-the Gorgon-like profile stridently set off against the black shadow. This shadow is part of the face and accentuates the form of the profile, just as the unlit area of the moon belongs to and helps define the visible crescent. This ambivalence of form accounts for the demonic, nightmare quality of the work.

As in his *Three Dancers* of 1925 Picasso here reinterprets and gives a new meaning to already existing means of expression. The broad color areas, the overlapping lines and curves—all these can be found in earlier works. Picasso's greatness and uniqueness, however, show in the fact that he is never the prisoner of a particular idiom, and is always prepared to re-adapt an idiom to give form to new visions. From 1925 on, his works increasingly reflect an uneasiness, a feeling of anguish—a sort of anticipation of coming disasters, justified by later events. *Seated Woman* of 1927 is one of the most striking figures in this vein—a figure that conjures up a new, contemporary mythology.

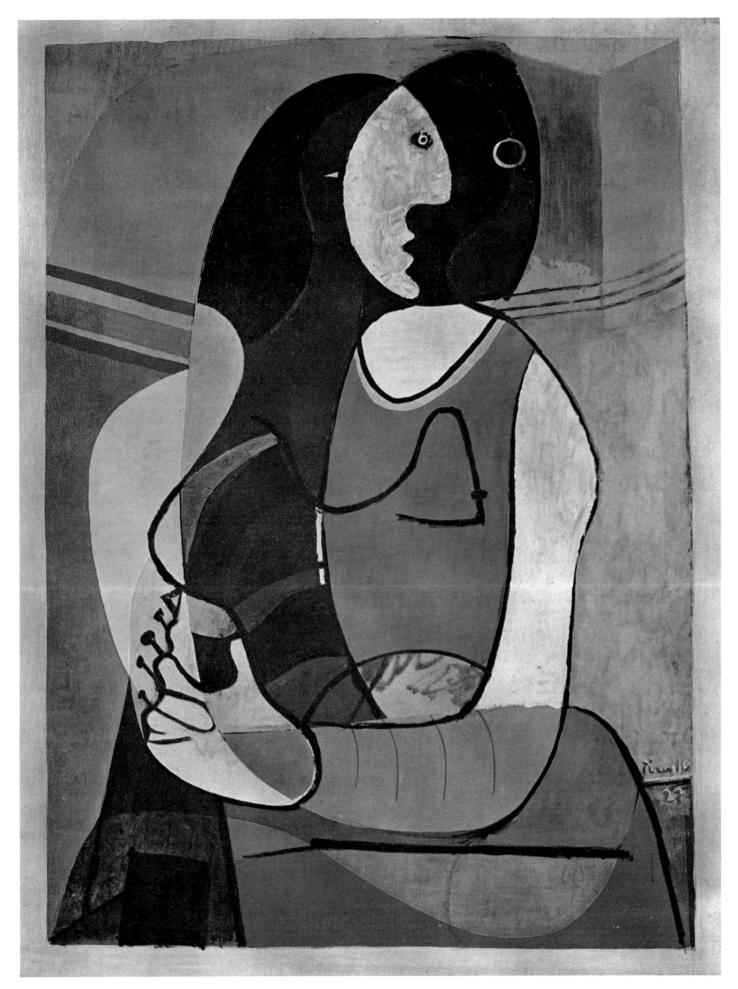

THE STUDIO

Oil on canvas, $59 \times 91''$

The Museum of Modern Art, New York (Gift of Walter P. Chrysler, Jr.)

The subject of this painting—the artist at work—began to preoccupy Picasso in 1926. In 1927 he included it in a group of etchings with tense, delicate lines that bring to mind Ingres' drawings; this etching, together with the near-abstract ink drawings of 1926 (figure 23), was among Picasso's illustrations for Balzac's *Le Chef-d'œuvre inconnu*, published in 1931.

In *The Studio* of 1928 the ideas present in all these earlier works are reduced to the simplest possible formula; simplification is carried still farther than it had been in the *Atelier of the Modiste* of 1926, the motif being conveyed by a few lapidary signs. At the left of the painting we see the artist standing in front of a canvas, brush in hand; at the right is a fruit bowl and a plaster head on a table with a red tablecloth. A vertical and horizontal form—probably a window and a mirror accentuate the back wall of the room; at the right is another vertical form, probably a door.

What strikes us first of all is that these objects have been translated into signs which have been completely integrated into the pictorial surface. The flatness of the painting is stressed by the light "frame" that surrounds the composition, thus continuing the pictorial surface beyond the actual composition, in the manner of a mural. *The Studio* also resembles a mural in that the forms are simplified and the colors reduced to a few strong tones—characteristic of a lapidary style. The work is not intended to be seen at close quarters but from a distance, as in a large hall or on a wall in a public square.

Such bareness and asceticism are exceptional in Picasso's works of this period, though there are many parallels in the paintings of Fernand Léger, Le Corbusier, and Ozenfant. At this time, these artists, too, were going in the direction of some more or less simplified mural painting. In the case of Picasso, this new spareness was paving the way for a new monumentality which, from 1929 on, was to take shape in projects for an actual monument. Contemporary with *The Studio* are other experiments with sign language, among them the wire sculptures (figure 26) which marked the return, after many years, of Picasso's interest in sculpture. All these departures are leading in the same direction: attempts to translate things into the terms of a kind of hieroglyphics, a concise system of magical signs.

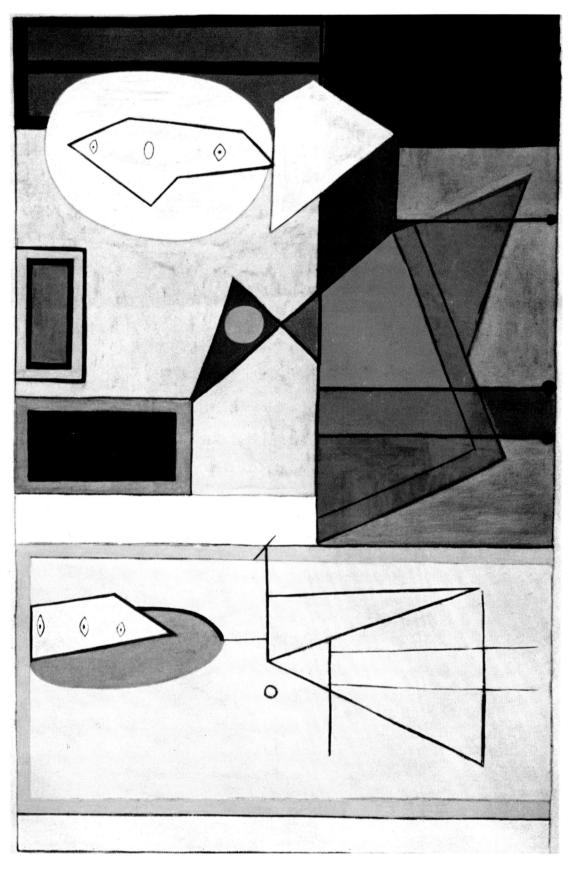

THE STUDIO

SEATED BATHER

Oil on canvas, $64^{1}/_{4} \times 51''$

The Museum of Modern Art, New York (Mrs. Simon Guggenheim Fund)

This work is an example of what has been called Picasso's "monster period." During these years Picasso was breaking away from the traditional conventions of human beauty, and explicitly creating an anti-image: man as monster, a dangerous, aggressive, destructive beast. In a few years Picasso's vision was to be given historical confirmation, but to his contemporaries the sense of these paintings was less apparent, and there are even today many who fail to grasp it.

The seated figure in this painting is one of these monsters. Though her forms are human, at the same time this woman is constructed like a machine of some substance both bony and cartilaginous. Her parts are jointed and hinged, they interlock and rotate around one another. As was to be shown only too clearly a few years later, this mechanized, machine-like quality is one of the attributes of human monsters who, once given the order to do so, murder, set fire, and destroy without compunction. Picasso's visionary gifts are obvious in these paintings and any viewer who looks at them today, remembering the recent past, must be amazed at how prophetically the artist stressed the aggressive features of the human organism, rendering it in terms of some demonic machine—the mouth that becomes a sawtoothed pair of tongs, the arm like a mechanical grapple.

Picamo hegan to demonine the human image in early at 1945, in *Three Dancers* (page 115). But in that painting the human figure is distorted in the spirit of a Dionysiac orgy, an ecstatic drunkenness. What achieved unexpected expression in this and related works was deep instinctual forces: it was these which led to the first distortions and deformations of the human figure. Even then contemporary history may have been supplying impetus for the irruption of demonic powers into the artist's order-creating world.

Picasso's monster period began around 1929, when the danger of the triumph of barbarism and organized inhumanity first began visibly to threaten Europe. In these anti-images, a spirit of Dionysiac exuberance no longer prevails. These are stiff, mechanically perfect zombies which, like machines, are constructed to serve some specific purpose—in this case, that of aggression, destruction. Kahnweiler called Picasso the most humane artist of our time: he has again and again proved his instinctive sensitivity to humanity's fate. In these works of the monster period, with their hard, bony forms and bald colors, he for the first time speaks distinctly as a visionary, hence as a moralist. The language of these works was not at first understood, the critics preferring rather to take refuge in esthetic speculation than to grasp what Picasso actually had to say.

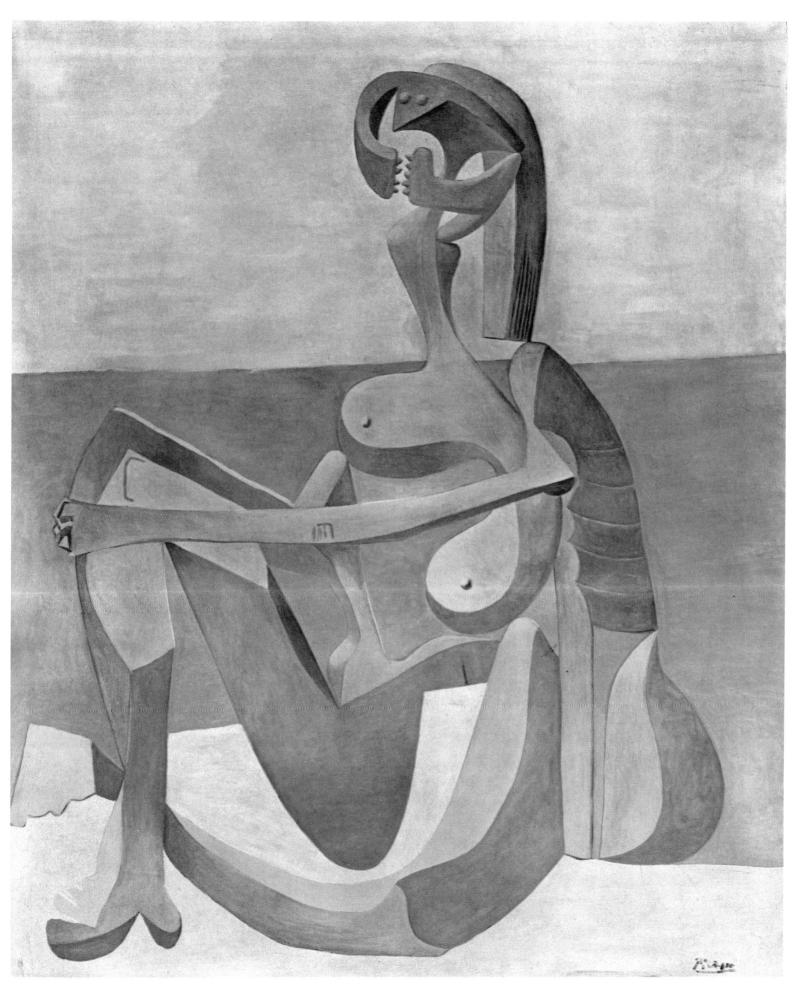

PITCHER AND BOWL OF FRUIT

Oil on canvas, $51^{1/2} \times 64''$ Private collection, New York

In 1930 Picasso acquired the little Château de Boisgeloup near Gisors, where he devoted himself to sculpture, a pursuit he had mostly neglected since the Cubist days. His need for three-dimensional, plastic form was encouraged and aided by a friend of many years standing, the Spanish sculptor Julio Gonzales. In the spacious rooms of Boisgeloup he at last could indulge this wish to his heart's content.

Sculptural themes had been turning up in Picasso's work for some years, but he had invariably solved the problems in terms of painting. Thus, in a series of sketches for a monument he imagined for the beachfront at Cannes, he transformed a colossal cube-like construction into a woman's head by adding a few accents: teeth and hair metamorphose geometry into figurative art.

In the first sculptures created at Boisgeloup this spirit of transformation produces ever new plastic forms: heads made of pieces of steel plate, radiating the same magical effects as the sketches for monuments in the preceding years. Not until later will Picasso make those peaceful sculptured heads which have so unmistakable an affinity with the paintings of 1932 and their model (page 127).

The tendency toward compact forms realized in the sculptures of 1931 is heralded in a few paintings done in late winter of 1931. These are a series of still lifes—usually showing just a few ordinary household objects, pitcher, fruit bowl, etc.—of which the work reproduced here is no doubt the strongest. The forms of the objects are captured in a few broad arc-shaped lines, reminiscent of the leading in medieval stained-glass windows. Within this network of lines the colors acquire a deep harmonious resonance, a very special luminosity.

To be sure, these works hark back to still lifes of the early 1920s in which arcshaped lines seem to have first appeared. But it is precisely the sculptural quality that makes the idiom here far more convincing: the formal unification gives the objects a solemn monumentality which anticipates paintings of the following years.

Characteristic of all Picasso's art is the way his different activities influence one another: sculpture influenced the large forms in these paintings, and other sculptures were in turn suggested by the paintings. Picasso's art is governed by the laws of organic growth; however often the technique may change, it is to him merely a means of giving his conceptions the most adequate possible embodiment.

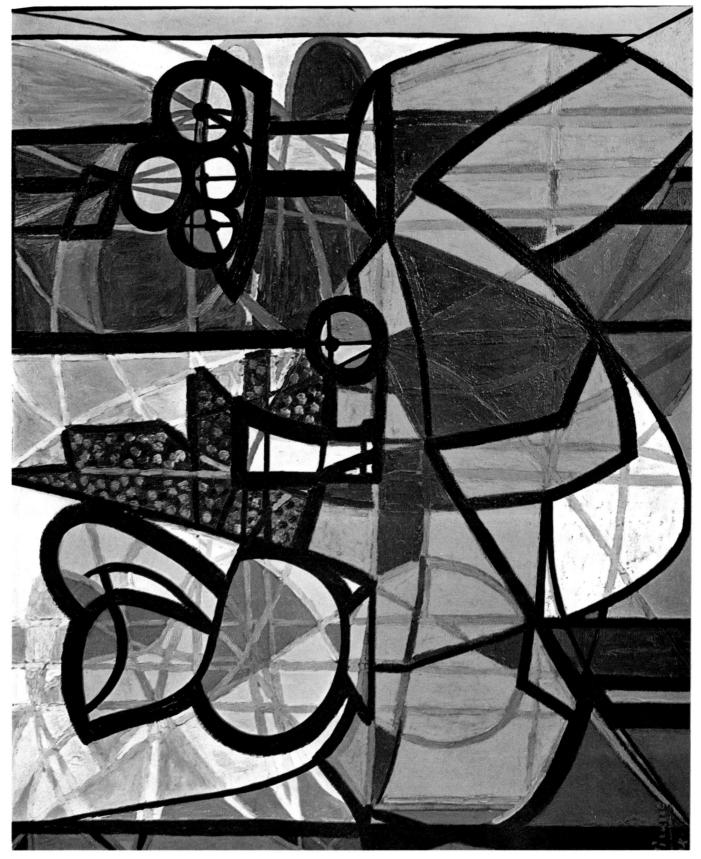

THE DREAM

Oil on canvas, 51 × 38¹/₂" Collection Mr. and Mrs. Victor W. Ganz, New York

In 1932 Picasso began a new series of paintings: a sequence of female figures, mostly nude but occasionally clothed, almost all of them shown quietly asleep. The model for these paintings was a young girl, Marie-Thérèse, who three years later was to become the mother of the artist's daughter, Maia. Thanks to his new model Picasso found new tranquillity, in marked contrast to the mood that inspired the monstrous figures of the preceding years. The charm of these works is the greater for the fact that a fresh, naive sensuality pervades them.

The Dream, showing the figure of a young woman asleep in a chair, was one of the earliest paintings in the series; it is also one of the finest and strongest, perhaps because here the full sensual charm, the erotic appeal of this budding young woman, is so candidly expressed. Fresh colors and long, lightly drawn curves invest this painting with the effortless magic that characterizes many of Picasso's earlier works, but which he had not been able to achieve since about 1925, troubled as he was by problems both personal and worldwide. The effortless ease of this cheerful painting is not merely a subjective impression. it is a verifiable fact: the inscription on the back of the frame runs, "painted Sunday afternoon, January 24, 1932." The carefree mood of the work is tied up with changes in Picasso's personal life. The artist who for years had been brooding over world problems, now creates one of his warmest, most joyous paintings.

For all the rapidity of the execution, this is a masterpiece of balanced composition, extremely rich in pictorial invention. Surprising above all is the combination of the profile of the face and the frontal view into a convincing whole: the two views of the face endow the painting with spatial fullness and with flowerlike serenity. It is also fascinating to see how Picasso changes the colors of the outlines that define the various segments of the peacefully slumbering body: blue around the neck, black at the shoulders, then red against a white area contrasting with blue against a greenish area at the forearm. Contributing to the carefree mood of the painting is the dancelike gaiety of the lozenge-patterned wallpaper.

Closely related to this series of paintings is a series of large modeled bronze heads. They are pervaded with a similar plantlike vitality, and characterized by the same warm plastic fullness. Picasso created them at the little château of Boisgeloup, where he devoted himself primarily to sculpture.

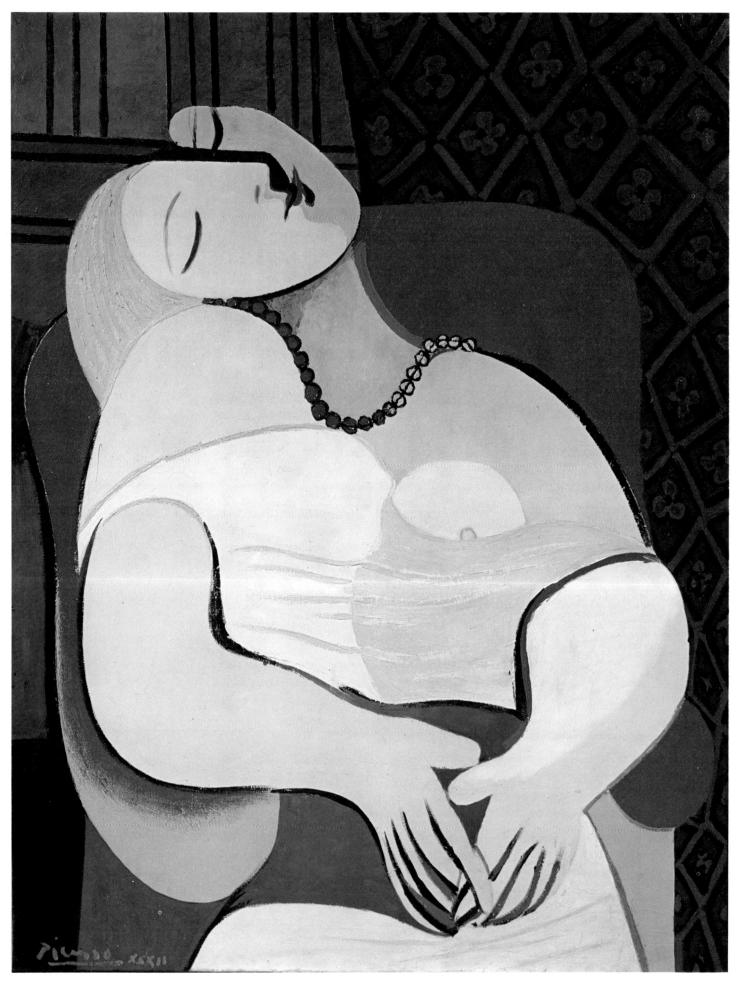

THE DREAM

BULLFIGHT

Oil on canvas, 38 × 51" Collection Mr. and Mrs. Victor W. Ganz, New York

In 1933 Picasso made a brief trip to Barcelona, and the following year he went back to Spain for a longer stay. Besides Barcelona, on this trip he also visited Madrid and Toledo. Impressions from these trips to Spain survive in a number of works on bullfight themes which he executed at Boisgeloup. In composition and color, the work shown here is perhaps the most striking of the series.

Picasso had been familiar with the bullfight from youth. As a subject, it turns up in his work as early as 1901, in a painting that almost impressionistically subordinates the dramatic action to the atmospheric sweep of the arena—half in blue shadow, the other half in glaring sunlight. Subsequently, the bullfight occurs again and again, either as main or subsidiary subject—for instance, in the sketch for the curtain of the ballet *Le Tricorne*, executed in London, 1919, as well as the 1927 etchings for Balzac's *Le Chef-d'œuvre inconnu*. However, in the work shown here the bullfight is treated quite differently. We see the beginning of a development which will reach its climax three years later in *Guernica* (figure 34).

In the history of Picasso's art this 1934 painting, and the paintings and drawings related to it, mark a first step toward the creation of a wholly personal mythology which he worked out for himself during the 1930s. As early as 1930 we find him treating a number of traditional mythological themes, most notably in the illus trations to Ovid's *Metamorphoses* (figure 70). A *Crucifixion* dating from the same year is further evidence of search for a thematic form capable of embodying dramatic ideas. In 1934, at the same time as such bullfight works as this one, Picasso produced etchings and lithographs for Aristophanes' *Lysistrata* (figure 72).

In the theme of the bullfight, since his trip to Spain and its renewal of childhood memories, Picasso saw a mythological symbol capable of embodying dramatic suffering, grief, and rage—capable of expressing, that is, the very feelings which were boiling in him in these years. Everything in the 1934 painting is focused on the dramatic clash between the black bull and the light-colored horse. The arena and the features of the spectators are only suggested, serve merely to frame the action. The drama of ferocious struggle has become the theme not only of this painting, but of the whole world of Picasso's imagination. These shrill contrasts of form and color evoke the manner he will employ in reacting to the events of the next few years: they anticipate the rage, the grief, the despair with which he will greet Fascism's ever more stultifying victory over the human spirit. With *Guernica*, in 1937, historical events will have caught up with such anticipations as this.

BULLFIGHT

YOUNG WOMAN DRAWING

Oil on canvas, $51^{1}/_{8} \times 76^{3}/_{4}''$ Musée National d'Art Moderne, Paris

In the early 1930s, along with sculptures and the series of sleeping nudes, Picasso was preoccupied with a new theme: a highly personal approach to mythological subjects. *Young Woman Drawing* falls into this very loose thematic category, within which Picasso developed a new and expressive style.

He had first treated mythological themes in 1930 when he illustrated Ovid's *Metamorphoses* with etchings done in a nervous, rhythmic linear style. That same year he painted a small *Crucifixion*: the style of this painting, with its dramatic distortions, points to a new Expressionist tendency in Picasso's art. By contrast, his illustrations for Aristophanes' *Lysistrata* are lithographs and etchings in the Neo-Classical linear style, whose witty elegance is so appropriate to the text.

His explorations into biblical history and classical mythology have in common an attempt to discover an emotionally charged symbolic language suitable for expressing contemporary events and the artist's own experiences. Given the extremely personal character of Picasso's vision, mythology too had to take on a personal form, and hence, to be more than mere convention.

Picasso's personal mythology has evolved through fusing themes drawn from mythology with more personal themes—especially the bullfight, which Picasso rediscovered during his trip to Spain in 1934. Thus he created the figure of the Minotaur to serve as symbol for the disaster hanging over Europe in the 1930s. Also into this category falls the series of drawings showing the sculptor in his studio, with overtones of classical mythology.

Young Woman Drawing belongs to the same group of themes. It originated in a number of paintings showing girls reading, writing, or drawing. Here too Picasso tends to endow even the subject chosen apparently at random with mythological significance.

The vehement colors, based on a harmony of green, violet, and blue, like the monumental treatment of the figures and the space, make this painting one of the major works of the 1930s. It is also the last important painting of the early 1930s. For personal reasons Picasso had no opportunity to paint after this; in 1935 he brought out his first efforts at writing poetry. However, he was jolted out of his depression by an event that soon concerned all of Europe, but first only his native land—the outbreak of the Spanish Civil War in the summer of 1936.

WEEPING WOMAN

Oil on canvas, $23^{1}/_{2} \times 19^{1}/_{4}$ " Collection Roland Penrose, London

Weeping Woman belongs to the same thematic group as Guernica (figure 34), that monumental work which Picasso painted in the spring of 1937 under the direct impact of news that a peaceful little Basque town had been bombed by Nazi planes coming to General Franco's assistance. There is a weeping woman in the very first preliminary sketch for Guernica—it is the figure ultimately at the left in the painting, holding her dead child in her arms. In the final version this figure has been somewhat changed, but the expression of heart-rending grief so fascinated the artist that, after completing the large composition, he picked out this very detail for separate treatment several times.

Guernica was the crowning point of Picasso's efforts to create a contemporary mythology. This enormous painting composed with such convincing sureness was executed in a very short time. In January 1937 the Spanish Republican government commissioned Picasso to paint a mural for its pavilion at the Paris World's Fair to be held that summer. Before Picasso had produced so much as a sketch, on April 28 the whole world learned of the bombing of Guernica by the Germans the first of those acts of senseless, inhuman, mass destruction that were, in the next few years, to demolish other cities in other countries. This event at once fired Picasso's imagination, and he poured out his bitterness and indignation in the first sketches for *Guernica*, dated May 1, in which the main lines of the composition are already clear. During work on the mural Picasso changed many details, but the painting has fully preserved the first and dramatic impulse of the initial emotion.

Picasso expressed his bitter, savage fury over this atrocious deed in an extremely rigorous composition. The mythical figures are linked with each other within a triangular form that brings to mind the pediment of a Greek temple. Apocalyptic events take place within this area—the scream of the mortally wounded horse, the fear of the woman in the burning house, the agony of the warrior with the broken sword, and, at the left, the weeping woman. The austere palette, confined to black, white, and a few shades of gray, accentuates the impression of paralyzing terror.

To this magnificent work, inspired by contemporary history yet far transcending any one occurrence, *Weeping Woman* is a "postscript," as Alfred H. Barr, Jr., has called it. And yet this detail, transformed into a self-sufficient composition, contains all the apocalyptic mood of *Guernica*. The handkerchief which the weeping woman is biting in her boundless grief is a later invention that adds to the hectic vehemence of the expression. In one respect the picture differs from *Guernica*—in the strident dissonance of the colors. They help to elevate the dramatic conflict to the timelessness of myth.

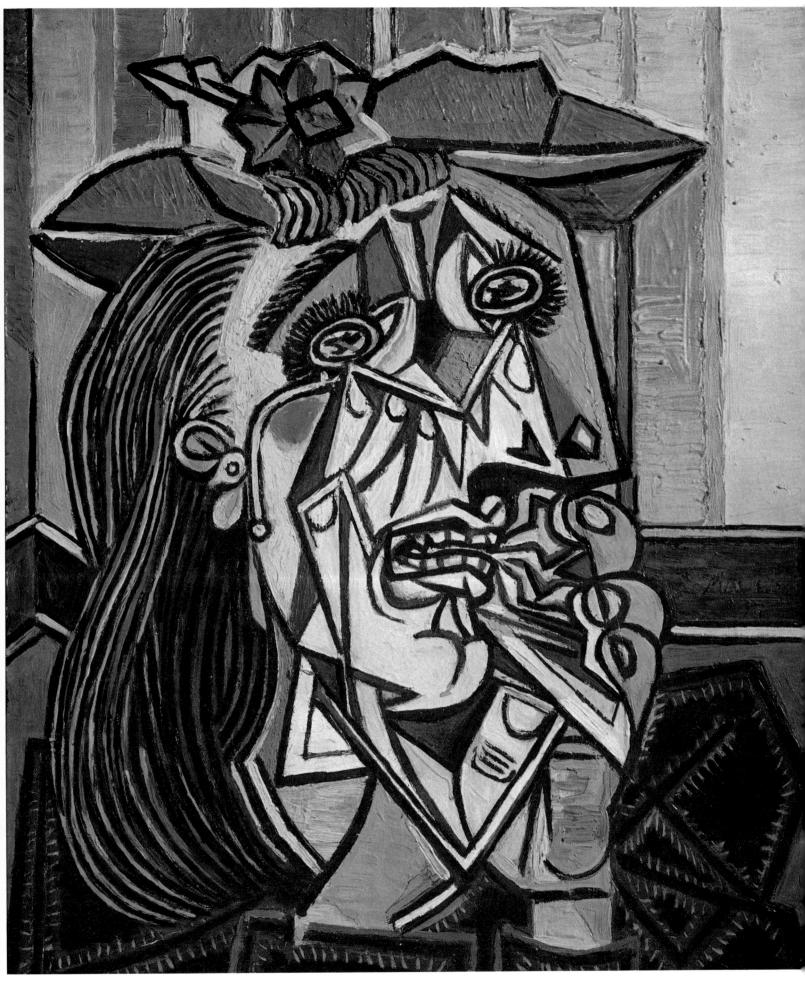

GIRL WITH COCK

Oil on canvas, $57^{1}/_{4} \times 47^{1}/_{2}$ " The Baltimore Museum of Art (Mrs. Meric Gallery Collection)

Even with paintings such as *Guernica* and *Weeping Woman* Picasso was unable to rid himself of rage at the inhumanity of the Spanish Civil War. His grief and anger, expressed above all in *Weeping Woman*, were not dispelled, but turned to disappointment and gloom when the downfall of the Spanish Republic became apparent.

In the course of 1938 he painted a number of works which give expression to his bitterness at the triumph of injustice; none, however, alludes directly to the events. That year Picasso went back to the themes of his monster period; he deforms and distorts the image of man in response to humanity's own selfdebasement through committing injustice or failing to intervene in the cause of justice. Picasso's paintings of 1938 portray this debased humanity.

This work shows a girl holding a rooster in her lap, which she is preparing to kill. It is perhaps the most terrifying of the 1938 paintings, not only because of the violent distortions of the human face and body, but because of the solemnity with which a kind of sacred rite is being performed. Once again Picasso—who rejects any symbolic interpretation of this work—shows himself the clearsighted interpreter of his time, and even of the future. In the years of terror that were approaching, it was precisely the seriousness, the conscientiousness with which the most loathsome atrocities were committed, that gave the deeds so especially sinister a character.

Thus *Girl with Cock* stands out among the works of 1938; it is more terrifying than the others, though most of them strike us in their harsh, merciless distortion. The portraits of the peasants of Mougins (where Picasso spent the summer), shown sucking lollipops, are pervaded with bitter irony and a demonic, self-tormenting anger (figure 35).

The impression of debased humanity, produced by the violent dismemberment and disrespectful piecing together of human forms, is strengthened by the shrill dissonance of the colors: the juxtaposition of pinks, greens, and blues has a provocative, bewildering effect. The sagacious observation of Meyer Schapiro, who discovered a similarity between the girl's head and Picasso's profile, may help us interpret this painting: Picasso identified himself—even though indirectly with the tragedy and crisis of his epoch.

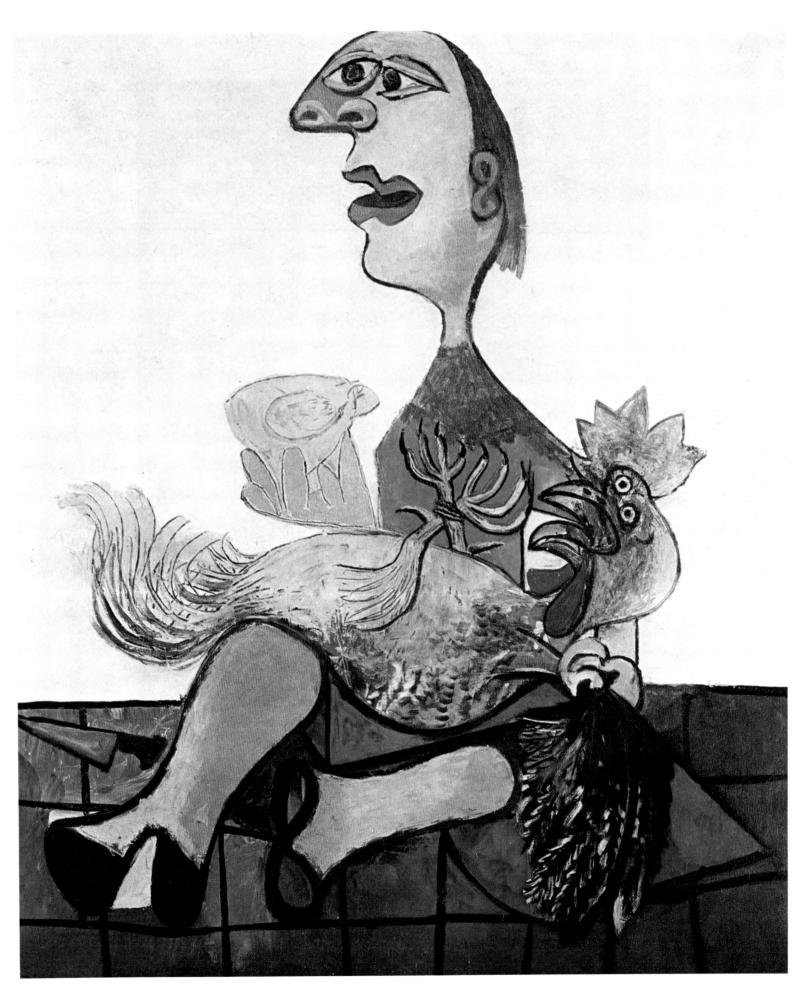

GIRL WITH COCK

WOMAN WITH FISH HAT

Oil on canvas, $39^{1/2} \times 32''$ Stedelijk Museum, Amsterdam

At the beginning of the war Picasso was urged to go to the United States or Mexico, but he refused, and early in the fall of 1939 he moved back to Paris from Royat (near Bordeaux), where he had been staying. He stayed in Paris until the liberation, working in the greatest seclusion. Curiously enough, the army of occupation left him alone, though he was forbidden to exhibit.

During the years that Picasso passed in a kind of voluntary imprisonment, he put all his energies into his work. He went back to sculpture, painted a number of large figural canvases and still lifes, and wrote a Surrealist play, *Le Désir attrapé par la queue (Desire Trapped by the Tail)*. It was staged in 1944, shortly before the liberation, at the home of Michel Leiris, for a small audience of friends.

The most characteristic works of the war years, besides the still lifes, are the numerous paintings of a woman seated in an armchair. Although the theme is treated with many variations, almost all these paintings show a woman seated in a narrow space, often identifiable as a corner of Picasso's studio in the Rue des Grands-Augustins. In all of them the woman is represented as a bust or half-h ugth figure, invariably with the hands showing.

The work reproduced here stands for a number of similar paintings. Some features are common to all of them: the figure always seems to be squeezed into her chair, as though imprisoned in an iron cage. In all of them the summarily treated body contrasts strikingly with the face which is painted in a new and original manner. To this last-named feature the paintings owe their gripping psychological effect, one of emotionally charged aggressiveness.

This particular work adds another feature to the series: Picasso transforms the woman's hat into a fish, adding knife and fork and lemon. This is a kind of grim humor which aptly characterizes the artist's mood during the war years. We may have here an allusion to the scarcity of food in occupied Paris.

In the same year Picasso demonstrated his amazing ability to change objects into the forms of a sculpture. In the *Bull's Head*, made of the handlebars and seat of a bicycle (figure 38), Picasso achieves the magical effect of the Negro masks which he had used for models as long before as 1907: the elements of form yield a meaning that is directly grasped by the viewer. During the war years Picasso rediscovered the magic power of his art.

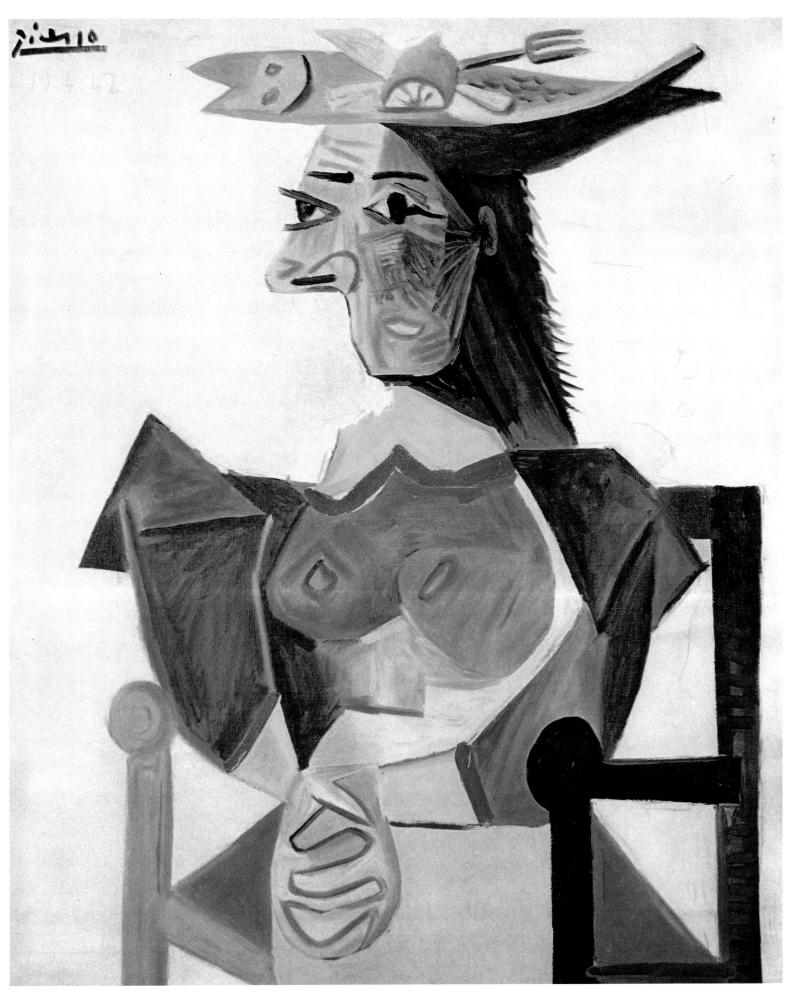

WOMAN WITH FISH HAT

STILL LIFE WITH PITCHER, CANDLE, AND ENAMEL POT

Oil on canvas, $32^{5}/_{8} \times 41^{3}/_{8}$ " Musée National d'Art Moderne, Paris

On August 25, 1944, the Free French Forces and the Allies entered Paris in triumph. To Picasso, as to many others, this day marked the end of a nightmare: the continual fear, the constant worry over the fate of countless friends, were gone. Typical of Picasso's concentration on his work and of the way his imagination invents pictorial forms for his experiences, is the painting he executed during the first feverish days of the liberation of Paris: a free copy of Poussin's *Bacchanal*, a work in which he found the spirit of those thrilling days (figures 39, 40).

In the fall of 1944 the French artists paid Picasso the tribute to which he was entitled for his irreproachable behavior during the years of oppression—unlike some French artists, Picasso never made any compromises with the occupying power. At the Salon d'Automne of 1944, held less than two months after the liberation of Paris, he was the guest of honor: seventy-four paintings and five sculptures were exhibited in a large room, to honor the master who had been hated by the Nazis and even more by the reactionary elements of the Vichy regime, but who had kept unswervingly to his course.

In those days he took a step that seemed to have nothing in common with his artistic interests: he joined the French Communist Party. In an interview published in *Lettres Françaises* for March 24, 1945, Picasso himself defined the artistic significance of his step: "What do you suppose an artist is? If a painter, an imbecile who has nothing but eyes, nothing but ears if he is a musician, a lyre at every level of his heart if he is a poet, nothing but muscles if he is a boxer? Quite the contrary, he is a political being, constantly aware of what is going on in the world, whether it be harrowing, bitter, or sweet, and he cannot help being shaped by it. How would it be possible not to take an interest in other people, to withdraw in some ivory tower so as not share existence with them? No, painting is not interior decoration. It is an instrument of war for offense and defense against the enemy."

From this time dates the powerful still life shown here, and the series of views of Paris. The paintings were executed in a vigorous, simple formal language; Picasso has rediscovered things in their modest form and dignity. But he also discovers new aspects of them, endows them with new significance. Thus the juxtaposition of three simple objects on a table—a pitcher, a candle, and a pot —becomes a monument to the quiet dignity of everyday things, a monument also to the creative power of the artist who endowed them with such striking form and the capacity for enduring existence.

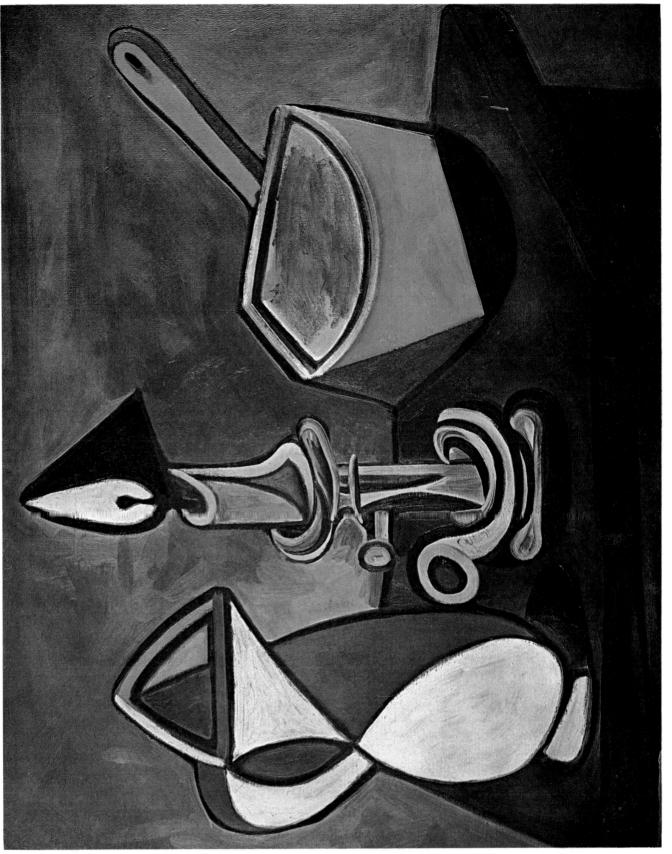

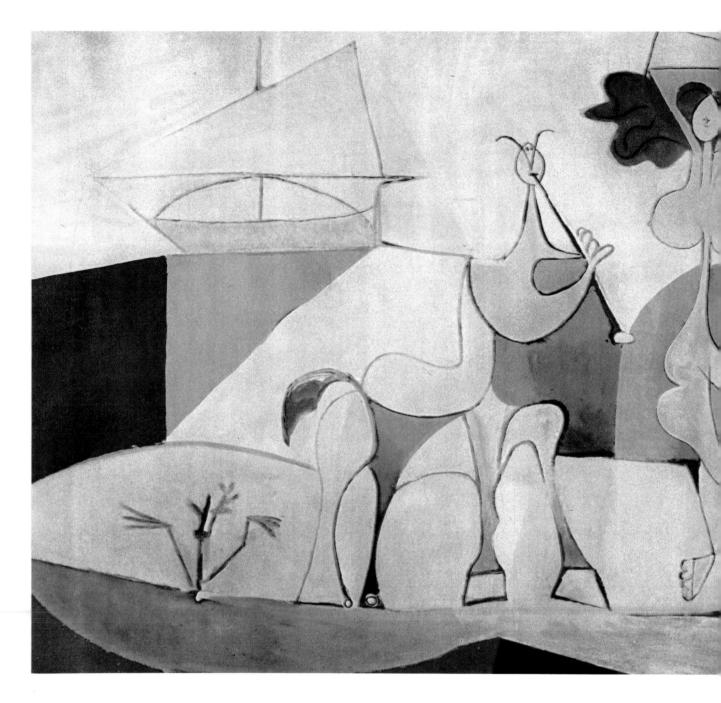

la joie de vivre

Oil on fibro-cement panel, $47^{1/4} \times 98^{1/2''}$ Musée Grimaldi, Antibes As he had done so often before the war, in the summer of 1946 Picasso went to the Mediterranean coast. There a development occurred which was to be very important for Picasso's work: he met the curator of the museum at Antibes who offered him his museum in exchange for one of his works. Picasso was so enchanted by the little museum in the old Grimaldi castle high above the old port, that he not only expressed himself ready to donate a work to the museum, but he also used one of the rooms as a workshop to create a number of paintings on large plaques of a fibrous material; these works have stayed in the museum. Thus the museum of Antibes has become a Picasso museum, where a group of paintings document the artist's creative joy in the years just after the Second World War.

Picasso's stay at Antibes was one of his happiest periods. Now, after the Second World War, joy at freedom regained seems to have inspired Picasso to a far greater extent. The environment too contributed to this: the Mediterranean sun, the ambiance of a gay culture thousands of years old, perhaps even memo-

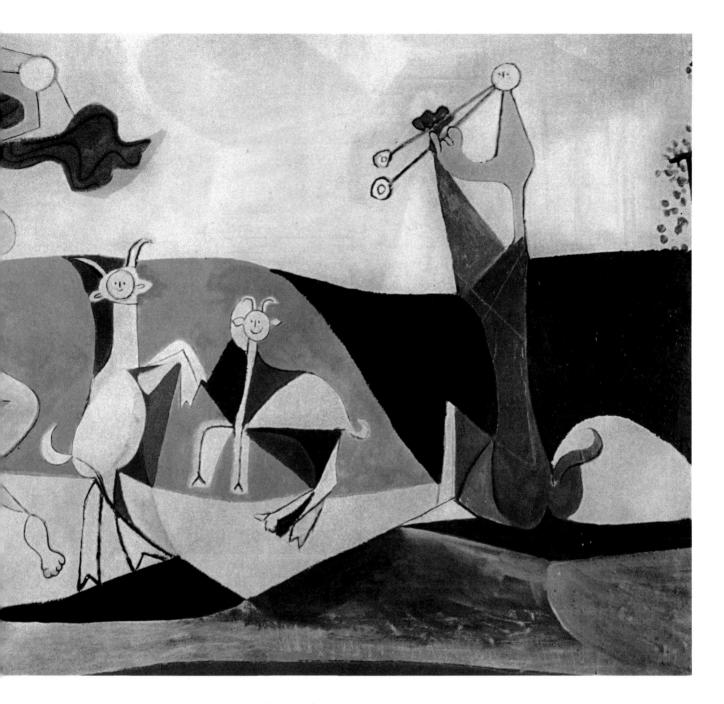

ries of happy childhood days on a similar beach.

La Joie de vivre, the painting shown here, magnificently combines personal and classical elements of mythology. The composition which, here too, seems defined by a pedimental triangle, brings to mind *Guernica*, but how enormous the difference in emotional content! At the center of the painting a female figure is leaping into the air, dancing uninhibitedly. At the left a centaur trots along, and at the right another centaur, seated, is playing the flute. Not far away two young goats are frolicking. The colors are luminous and applied in large bright areas. Both color and form produce the impression of winged, carefree relaxation. Moreover the panel is big enough to give Picasso's inventiveness and delight in color free rein. Thus came into being a world of mythological joy, at the center of which stands the cult of woman. Françoise Gilot, Picasso's new companion, inspired this natural, happy joy in living, which enchants us time and again in all the cheerful paintings of the Antibes period.

PORTRAIT OF A PAINTER (after El Greco)

Oil on canvas, $39^{3}|_{a} \times 31^{3}|_{a}''$ Collection Mlle. Angela Rosengart, Lucerne

The years that followed *La Joie de vivre* and similar large paintings at Antibes were filled with intense artistic creation falling outside but running parallel to work on pictures. Toward the end of 1945 Picasso had discovered a new medium for his creativeness: lithography. At Mourlot's workshop in Paris he produced a large number of lithographs, some of which treat a single formal problem—for example, the series in which the forms of a bull are reduced to their simplest elements (figure 80). Other lithographs, loosely connected with Picasso's paintings, record a wealth of ideas that belong to the domain of mythology, or still life, or the figure, or are simply improvised on the stone.

In 1946, while engaged in lithographic work, Picasso discovered another medium in which to express his rich imagination. During that summer he happened to visit the town of Vallauris, a ceramics center on the French Riviera. There he met the ceramist Georges Ramié and his wife. During a second visit, in the summer of 1947, he became enthusiastic about the potentialities offered by ceramics, and from that moment dates his passionate interest and many-sided work in the medium. He not only breathed new life into the ceramics industry of Vallauris, he also opened up new and unsuspected possibilities for the art. His first ceramic works were painted plates and bowls, on which he conjured up a brilliantly colorful world of fauns and similar mythical figures. In the course of time he grew bolder in his treatment of the material, and produced vases, sculptured pitchers, and covered dishes, which unexpectedly take on the form of human beings or animals. Many paintings of this period bring to mind his painted ceramics with their enamel-like colors.

Picasso stopped indulging his joy at discovering and playing with new mediums when he set himself a new problem: making a free copy of a masterpiece of the past. He had experimented with the idea earlier—at the moment of the liberation of Paris he was engaged in copying Poussin's *Bacchanal*. Now he took for models the *Portrait of a Painter* by El Greco (in the museum of Seville) and Courbet's *Girls on the Banks of the Seine* (figures 51, 52). Picasso's two paintings can scarcely be regarded as copies; they are, more properly, translations into a personal idiom, or variations in the musical sense. While following his model to a very great extent, Picasso has transformed it so thoroughly that the portrait by El Greco becomes a painting by Picasso. Picasso is as free toward art as toward nature—he takes it as a starting point and changes the forms in such a way that they give clear expression to his own experience of life, his own need for form.

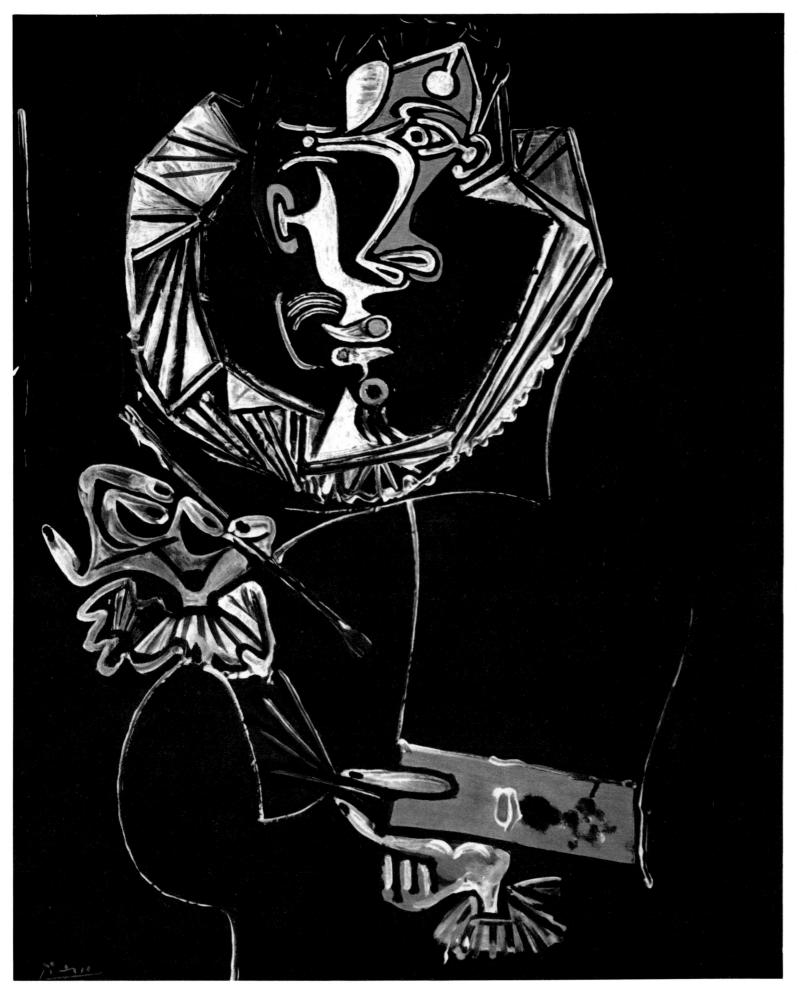

PORTRAIT OF A PAINTER (after El Greco)

PORTRAIT OF J.R. WITH ROSES

Oil on canvas, $39^3/_8 \times 31^7/_8$ " Collection the Artist

In 1953 Picasso went through a number of personal difficulties and disappointments. He had to separate from Françoise Gilot, his companion for many years and the mother of his two youngest children. He lost some of his closest friends— Henri Matisse, Picasso's opposite pole in early twentieth-century art, and Maurice Raynal, his biographer and a very old friend, both died that year.

During this troubled time he produced a sequence of drawings and lithographs which, often with bitter humor, treats the theme of the painter and his model. The confrontation between the figures is continually varied, and often the humor borders on caricature, but in these works woman is invariably at the center of the artist's pictorial and psychological interest.

In addition to these drawings and lithographs, which are playful only in appearance and often tragic in underlying mood, in the spring of 1954 Picasso produced a sequence of portraits of a young woman, Sylvette D. Here, too, a type of feminine beauty is a theme for Picasso's constant variations over a series of twelve paintings. Because of the rapidity of his technique Picasso in these same years was led to make cycles of pictures on a given theme. Unable to exhaust his imagination and his theme in a single painting, he would do a whole series of paintings, each showing a different aspect of his theme. Picasso's "series" have been likened to Claude Monet's landscape series and his successive treatments of Kouen cathedral-but the comparison is a bit unfair, for Monet painted these variations for a primarily optical purpose, to show the same object in different lights. In Picasso's paintings, the artist's attitude toward the object constantly changes the essential character of one work from the other. This is why the range of his series is so great: looking at the various pictures, even the non-artist is able to experience the creative process by which Picasso saw his model in ever-changing ways, and thus "defined" it in different versions of the same portrait.

Picasso's new interest reached a climactic point in two portraits, both dated 1954, of a young woman whose clear beauty and classical bearing was from then on to hold Picasso spellbound to an ever greater extent. This was Jacqueline Roque, who became Picasso's wife on March 2, 1961. In one of the portraits she is shown sitting on the floor, her hands on her knees; the work reproduced here, which was painted one day earlier, shows her classical profile clearly outlined against a simple blue background, on which fragrant roses are suggested in light colors. In this work Picasso's art of the portrait achieves a special peak, for the conquests of the earlier portraits are supplemented here by classical mastery in technique, and a warm human tenderness.

146

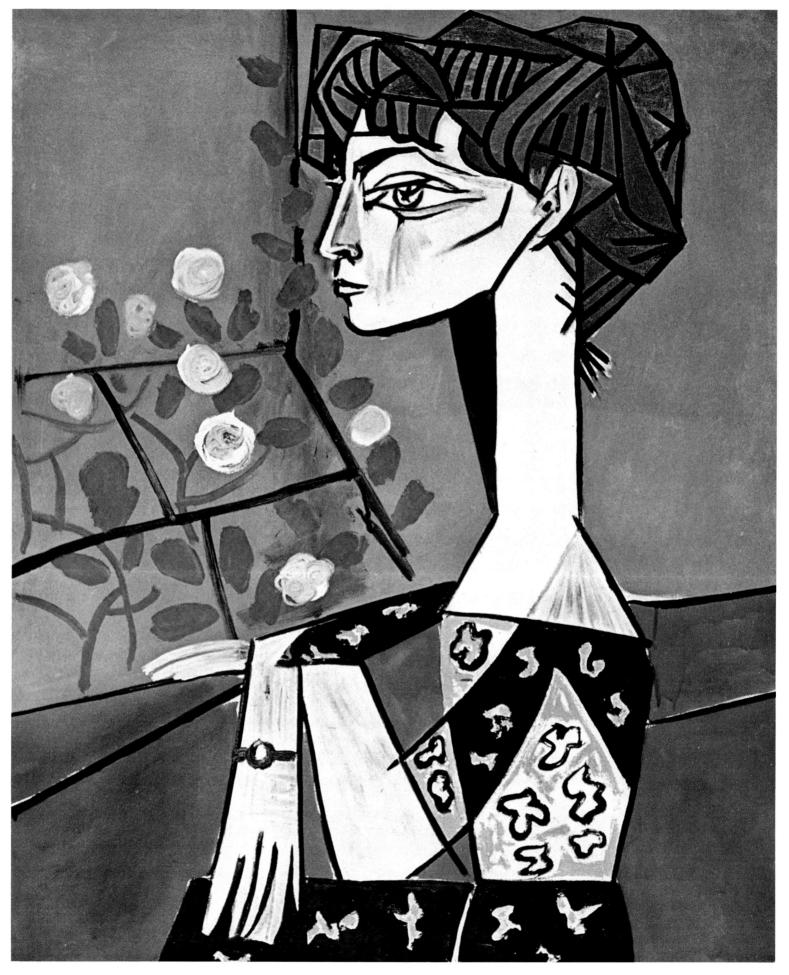

WOMEN OF ALGIERS February 14, 1955 (after Delacroix)

Oil on canvas, $44^{7}/_{8} \times 57^{1}/_{2}$ " Collection the Artist

Picasso's new procedure, which is best designated by the term "variations," led, in the summer of 1955, to a cycle of at least fifteen paintings based on Delacroix' *Femmes d'Alger*. Picasso had produced variations on old masters before, but he had hitherto painted only one version of these works, for instance, his *Portrait of a Painter* after El Greco, and his copy of Courbet's Girls on the Banks of the Seine. The idea of these variations goes back to Delacroix, and perhaps to an even greater extent to Vincent van Gogh, who wrote his brother Theo as follows:

I am going to try to tell you what I am seeking in it and why it seems good to me to copy them. We painters are always asked to compose ourselves and be nothing but composers.

So be it—but it isn't like that in music—and if some person or other plays Beethoven, he adds his personal interpretation—in music and more especially in singing the interpretation of a composer is something, and it is not a hard and fast rule that only the composer should play his own composition. . . .

I let the black and white by Delacroix or Millet or something made after their work pose for me as a subject.

And then I improvise color on it, not, you understand, altogether myself, but searching for memories of their pictures—but the memory, "the vague consonance of colors which are at least right in feeling"—that is my own interpretation.

Many people do not copy, many others do. I started on it accidentally, and I find that it teaches me things, and above all it sometimes give me consolation. And then my brush goes between my fingers as a bow would on the violin, and absolutely for my own pleasure.*

It was in this spirit that Picasso copied the Delacroix work. However, he did not content himself with a single version, but rendered his recollection of the work, his personal "Interpretation," in a number of variations. The cycle thus created shows Picasso's extraordinary versatility, whether he is treating a natural object or a work of art. As the work proceeded, Picasso became more and more interested in the abstract construction of the painting—its skeleton, as it were—and he sought to make out this inner structure beneath the surface. But in the last version—the one shown here—he combines the bone structure and the skin of Delacroix' masterpiece so that they form a single work: the seated figure at the left and the sensually reclining figure at the right complement each other like two sides of the same coin, endowing the painting with full, deep resonance strengthened by the sumptuous colors.

It would be erroneous to look upon this last version as the "definitive" one. Picasso has given us his interpretation of Delacroix' work in fifteen paintings which are interrelated, and what characterizes Picasso's manner of seeing and creating is his many-sidedness, his rejection of a definitive solution. This cyclic mode of work now takes on more and more importance in his art: he comes to grips with his themes, but he never exhausts them.

* The Complete Letters of Vincent van Gogh (Greenwich, Conn., 1958), vol. III, p. 216, letter 607.

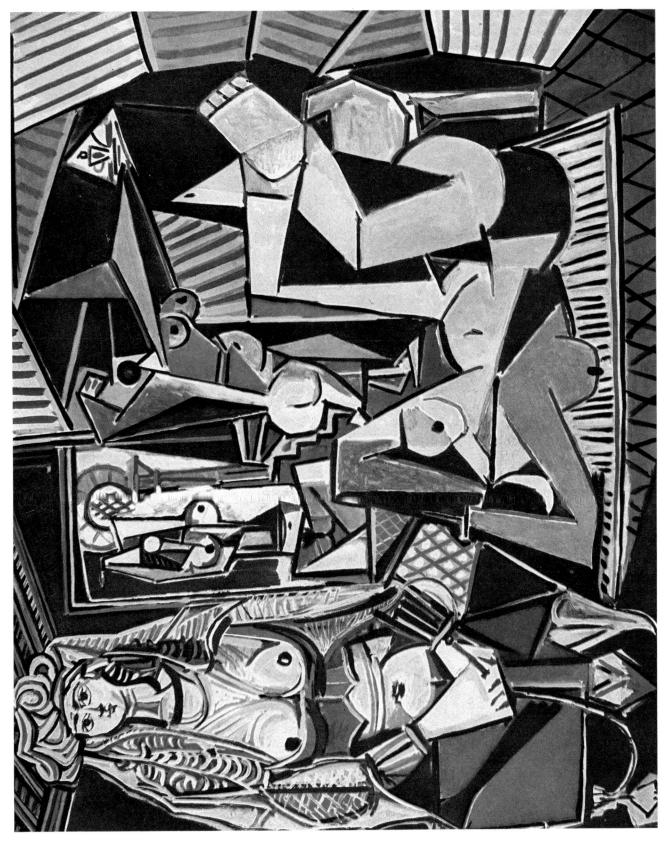

WOMEN OF ALGIERS February 14, 1955 (after Delacroix)

THE STUDIO

Oil on canvas, 35 × 43³/₄" Collection Mr. and Mrs. Victor W. Ganz, New York

In the summer of 1955 a comprehensive exhibition of Picasso's work was held in Paris at the Musée des Arts Décoratifs and the Bibliothèque Nationale. Here the viewer was enabled to obtain some over-all idea of the master's gigantic body of work, and his extraordinary versatility and productivity. And yet this double exhibition was confined to paintings (at the Musée des Arts Décoratifs) and graphic works (in the Bibliothèque Nationale). No sculptures, ceramics, or drawings were represented.

This exhibition in 1955 disclosed to what an extent Picasso's different mediums influence one another, and how his different styles and themes continually interpenetrate. In reference to Picasso's work one cannot speak of development, but only of continual transformations. The term "variations" actually applies not only to the cycles of pictures—such as the portraits of Sylvette, or the copies after Delacroix—it can also be applied to Picasso's work as a whole. His total production forms one great cycle in which a few themes are treated over and over again, each time in a new way. It is likewise impossible to speak of a "definitive" presentation of any theme: this is what makes Picasso a contemporary artist. He realizes that in our time the definitive solution is an improbable exception to the rule, and instead he offers us the whole richness of his invention, the overabundance of his ideas. Sabartés, his lifelong friend and faithful secretary, recorded this saying of Picasso's: 10 finish a thing 13 to kill it, to deprive it of its life and soul." Picasso's art 15 always in flux, because he values life more highly than perfection.

And yet those who pore over the body of his work, with all its versatility and imaginativeness, are forever being surprised by its constancy; Picasso repeatedly goes back to earlier works, and repeatedly attacks the same problems. Thus, in 1956, the theme of the studio turns up again—the occasion for it was no doubt the new studio he found in his villa La Californie at Cannes.

Once again we are confronted with a cycle of paintings. The starting point is the actual studio, a room with an unusually high ceiling, filled with objects of all kinds. In a series of paintings Picasso varies the original sketch: now he stresses, by means of colors, the clear spaciousness of the room; and now, as in the work shown here, his eye plays with the decorations of the room and the things in it, endowing them with a Moorish-Spanish character. But in this painting, so lively, so musical, one important detail strikes us—the white canvas at the center. For Picasso, work remains the central preoccupation! Even though these paintings bring to mind earlier paintings of interiors, they clearly point to the future: this series of "Studios" is followed by the series of *The Maids of Honor* after Velázquez, which once again treats the problem of the artist in his studio.

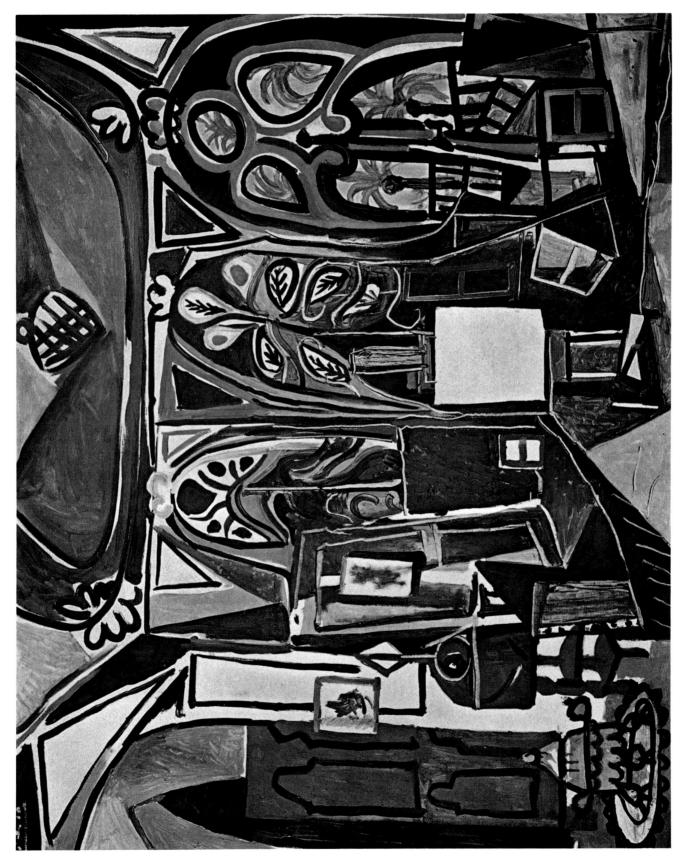

THE STUDIO

LAS MENINAS (THE MAIDS OF HONOR) October 2, 1957 (after Velázquez)

Oil on canvas, $63^{3}/_{8} \times 50^{3}/_{4}$ " Collection the Artist

In 1954 Picasso moved to the villa La Californie at Cannes. There he created his second cycle of paintings after an old master (the first being the series after Delacroix' *Women of Algiers*)—the variations on Velázquez' *The Maids of Honor*.

As a fourteen-year-old boy Picasso had admired this work by his great fellow countryman of the seventeenth century. He admired it again during his visit to Spain in 1934, and the painting must have become even dearer to him when the Spanish Republican government named him director of The Prado after the outbreak of the Civil War.

In addition to the painting's Spanish character, Picasso may have been particularly fascinated by the fact that it treats—in a brilliant, mysterious way—a problem that had often preoccupied him: the painter and his model. Velázquez presents the theme in a very peculiar form: the painter portrays himself painting the Spanish royal couple—this in a mirror on the back wall—while the Infanta and her maids of honor come up to the artist to look at his portrait of the royal pair. Reality and sham-reality are interlocked in Velázquez' masterpiece—and this must have held a very special attraction for Picasso.

He devoted to this work a cycle of about twenty variations, repeating this play with reality in his own free, personal way. As is the case with *Women of Algiers*, Picasso displays equal freedom of treatment whether he deals with natural objects or works of art. In the catalogue to the first exhibition of *The Maids of Honor*, Michel Leiris observes that Picasso "makes himself at home" in Velázquez' painting, that he himself moves into the royal palace and fills it with his own furniture. But this is not all: Picasso must have felt at home in this painting, for in his *Maids of Honor* there are only paintings by Picasso. Linked to the painting by an elective affinity, he enriches it by his interpretation, and translates Velázquez' pictorial idea into the language of our own century. Picasso not only renews himself, but also renews time and again the entire artistic heritage of modern man.

At the same time as his cycle of *The Maids of Honor*, Picasso produced another cycle—the series of views from his window with a swarm of pigeons. The paintings after Velázquez may owe some of their own radiantly bright color to these views. Nature and art once again grow together to form a unity, a fuller reality.

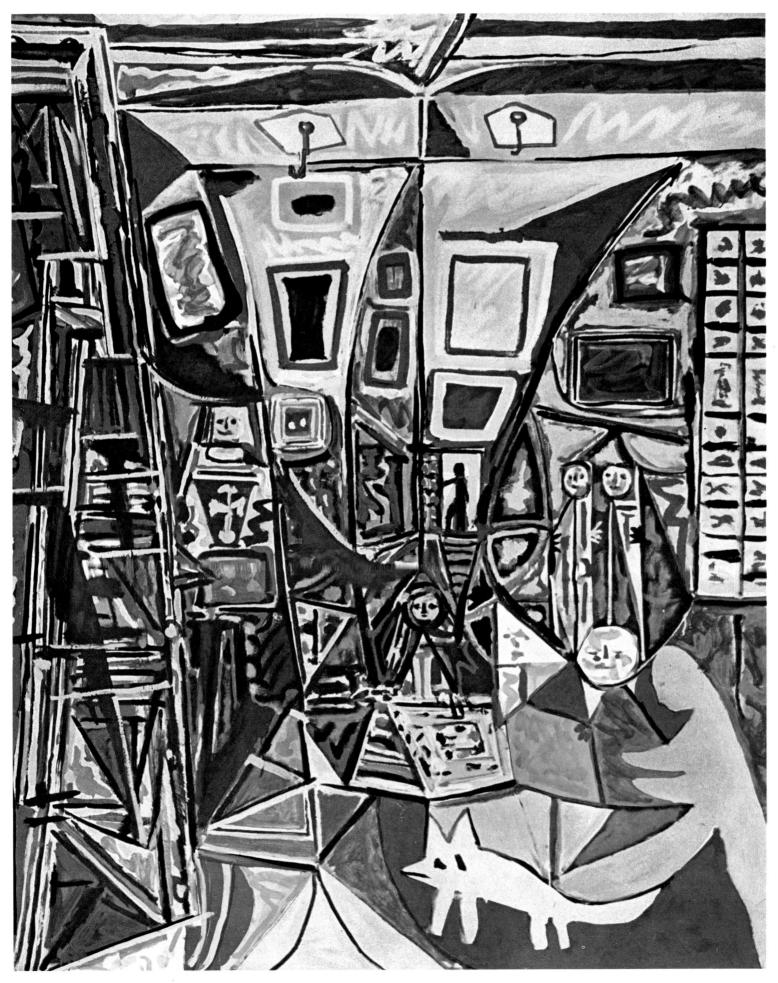

LAS MENINAS (THE MAIDS OF HONOR) October 2, 1957 (after Velázquez)

STILL LIFE

Oil on canvas, $35^{1}/_{8} \times 45^{3}/_{4}''$ Galerie Louise Leiris, Paris

After the series *The Maids of Honor* Picasso executed a monumental work that presented him with entirely new problems—the mural for the new UNESCO building in Paris. This painting is a continuation of the mythological themes which he treated after the Second World War, primarily in his large paintings. What is new in this mural is above all the technical execution. It was impossible to paint it on the spot where it was to be placed. Therefore Picasso resolved to paint the gigantic work in his studio at Vallauris, on a number of panels which were to be joined later in the building itself. He brilliantly solved this extremely difficult problem; the mural is set in the wall in such a way that the motion of the viewer approaching the painting brings him into the composition as an active and dramatic element.

After completing this work, Picasso found a new studio. He had become tired of the noise and bustle of Cannes where he had worked in his villa La Californie, and was searching for greater peace and quiet in order to concentrate on his work. These he found in the Château de Vauvenargues, situated on the slopes of Mont Sainte-Victoire near Aix-en-Provence; he purchased it in 1958, and soon set it up as his studio. He moved his paintings and sculptures there, and these contribute to the atmosphere of timelessness which is evoked by the simultaneous presence of Picasso's works from over the years, and prevails in all the master's studios.

At Vauvenargues, however, he also created a new type of painting, of which this still life is a good example. Simple forms and harmonious colors characterize these paintings; in the contrast between the bulging wicker-encased bottle and the slender forms of the other bottle, Picasso finds the tension on which this painting is based. The simple background of exactly balanced yellow, red, and green areas raises the contrast between the two forms to monumental proportions.

In his biography of Picasso, Penrose refers to the paintings executed at Vauvenargues as those of his "Spanish" period. The fact is that in these years Picasso's ties with his homeland have recently grown closer: many visitors from Spain have told him how popular his art is in his native land, where he has not set foot since the 1930s. Thanks to these visitors, the Spanish side of Picasso's character has been reawakened. He has published three poems in Spanish, and his painting is once again characterized by austerity—a quality inspired both by the situation in his homeland and by the austerity of the Vauvenargues landscape. The *Still Life* of 1959, with its simple harmony and noble restraint in form and color, adds a naw Spanish accent to Picasso's work.

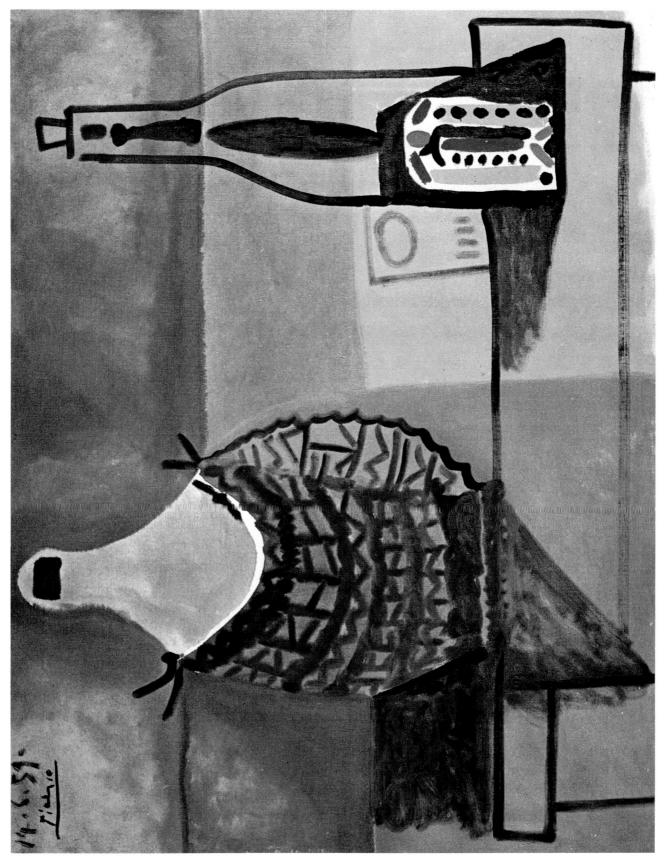

STILL LIFE

LE DEJEUNER SUR L'HERBE (LUNCHEON ON THE GRASS) July 10, 1961 (after Manet)

Oil on canvas, $44^{1/2} \times 57^{1/8''}$ Collection the Artist

This series of variations on Manet's famous work adds new riches to those we find in Picasso's two earlier cycles (after Delacroix and Velázquez). For more than two years, from August, 1959, to September, 1961, he worked on this cycle, which consists of twenty-seven paintings and many drawings. Once again he has found an opportunity to take up a number of his favorite themes.

Manet's composition, showing two nudes with two clothed men in a landscape, is itself a kind of variation. Almost exactly 100 years before Picasso treated this theme, Manet, building on a theme taken from an engraving by Marcantonio Raimondi, attempted to translate Giorgione's *Concert champêtre* (in The Louvre) into a contemporary idiom. The Arcadian figures in the work of the great Venetian painter were transformed by Manet into Parisians of his own day, and Arcadia itself took on a new, contemporary form just outside the gates of Paris.

Picasso's variations are of an entirely different kind: he takes Manet's composition as a sort of springboard for his own imagination, which carries him into new, as yet unsuspected directions.

In the course of this work we find Picasso often straying far from his starting point, then coming back to it again, and inventing ever new variations on the theme. To Picasso, Manet's painting—like anything in art or nature—is a theme.

In the painting reproduced here (it is the last of one series of variations) Picasso retransforms the model into an Arcadian scene: instead of juxtaposing nude and clothed figures, we have here an idyl with four nude figures, shown near a pond in the subdued green light of the foliage. This brings to mind the themes of the Bather, and Figures on the Beach, which turn up so often in Picasso's works. But, via Manet, a new background has been added to these themes—the dimension of mythology—and the link with nineteenth-century painting has deepened the relationship between the figures, endowing them with greater tension and thus bringing them closer to the spirit of our own days.

Picasso has repeatedly felt tempted to match himself against the old masters. He is conscious of his equality with them, and this feeling gives him the freedom to make whatever use of the old masterpieces he cares to. These paintings show his magnificent ability to transform things and forms alike into new signs, which disclose a new meaning, and in which the image of our time is recorded for posterity.

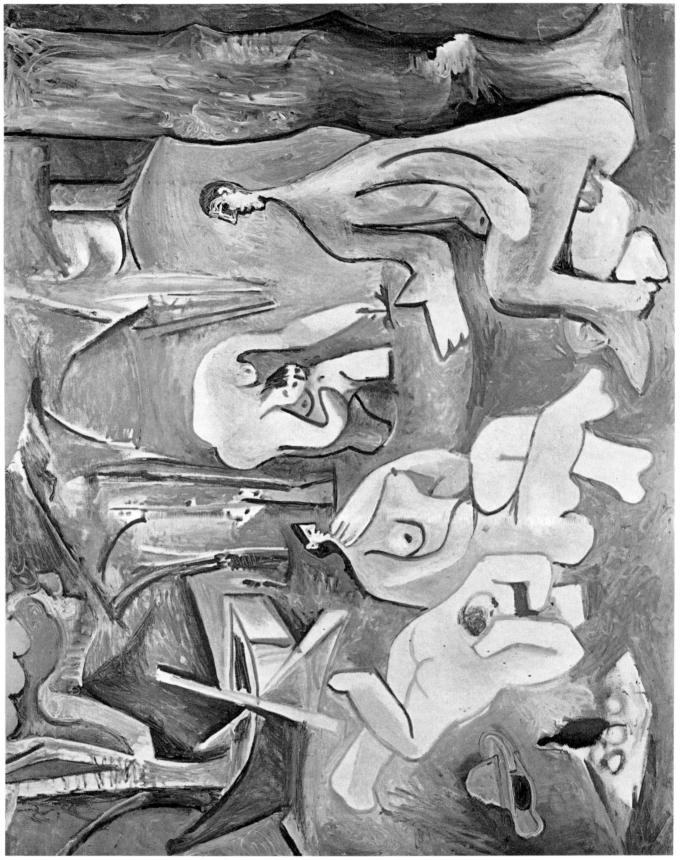

WOMAN WITH DOG

Oil on canvas, $63 \times 51^{1/4}$ " Formerly Galerie Louise Leiris, Paris

Early in 1964, an exhibition was held in Paris of Picasso's works produced over the previous two years—that is, since his eightieth birthday. Visitors to this exhibition were amazed by Picasso's productivity, by the range and freshness of his talent. Incredibly, without regard for his own past, the artist was still drawing upon apparently inexhaustible sources within himself, still renewing and rejuvenating his art. Most astonishing of all was the remarkable youthfulness of this octogenarian's current production.

Three themes dominated among these most recent of Picasso's works to have been given public exhibition. There was a mythological theme—the Rape of the Sabines; a theme suggesting the artist's own credo—the Painter and His Model; and a purely personal theme—a series of portraits of his wife, showing her with his huge dog or peacefully seated in an armchair, which record the peace and quiet of settled domesticity.

The three themes seem but loosely connected, brought together as though by accident. Closer scrutiny of the order in which they were executed, however, suggests a different view, and leads to an interpretation that may cast light on the connection between Picasso's creations and the general course of events.

Thanks to the fact that the artist has dated each work, we are in a position to relate the different themes to contemporary historical developments. Thus, the works depicting the Rape of the Sabines were executed during and shortly after the Cuban crisis, and the portraits of the artist's wife with the dog were done Immediately alterwards. The third series, on the subject of the Painter and His Model, does not begin until some time later, early in 1963, and continues through the summer of that year. Thus the works of the fall of 1962—all treating the subject of the artist's wife seated, with or without the dog—seem to testify to a return of peace, to symbolize a domestic happiness that has just survived the threat of catastrophe. And they are painted in that spirit—rich and magnificent, in full, sonorous colors.

After this series Picasso turned to a new subject: the Painter and His Model—a subject all the more surprising for the well-known fact that Picasso almost never paints from the model. These works formulate the problem of artistic creation (including his own): the contact between artist and object takes on ever new forms. Picasso has recently written: "Painting is stronger than I am—it makes me do what it wants." The works since then show in what sense this is meant. So strong a personality as Picasso's has produced some of the greatest art of our time, precisely because he does not rigidly impose a style on his models, but lets himself change with events, because he places the truth of feeling above the correctness of form.

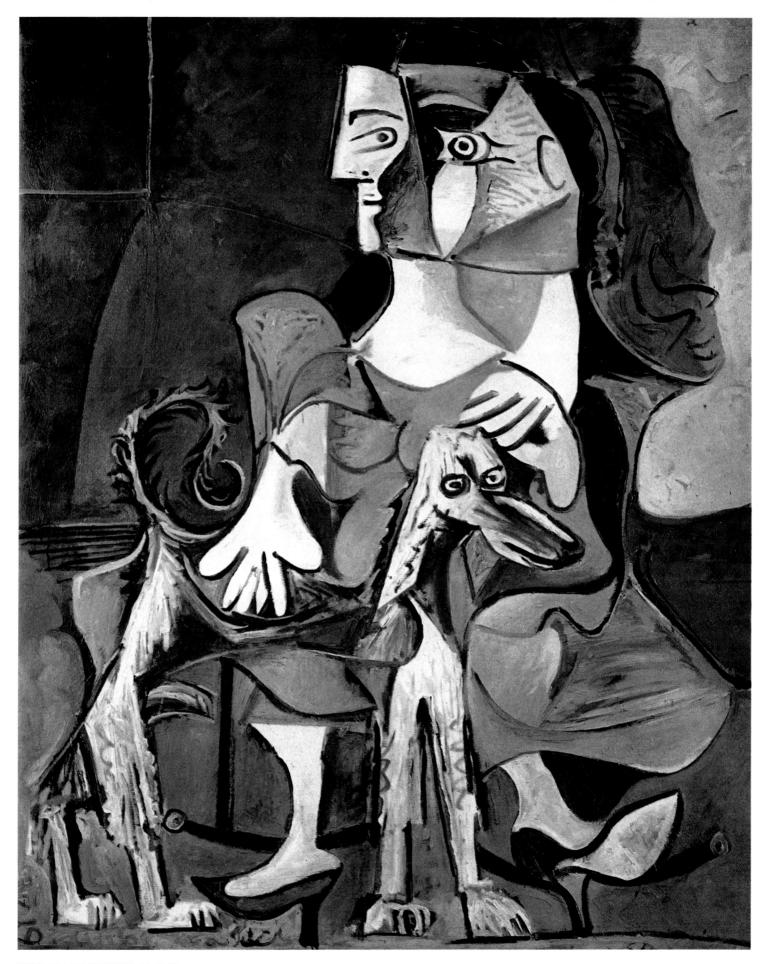

WOMAN WITH DOG

SELECTED BIBLIOGRAPHY

GENERAL WORKS

APOLLINAIRE, GUILLAUME. The Cubist Painters. Tr. by L. Abel. Wittenborn, New York, 1944 (French edition, 1913)

ARNAR, JOSÉ CAMÓN. Picasso y el cubismo. Madrid, 1956

BARR, ALFRED H., JR. Picasso: Fifty Years of His Art. The Museum of Modern Art, New York, 1946

BOECK, WILHELM, and SABARTÉS, JAIME. Picasso. Abrams, New York, Thames and Hudson, London, 1957

Cahiers d'art (ed. Christian Zervos). Paris, 1927—(contains numerous important articles on Picasso)

CASSOU, JEAN. Picasso. Tr. by M. Chamot. Hyperion, New York, 1940

DANGERS, ROBERT. Pablo Picasso, Darstellung und Deutung. Munich, 1958 ELUARD, PAUL. A Pablo Picasso. Trois Collines, Geneva-Paris, 1944 (also London, 1948)

ELGAR, FRANK, and MAILLARD, ROBERT. *Picasso*. Tr. by F. Scarfe. Praeger, New York, Thames and Hudson, London, 1956

KAHNWEILER, DANIEL-HENRY. The Rise of Cubism. Tr. by H. Aronson. Wittenborn, Schultz, New York, 1949 (German edition, 1920)

MERLI, JOAN. Picasso, el artista γ la obra de nuestro tiempo. Buenos Aires, 1942

PENROSE, ROLAND. Homage to Picasso on his 70th Birthday. Lund, Humphries, London, 1951

_____. Picasso: His Life and Work. Gollancz, London, 1958

RAYNAL, MAURICE. Picasso. Tr. by J. Emmons. Skira, Geneva, 1953

ROSENBLUM, ROBERT. Cubism and Twentieth Century Art. Abrams, New York, Thames and Hudson, London, 1960

SABARTÉS, JAIME. Picasso, documents iconographiques. Cailler, Geneva, 1954 STEIN, GERTRUDE. Picasso. Batsford, London, 1938

UHDE, WILHELM. Picasso and the French Tradition. Tr. by F. M. Loving. Weyhe, New York, 1925

VALLENTIN, ANTONINA. Pablo Picasso. Michel, Paris, 1957

Verve: Review of literature and the arts (ed. E. Tériade). Vol. V, nos. 19 and 20; vol. VII, nos. 25 and 26; vol. VIII, nos. 29 and 30

STYLISTIC PERIODS

BLUNT, ANTHONY, and POOL, PHOEBE. Picasso, the Formative Years. Studio, London, 1962

CIRICI-PELLICER, A. Picasso avant Picasso. Tr. by M. de Floris and V. Gasol. Cailler, Geneva, 1950

COCTEAU, JEAN. Picasso. Stock, Paris, 1923

D'ORS, EUGENIO. Pablo Picasso. Zwemmer, London, 1930

JANIS, HARRIET, and JANIS, SIDNEY. Picasso: the Recent Years, 1939-46. Doubleday, New York, 1946

LEVEL, ANDRÉ. Picasso. Crès, Paris, 1928

LIEBERMAN, WILLIAM S. Pablo Picasso: Blue and Rose Periods. Abrams, New York, 1954

RAYNAL, MAURICE. Picasso. Crès, Paris, 1922

REVERDY, DIERRE. Pablo Picasso. Nouvelle Revue Française, Paris, 1924

WITNESS ACCOUNTS

BUCHHEIM, LOTHAR. Picasso, eine Bildbiographie. Munich, 1958 DUNCAN, DAVID D. Picasso's Picassos. Harper & Brothers, New York, 1961 — — — . The Private World of Pablo Picasso. Ridge, New York, 1958 OLIVIER, FERNANDE. Picasso et ses amis. Stock, Paris, 1933

PENROSE, ROLAND. Portrait of Picasso. The Museum of Modern Art, New York, 1957

SABARTÉS, JAIME. Picasso, portraits et souvenirs. Carré and Vox, Paris, 1946 SOUCHÈRE, DOR DE LA. Picasso in Antibes. Tr. by W. J. Strachan. Pantheon, New York. 1960

STEIN, GERTRUDE. Autobiography of Alice B. Toklas. Modern Library, New York, 1955

PICASSO'S WRITINGS

BRETON, ANDRÉ. "Picasso poète," Cahiers d'art, 1935, nos. 7-10 (German translation, Pablo Picasso. Wort und Bekenntnis. Arche, Zurich, 1954)

PICASSO, PABLO. Le Désir attrapé par la queue. Gallimard, Paris, 1945 (Desire Trapped by the Tail. Tr. by H. Briffault. New World Writing, New York, 1952)

EXHIBITIONS AND SPECIAL STUDIES

ARGAN, GRATIO CARLO. Scultura di Picasso. Alfieri, Venice, 1953

BOECK, WILHELM. Picasso Linoleum Cuts. Abrams, New York, Thames and Hudson, London, 1963

BOGGS, JEAN SUTHERLAND (ed.). Picasso and Man (catalogue). The Art Gallery of Toronto, 1964

BOLLIGER, HANS. Picasso for Vollard. Tr. by N. Guterman. Abrams, New York, Thames and Hudson, London, 1956

COOPER, DOUGLAS. Picasso: Les Déjeuners. Abrams, New York, Thames and Hudson, London, 1963

DOMINGUIN, LUIS, and BOUDAILLE, GEORGES. Picasso: Bulls and Bullfighters (Toros y Toreros). Abrams, New York, Thames and Hudson, London, 1961

GEISER, BERNHARD. Pablo Picasso: Lithographs 1945-48. Curt Valentin, New York, 1948

— — — Picasso: Fifty-Five Years of His Graphic Work. Tr. by L. Gombrich. Abrams, New York, Thames and Hudson, London, 1955

____ Planon, Poture-graneur (catalogue raisonne). Bern, 1933 (and ed. 1955)

JARDOT, MAURICE. Pablo Picasso: Drawings. Abrams, New York, Thames and Hudson, London, 1959

KAHNWEILER, DANIEL-HENRY. Les Sculptures de Picasso. Editions du Chêne, Paris, 1949

LARREA, JUAN (ed.). Guernica. Curt Valentin, New York, 1947

LIEBERMAN, WILLIAM S. "Picasso and the Ballet," Dance Index, New York, 1946, pp. 261-308

MELVILLE, ROBERT. Picasso, Master of the Phantom. Oxford University Press, London, 1939

MOURLOT, FERNAND. Picasso lithographe. 3 vols. Suaret, Monte Carlo, 1940-56

OATES, WHITNEY (ed.). From Sophocles to Picasso. Indiana University Press, 1963

RICHARDSON, JOHN (ed.). Picasso: An American Tribute (catalogue). Public Education Association, New York, 1962

ROY, CLAUDE (ed.). La Guerre et la Paix. Cercle d'Art, Paris, 1952 SABARTÉS, JAIME. Picasso ceramista. Pesce d'Oro, Milan, 1953

— — —. Picasso's Variations on Velázquez' Painting "The Maids of Honor". Abrams, New York, Thames and Hudson, London, 1959

TZARA, TRISTAN. Picasso et sa poésie. De Luca, Rome, 1953

ZERVOS, CHRISTIAN. Picasso, œuvre catalogue. 12 vols. Cahiers d'Art, Paris, 1932-61